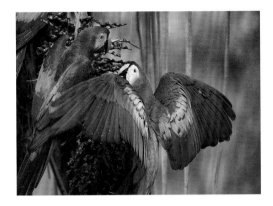

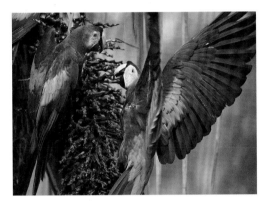

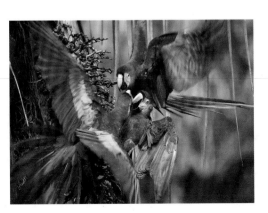

NATIONAL Audubon SOCIETY GUIDE TO

# NATURE PHOTOGRAPHY

## DIGITAL EDITION

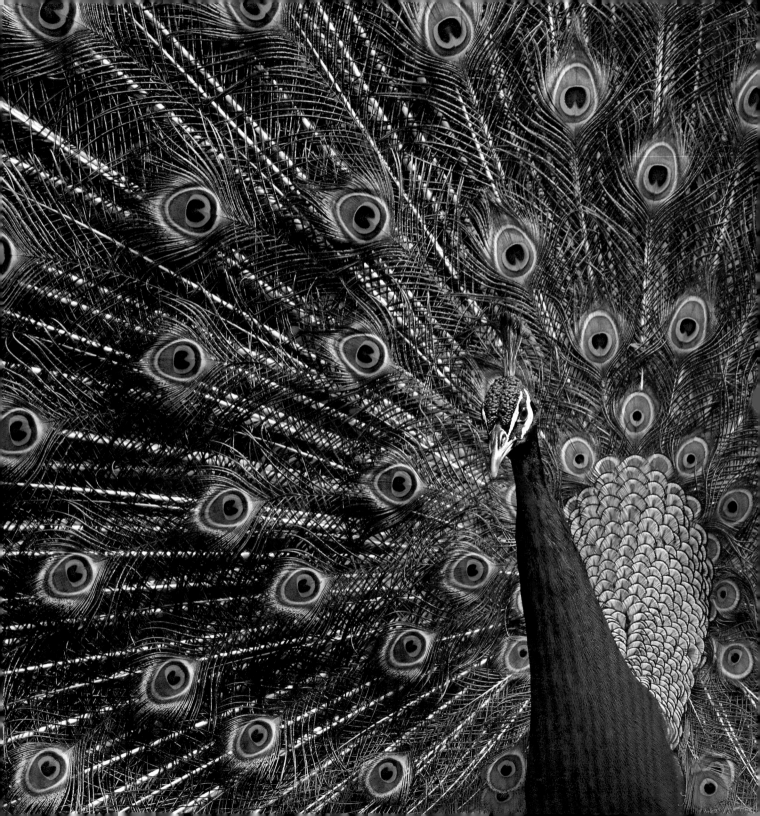

NATIONAL Audubon SOCIETY GUIDE TO

# NATURE PHOTOGRAPHY

DIGITAL EDITION

Tim Fitzharris

FIREFLY BOOKS

# A FIREFLY BOOK

Published by Firefly Books Ltd., 2008

First printing, digital edition, 2008
Revised edition published 2003
First paperback edition published 1996
First edition published 1990

**Publisher Cataloging-in-Publication Data  (U.S.)**
Fitzharris, Tim, 1948–
National Audubon Society guide to nature photography / Tim Fitzharris.
Digital ed.
[208] p. : col. photos. ; cm.
Summary: Provides how-to information on photographing nature subjects, including wildlife, landscapes, wildflowers with professional-level digital cameras. It also provides information on computer post-processing darkroom techniques.
ISBN-13: 978-1-55407-392-4
ISBN-10: 1-55407-392-8
1. Nature photography. I. National Audubon Society. II. Title.
778.93 dc22          TR721.F589 2008

**Library and Archives Canada Cataloguing in Publication**
Fitzharris, Tim, 1948–
National Audubon Society guide to nature photography / Tim Fitzharris. — Digital ed.
ISBN-13: 978-1-55407-392-4
ISBN-10: 1-55407-392-8
1. Nature photography.  I. National Audubon Society  II. Title.  III. Title: Guide to nature photography.
TR721.F574 2008          778.9'3          C2007-907546-0

Published in Canada by
Firefly Books Ltd.
66 Leek Crescent
Richmond Hill, Ontario, L4B 1H1

Published in the United States by
Firefly Books (U.S.) Inc.
P.O. Box 1338, Ellicott Station
Buffalo, New York, 14205

Designed and produced by Tim Fitzharris, Joy Fitzharris, Rester Atillo

**Photo Captions**
Half-title page: Scarlet macaws
Title page: Peacock display

Printed in China

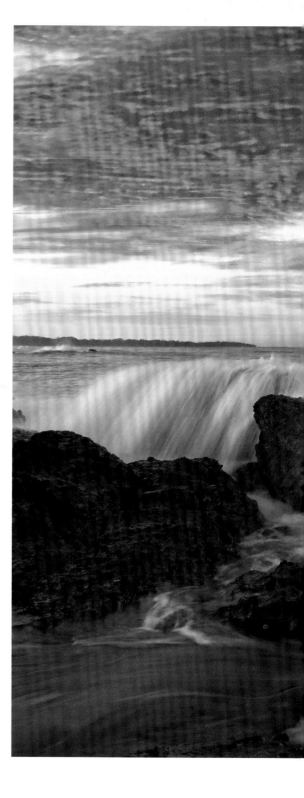

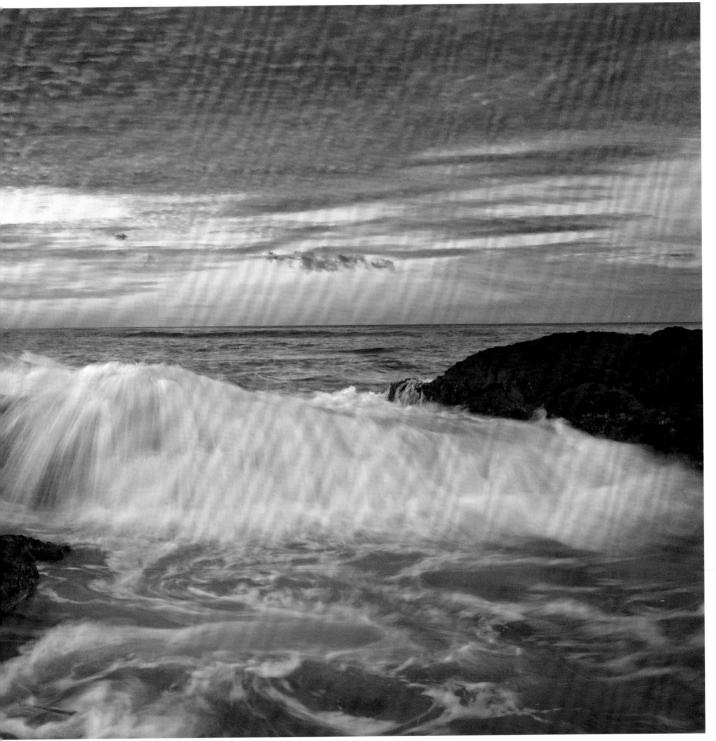

*Sunrise on Playa Langosta, Costa Rica*

*For Joy*

**Recent Books by Tim Fitzharris**

*Close-up Photography in Nature: Third Edition*

*National Audubon Society Guide to Landscape Photography*

*Big Sky: Wild West Panorama*

*AAA National Park Photography*

*Rocky Mountains: Wilderness Reflections*

*Virtual Wilderness*

*The Sierra Club Guide to 35mm Landscape Photography*

*Wild Bird Photography: National Audubon Society Guide*

*Fields of Dreams*

*Wild Wings: An Introduction to Birdwatching*

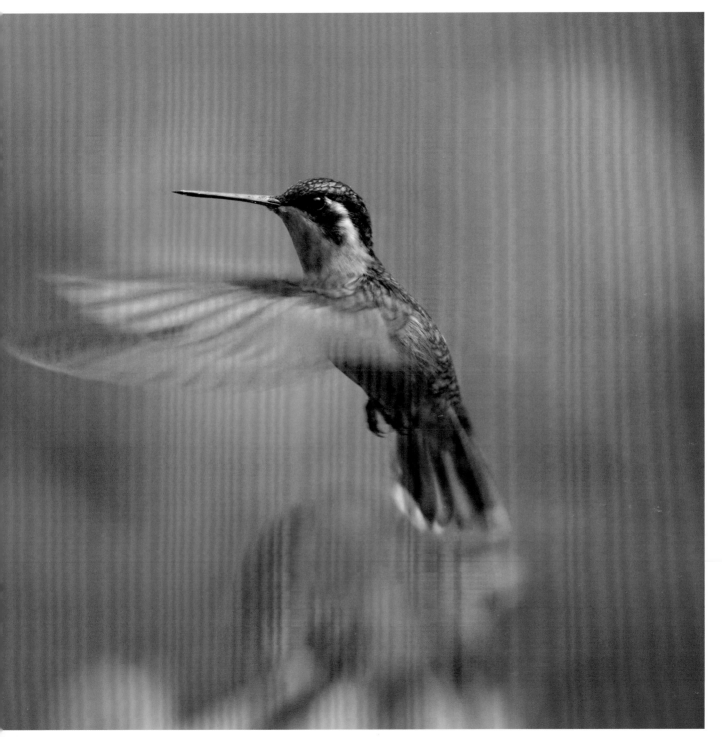

*Gray-tailed mountain gem hummingbird*

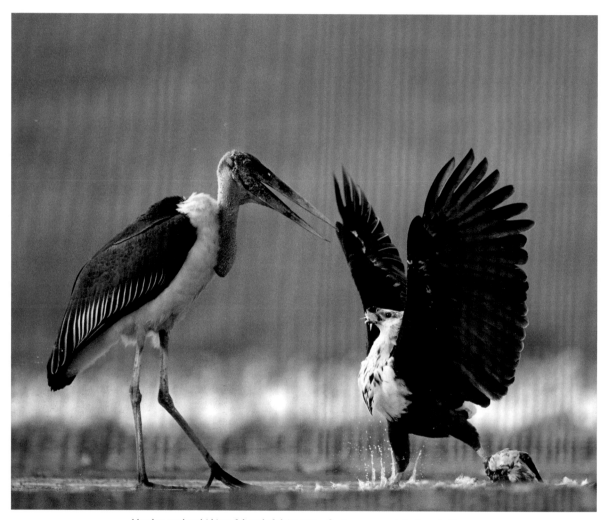

*Marabou stork and African fish eagle fighting over a flamingo carcass, Lake Bogoria, Kenya*

# NATIONAL Audubon SOCIETY

**THE AUDUBON MISSION** is to conserve and restore natural ecosystems, focusing on birds, other wildlife and their habitats for the benefit of humanity and the earth's biological diversity.

Through its education, science and public policy initiatives, Audubon engages people throughout the United States and Latin America in conservation. Audubon's Centers and its sanctuaries and education programs are developing the next generation of conservation leaders by providing opportunities for families, students, teachers and others to learn about and enjoy the natural world. The science program is focused on connecting people with nature through projects like Audubon at Home and Great Backyard Bird Count. Audubon's volunteer Citizen Scientists participate in research and conservation action in a variety of ways, from monitoring bird populations and restoring critical wildlife habitat to implementing healthy habitat practices in their own backyards. Audubon's public policy programs are supported by a strong foundation of science, environmental education and grassroots engagement. Working with a

network of state offices, chapters and volunteers, Audubon works to protect and restore our natural heritage.

To learn how you can support Audubon, call 800-274-4201, visit www.audubon.org or write to Audubon, 225 Varick Street, 7th Floor, New York, New York 10014.

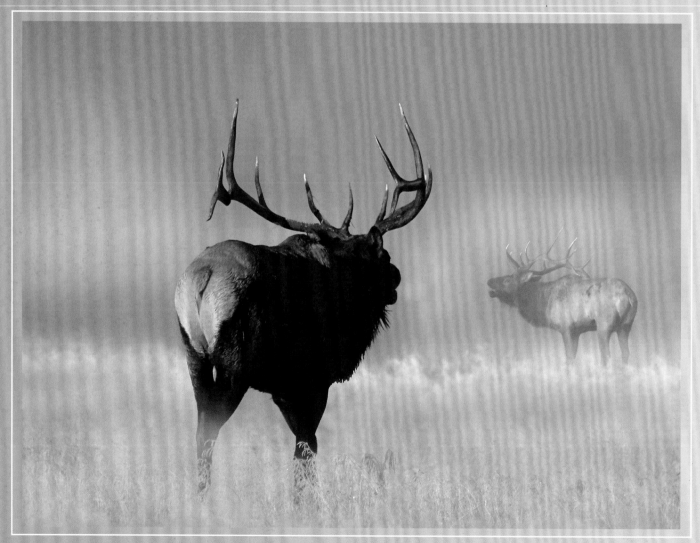

*Bull elk bugling, Yellowstone National Park, Wyoming (digital composite)*

# Contents

# Introduction

## The Craft and Art of Nature Photography

**NATURE PHOTOGRAPHY MEANS** different things to different people. But it is for all of us an acting-out of the instinctive urge to hunt and gather, even to claim territory. On a conceptual level it is an expression of our appreciation of beauty. The philosophy, experience and practice of nature photographers allow each to be placed for the moment somewhere along this continuum between subject matter and theme, between craft and art. This book is intended to help photographers with a knowledge of photography's basic principles find their way along this route and enjoy its numerous attractions.

Photographing wild creatures is a challenging undertaking with infinite possibilities. When shooting a bird or mammal, the approach is mostly determined by the subject. There are logical, hard-to-ignore prerequisites that concern us when filming whales, giraffes or butterflies. We want to capture expression in the eyes, definition of specialized limbs or how the subject gets its food. These subject-generated issues are not so compelling when working with inanimate trees, sand dunes or breaking waves. Instead, the approach is guided more by influences from within — a philosophy, a mood, a telling experience, a visual sensation. This engagement with self-expression is at once easier (who's to say you're wrong?) and more challenging (does anyone care?) than satisfying the more apparent and objec-

*Havard agave (right). This diminutive composition of multihued succulent leaves could be overlooked easily in the excitement of a field excursion. Small, undramatic elements are tractable vehicles for recording impressions and feelings about the natural world. Your choice and approach to subject matter can be a reflection of how you view yourself and the world. Mamiya 645 AFD with Phase One P25+ digital back, 55–110mm f/4.5 lens, extension tube, Singh-Ray circular polarizer, ISO 100, 1/4 second at f/16.*

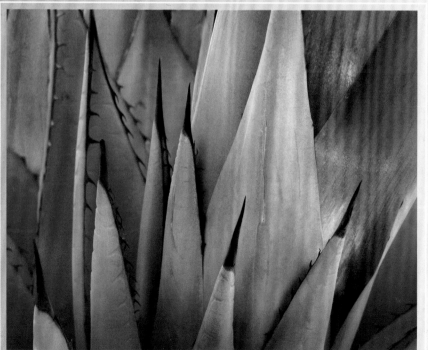

tive criteria of subject-based imagery. Depending on mood, inspiration and encounters with compelling subjects and settings, most of us move back and forth between crafting photographs and expressing our artistic urges.

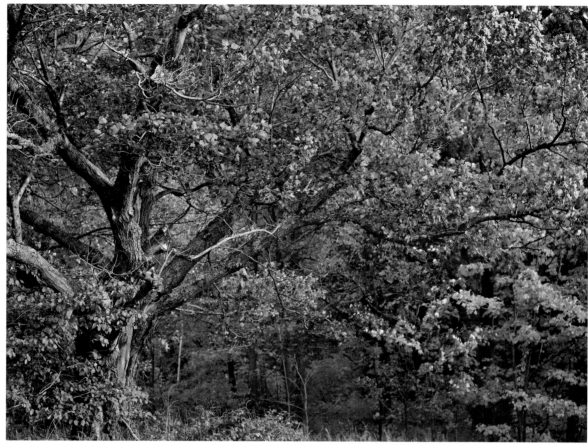

*Autumn color at Chippewa River, Ontario (above). Brilliant autumn foliage is captured in a simple study of color, scale and texture. Mamiya 645 AFD with Phase One P25+ digital back, 55–110mm f/4.5 lens, Singh-Ray circular polarizer, ISO 400, 1/125 second at f/16.*

The recent development and near universal embrace of digital cameras and related technology has engaged photographers ever more deeply in the creative process. By providing higher quality in-camera image capture as well as vastly more pliant post-capture computer processing and image modification (formerly darkroom) methods, photographers can pursue their artistic goals relieved of most of the technical limitations that formerly hampered creativity.

However, this is not the book to find detailed advice on how to run your high-tech digital equipment. Most of the time, this preoccupation is peripheral to making pictures of the natural world. This book is intended to help you make the best pictures in the most direct, practical, economical, intuitive way possible. Photography isn't complicated — a camera is a basically simple machine for capturing images on a light-sensitive storage medium. Although technical advances of the last three decades have made cameras more responsive and (electively) automated, they have also made the creative component of picture-making more

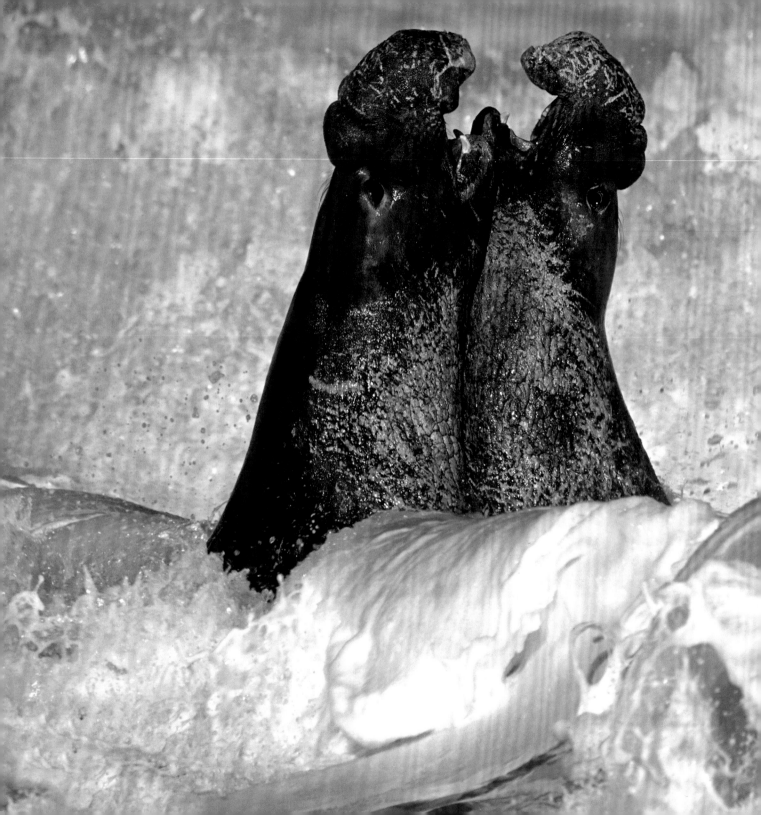

challenging. Art photographers, freed from working within the confines of film, can now engage a near infinite world of conceptual possibilities.

At a time when the earth's natural resources and wild places are being destroyed at a pace unmatched in human history, you could choose few better ways to spend your life or your leisure time than photographing nature. No matter the result of your picture-taking efforts, the act itself serves as an example to family members, friends and even the larger community of a philosophy that marries aesthetic abstraction with the elemental dictums of survival. As photographers and artists, we can use our influence to help turn society's focus on resource development and consumption to one that favors preservation. At this point it's a losing battle, but this could change. And you'll feel better about your life and even more appreciative of the subjects you photograph just for making the effort.

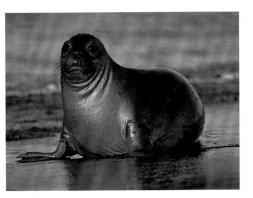

*Northern elephant seals, Point Piedras Blancas, Big Sur, California (left and above). Nearly extinct in the 1880s, elephant seals have recovered thanks to a ban on commercial hunting and habitat protection principally along the west coast of the United States. More than 2,000 pups are born each year at this idyllic location.*

*Part One*

# The Right Equipment

# Basic Kit

*Essential Equipment for Photographing the Natural World*

**MOST SERIOUS AMATEUR** and professional nature photographers rely on single-lens reflex (SLR) cameras to handle all of their picture-taking needs, whether they are shooting grizzly bears in Alaska, volcanoes in Hawaii or butterflies in the Texas Hill Country. The SLR allows you to view the scene directly through the lens by means of a pentaprism that delivers an accurate image to the viewfinder, a feature especially important when shooting small subjects at close range. Just prior to exposure, a mirror that reflects the scene through the pentaprism to the eye, flips up and out of the way to allow light to strike the film. This happens almost instantly, allowing you to keep continuous sight of the subject, a boon when trying to capture moving wildlife. Single-lens reflex cameras permit lens interchange, a feature that makes it possible to photograph the panorama of an alpine vista with a wide-angle lens and a moment later to capture a bird with a telephoto or record drops of dew lined up on a blade of grass.

Digital cameras capture the subject on a light sensor and save it as pixels (tiny, computer-coded bits of light) on a compact memory card similar in function to a computer storage disk.

## DIGITAL CAMERA ADVANTAGES

For enlargements up to large wall-calendar size,

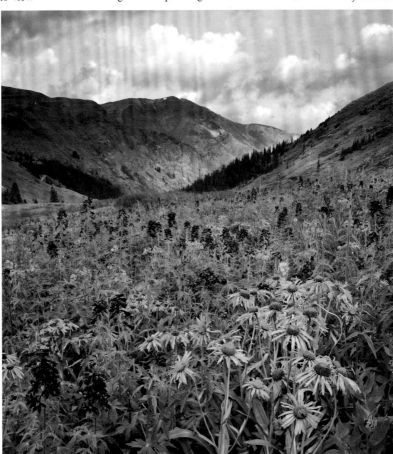

*Orange sneezeweeds, American Basin, San Juan Mountains, Colorado (left). This photograph was made with an SLR camera at close range. The accurate viewing system allowed me to carefully frame the array of flowers to capture the most effective pattern. Due to the interchangeable lens system, I was able to shoot with an ultra wide-angle lens to create a sense of depth. Mounting the camera on a tripod made it convenient to adjust exposure settings and steady the scene while I considered the composition. Mamiya 645 AFD with Phase One P25 digital back, Mamiya Sekor 35mm f/3.5 lens, extension tube, Singh-Ray circular polarizer, one-stop split neutral density filter, ISO 100, 1/4 second at f/22.*

the best digital cameras produce results equal to or better than traditional film cameras in image resolution, highlight and shadow detail, and grain/noise. With a digital camera, exposure and composition can be verified on a small screen immediately after exposure allowing you to reshoot on the spot if corrections are needed. Of great benefit is the ability to adjust ISO speed of individual takes to match shooting conditions. Digital images can be easily modified on your computer. You can dodge, burn, adjust color and brightness, and enhance sharpness with image editing software (Adobe Photoshop being the standard). Once the image is adjusted to your satisfaction, you can print it on a photo-quality desk-

*Lesser scaup (below). This photograph was reproduced from a 35mm transparency scanned on the desktop. I approached the preening drake in silence from a floating, mobile blind. The shallow depth of field of the telephoto lens produced an out-of-focus background that throws the arabesque bird into strong relief. Canon EOS A2, Canon 500mm f/4 IS lens, Fujichrome Velvia 50, $^1/_{250}$ second at f/4.5.*

top printer and achieve professional results. Along with your digital SLR camera (DSLR), you also need to invest in a high-speed computer, imaging software and a photo-quality printer. But, unlike in days of old, you never need buy a single roll of film or pay for processing.

### REJUVENATING YOUR FILM ARCHIVES

Traditional film images that you worked so hard to make in past years can be digitized with desktop scanners and edited on the computer with the same facility as images from digital cameras. Transparencies that have faded over the years or been damaged through handling can have color restored and scratches repaired. In this way, you can bring all of your collection under the digital umbrella for presenting in slide shows, sharing through the Internet or e-mail, or making easy, no-risk submissions to print-media publishers. All of the film images in this book were reproduced via a desktop scanner (Nikon Super Coolscan 9000 ED).

### BUYING A DIGITAL CAMERA

Amateur shooters needn't go beyond a 6-megapixel camera, which is adequate for mak-

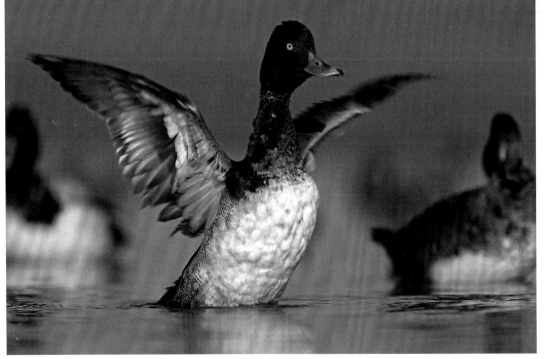

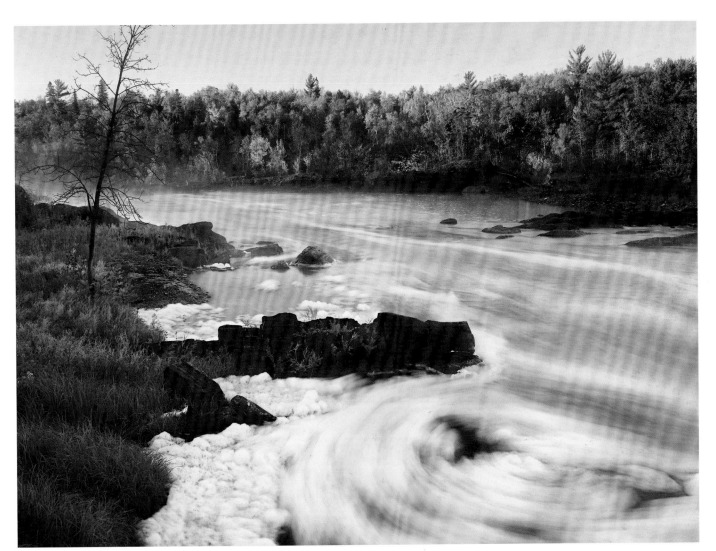

ing high-quality enlargements up to wall calendar size. More serious photographers will want a DSLR with a higher pixel count (10–40 megapixels). The added detail captured is of value for making large fine-art prints and commercial grade applications such as billboards, murals, posters and jumbo wall calendars. If you enjoy shooting landscapes, give preference to models with full-frame sensors (Nikon and Canon). Due to their partial-frame sensors, many DSLRs multiply focal length by about 1.6X, effectively eliminating extreme wide-angle focal lengths. Full-frame sensors retain actual lens focal

*St. Louis River, Jay Cooke State Park, Minnesota (above). A lightweight tripod was essential to steady the camera for this 15-second exposure.*

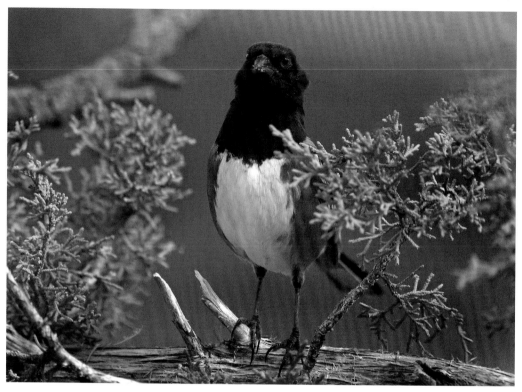

*Rufous-sided towhee (right). For a brief second, this cautious song-bird stared curiously into the lens. A motor drive and smooth-panning tripod head allowed me to quickly frame the composition and take a few steady shots. Canon EOS 5D, Canon 500mm f/4 IS lens, ISO 400, $1/750$ second at f/5.6.*

*Lost Maples State Park, Texas (far right). A sturdy, lightweight tripod with clip-lock leg sections (Bogen 055MF3 made it easy to position the camera on the steep riverbank where these trees were showing their fall splendor. Mamiya 645 AFD with Phase One P25 digital back, Mamiya Sekor 55–110 f/4.5 lens, extension tube, Singh-Ray circular polarizer, one-stop split neutral density filter, ISO 100, $1/4$ second at f/22.*

length, but they are expensive and not widely available. At present, Canon is the DSLR brand of professional choice due to its numerous full-frame sensor models and wide selection of super-telephoto lenses equipped with image stabilization, a feature of great benefit when shooting wildlife.

### THE BASICS: CAMERA AND TRIPOD

The backbone of any nature photographer's system is the 35mm format single-lens reflex camera. New or used, it really doesn't matter as long as the camera has depth-of-field preview, high-speed image capture (three frames per second or faster), and can

make use of a cable shutter release. Other crucial features (lens interchange and through-the-lens exposure metering, for instance) are standard features on practically any 35mm DSLR. Depth-of-field preview is necessary for judging picture composition prior to exposure; high-speed image capture gives you the best chance of recording nature in its multitude of ever changing, always moving configurations; a cable release is often necessary to avoid camera shake during exposure, something that will prevent you from attaining sharp images.

A tripod should be your first additional purchase once you have acquired a basic camera and lens. A

tripod is necessary for shooting most subjects in the dramatic but weak light of dawn and dusk when exposure times are too long for you to hold the camera steady. It is also indispensable for attaining sharp images if shooting with telephoto lenses or close-up equipment when even minor movements of the camera during exposure become exaggerated, resulting in blurred pictures. The most suitable tripods have tubular legs (for sturdiness), are tall enough to bring the camera to eye level with the center column seated, have legs that spread independently for easy setup on uneven terrain, and have clip-lock levers controlling the extension of leg sections (concentric controls get easily jammed by dirt and even water). Ball heads (rather than pan/tilt heads with levers) make the best links between tripod and camera. They are compact, don't get snagged on vegetation, and allow you to lock the camera in any position quickly by tightening a single control. (For more information on tripods see the next chapter.) The camera body and tripod are integral to shooting every type of nature subject. Once you have these two items, you can expand your system according to your special interests and budget.

## BIG LENSES FOR WILDLIFE

Making professional caliber wildlife images (including birds) requires a super-telephoto lens, one of your largest financial investments in equipment. Wild animals are generally not afraid of photographers, and given the chance, they will tolerate us

*Rocky Mountain columbine (below). A telephoto zoom lens equipped with a close-up extension tube provided the magnification for this portrait.*

*White Pelican (far right). This relaxed but ultra-wary species was photographed from a blind from a nonthreatening distance with a 500mm lens and 1.4X teleconverter (effectively 700mm).*

at close range in areas where hunting is proscribed year-round. Even so, frame-filling pictures of most species are not possible without using a telephoto lens in the 400mm and longer range. To be able to react quickly to subject behavior, I prefer smaller, lighter telephotos in the f/4 to f/5.6 maximum aperture range, specifically a 300mm for large animals and handheld shots of subjects in motion and a 500mm for small and/or wary creatures. The best and most expensive telephoto lenses have glass elements described as ED (extra-low dispersion)

or APO (apochromatic). The ultimate in super-telephoto lens quality resides in Canon's IS (image stabilizer) and Nikon's VR (vibration reduction) lenses, which reduce or eliminate camera shake during exposure, producing the most consistently sharp telephoto images of any camera system. If you're interested in one of these, you might want to start thinking about a second mortgage. (For more information on buying and using telephoto lenses see page 32.)

Ideally, your wildlife shooting kit will be rounded out with a 1.4X tele-converter (increases focal length of the prime lens by 1.4) and an extension tube of around 25mm (allows extra-close focusing for songbirds, chipmunks, butterflies, frogs and other small creatures).

## To Shoot the Landscape

Here, we are closer to earth in terms of a financial commitment. Zoom lenses are preferred for landscape work because they allow you to precisely

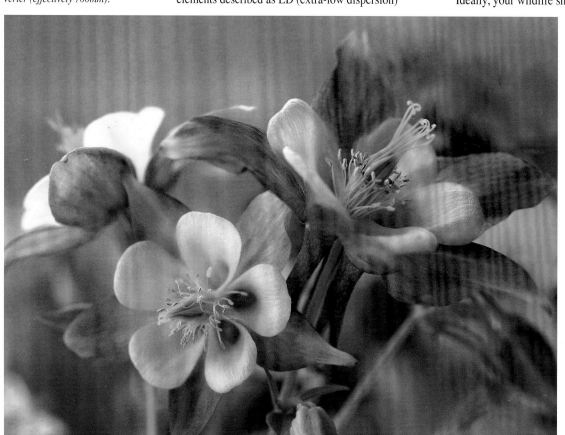

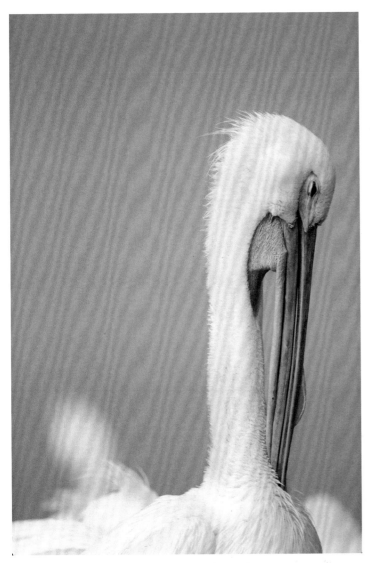

lenses with aspherical elements produce the best quality. Internal focusing (IF) lenses provide great convenience when using polarizing and graduated filters, which otherwise must be readjusted each time you change focus. It also saves aggravation (and money) if all of your lenses use the same size screw-on filters.

You will need two types of filters: First, a screw-on polarizing filter to darken blue skies, modify reflections from water, and eliminate reflections from foliage for increased color saturation; and second, a graduated neutral density filter to bring the contrast range of the landscape within, or closer to, the contrast range of the digital sensor. This is often the only in-camera way (it can be done with more effort on the computer) to achieve good

magnify the scene for the best composition. It's not important what combination of lenses you have, but you will want to cover all of the territory between about 18mm and 200mm with two or three lenses (the fewer the better). For wide-angle focal lengths, detail and color in both the lightest and darkest parts of the image. Neutral density filters are square and fit into adjustable holders that screw onto the front of the lens. A one-stop graduated neutral density filter is usually sufficient for digital shooters. Cokin

## Equipment List
### (In Order of Purchase)

35mm DSLR with interchangeable zoom lens (80–200mm approximately)

Tripod with ball head

Cable shutter release

25mm extension tube

Circular polarizing filter

Modular photo vest

Fold-up reflector (two sides — silver + white)

Wide-angle to short telephoto zoom lens (24–80mm approximately)

Split neutral density filter (one-stop, hard-edge)

1.4X teleconverter

Ultra wide-angle lens (17–20mm range)

500mm or 600mm super-telephoto lens

50mm extension tube

Macro flash and bracket

Extra camera body

produces low-cost filters of this type, while Singh-Ray supplies the best quality and the most extensive selection.

### Intrigue with Tiny Critters

Nature's miniature world is home to some of the most beautiful and easily photographed subjects — dewdrops, wildflowers, butterflies. You cannot make frame-filling records of these subjects with standard lenses. You need to buy special close-up adapters to extend the focus range of your existing optics (least expensive) or buy macro lenses that are specially designed for this type of work (more convenient). Both approaches yield excellent results.

Add-on close-up accessories include screw-on supplementary filters — simple meniscus lenses that work just like magnifying glasses. (Two-element supplementary lenses are recommended for top

*Pointed phlox and paintbrushes, Texas Hill Country (right). This floral tapestry was recorded with a specialized tilt/shift lens which allowed me to match the plane of sharp focus with the slope of the hillside overgrown with flowers. This in turn made possible the use of a brief shutter speed that arrested subject motion and produced a detailed image. Mamiya 645 AFD with Phase One P25 digital back, Rodagon 135mm f/4.5 lens, Horseman View Camera Converter, Singh-Ray circular polarizer, ISO 200, $^{1}/_{125}$ second at f/16.*

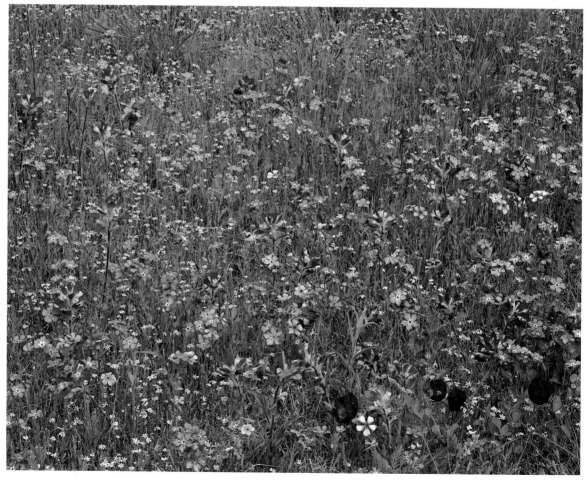

quality.) These accessories cost only a little more than standard filters and give you access to the greatest variety of nature subjects for the least amount of money. Extension tubes provide another relatively inexpensive way to get close. These hollow tubes, available in a variety of stackable sizes, are fitted between the prime lens and camera body. They generally yield better quality images and a greater range of magnification than supplementary lenses. They work best when used with prime lenses of normal to telephoto length.

Fixed focal-length macro lenses focus from infinity to a close-up range that generally provides enough magnification to take a frame-filling picture of a bumblebee. No need to fiddle with accessories; shoot the landscape on one frame and a butterfly on the next without taking your eye from the viewfinder. Zoom or telephoto lenses with macro capability do not normally yield this much magnification, being suitable for portraits of animals the size of chipmunks and larger. For animals smaller than a bumblebee, more specialized techniques and equipment are necessary.

Another essential piece of close-up gear is a reflector to modify lighting conditions. A portable, fold-up reflector with one side silver for maximum reflection and the other side white for a more subtle effect is inexpensive, easy to carry and yields professional-looking results. Unlike electronic flash, you can see the effects in the viewfinder before you take the picture. Reflectors made by Flex-fill are popular and widely available. (For more about close-up photography see page 169.)

This is only an outline of the range of equipment you need to photograph the natural world. These suggestions should keep you on track until you get a better feeling for the subject, how you wish to work and the types of imagery you are interested in producing. Technical marvels that are generally overdesigned, modern cameras and lenses are only tools for taking photos of nature's world. Great images will be made by you, not the equipment.

*House spider (left).* *This tiny subject appeared in my bathtub one morning. I transferred it to a daisy plucked from the garden and made the portrait indoors with a handheld camera. The scene was illuminated by the brief light of an electronic flash. Canon EOS Elan 11, Canon 28–105mm lens with 25mm extension tube, two electronic flash units with Kleenex tissue diffusers, Fujichrome Provia 100F, $1/60$ second at f/22.*

# Tripods

*The best tripod features for nature photography*

*Roseate spoonbill (below).*
*A tripod is essential to steady the super-telephoto lenses used for wary wildlife species. Here the tripod was set up at minimum height, which offered an angle on the bird that threw the background out of focus. Effortless framing was achieved with a gimbal head (Wimberley Sidekick). Canon EOS 3, Canon 500mm f/4 IS lens, Fujichrome Provia 100F, 1/500 second at f/5.6.*

**RUBY BEACH ON OLYMPIC** National Park's Pacific Coast is holy ground for photographers, a remote landscape shrine where the faithful quietly appear on foggy mornings. The tide is out and sheens of sand stretch hundreds of yards to the water's edge and for as far as you can see to the north and south. Big rocks and looming granite stacks are arranged in the sand among mirrored pools, their naked bases adorned by blue mussels in neat ranks and sea stars tangled in orgies of pastel color. While fog writhes under the beam of a rising sun, I wander this

beach, searching for angles. My tripod goes up for 10 minutes at a stretch to fix the camera on each revelation. It is stationed precariously atop a jumble of boulders, next it is half submerged in a tidal pool, then spread low on a slope of mushy sand as I kneel to record pebbles and gull feathers. Many times it is on and off my shoulder, extended, retracted, pulled and prodded, soaked and muddied. After two hours, the wind stirs and the fog retreats, leaving the beach exposed to the sun's glare. I shoulder my gear and begin the climb back up the trail.

For nature photographers, a tripod is nearly as important as a camera and lens. Rarely are top-quality images made without one. It is essential for stabilizing telephoto lenses for shooting wildlife and macro lenses for recording insects and wildflowers. For scenic work, a tripod makes possible the long exposures needed to achieve sharp focus throughout the image field. Its controls require repeated adjustment, on the whole nearly as much as camera and lens.

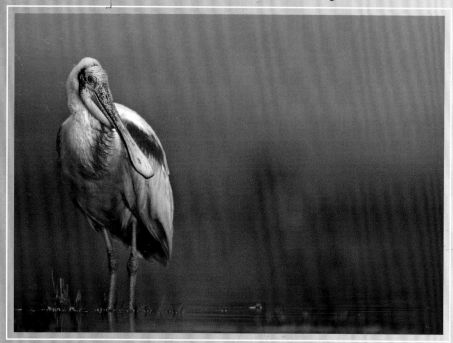

To capture nature's fleeting dramas, they must be precise, quick and sure.

## APPROPRIATE SIZE

When fully extended the tripod with camera mounted should come to eye level with the center column seated. (Eye level is about 5 inches less than your height.) A manufacturer's specifications for tripod height do not include the tripod head, which gives about a 5-inch boost, nor the position of the camera's viewfinder, which adds a further 3 inches or more. The lower the tripod can be set up the better. Some tripods drop right to ground level when fully spread if the center column is removed. This may be beneficial for macro specialists but for general nature work this is not advisable. A long center column is valuable in landscape work

to bring the camera up to eye level when you are working on a steep slope or perhaps atop a boulder with the tripod set up below you. It's valuable in wildlife shooting to raise the camera position a few inches to avoid a foreground interference such

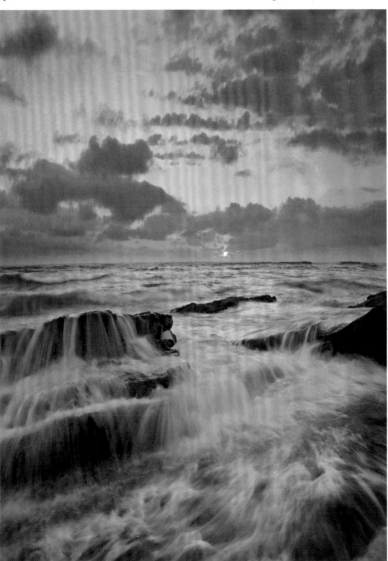

***Playa Santa Maria, Costa Rica (left).*** *To ensure image sharpness a tripod was necessary to steady the camera during this extended sunrise exposure. I was able to set up the tripod quickly and securely on this uneven coral shelf because the legs spread independently, allowing them to be secured on almost any surface no matter how uneven. Salt water causes minimal harm to tripods as long as the working mechanisms and other corrosive parts are kept lubricated. Canon EOS 5D, Canon 17–40mm f/4 EF lens, ISO 100, one-stop split neutral density filter, ISO 50, 1 second at f/22.*

as a twig or leaf. The best center columns for general nature work are ones that are shorter (8 to 9 inches) or can be removed and mounted horizontally on the tripod legs.

### TRIPOD HEADS

A compact, fast-working ball-and-socket head with panning capabilities is best for nature photography. The head should have comfortable knobs for both locking the head and setting the ball's base tension. When locked down the head should not creep in response to the camera's weight even when using a heavy lens. There are good ball heads on the market in the $200 to $400 range.

### HEADS FOR SUPER-TELEPHOTO LENSES

For large and heavy telephoto lenses, a gimbal-type head provides quick, sure, fingertip control of aiming, tracking and panning (see photo page 30). Such heads are made by Wimberley (www.tripodhead.com) in two sizes. For lenses 600mm f/4 and larger, the full-size Wimberley Version II provides the most stability and best balance, but this head is large and heavy and primarily used by wildlife specialists who do not move around much when shooting. Due to its smaller size and weight, the Wimberley Sidekick is the best choice for those who enjoy working with a variety of subjects. The less expensive Sidekick attaches to a regular ball head and offers advantages similar to the full-size gimbal head. To work properly, the Sidekick must be mated with a ball head that has a panning mechanism.

### LIGHTNESS OVER STABILITY

A massive tripod may impart a comforting sense of stability when you first lower a 600mm f/4 into its saddle, but out on the range you will find the big tripod seldom desirable. Both amateurs and professionals get more keepers in the bag and have more fun doing it when they err on the side of lightness. When shooting wildlife, I change positions often in response to the animal's behavior for improved magnification, lighting, background, foreground or subject view — a tiresome exercise even with a light outfit. I usually collapse the tripod and spread the legs a little wider for more stability so that I can shoot from a kneeling position. This provides a desirable near eye-level view of most species — from wild

*Bleeding hearts (below). To get this knee-high view of springtime Texas, I used a tripod (Manfrotto Carbon One 441) that permitted me to remove the center column and reinsert it parallel to the ground. Unlike the more standard practice of reinserting the column upside-down, this method gives ready access to the viewfinder (no squeezing yourself between the legs to peek at your subject).*

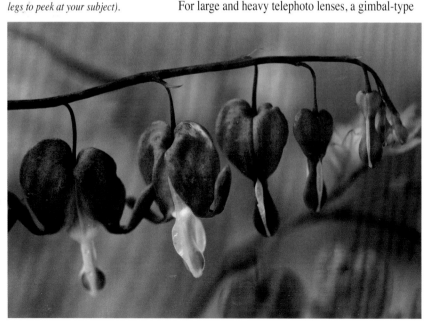

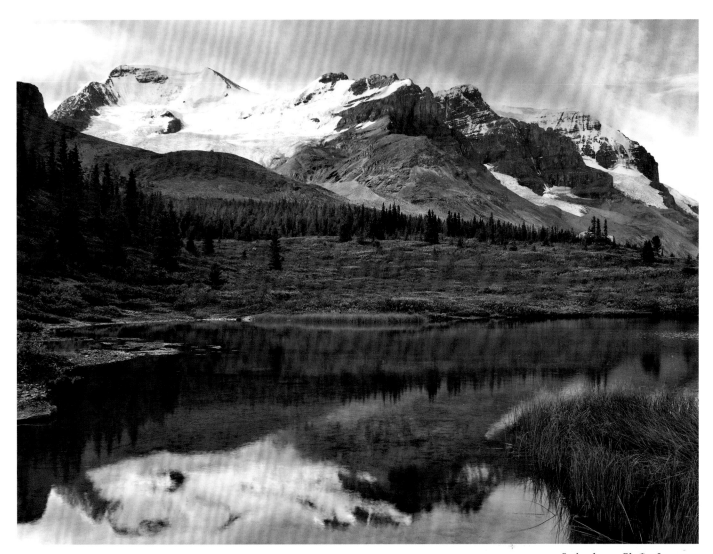

turkeys to mule deer. When set low, the tripod is less conspicuous, stronger than at full extension, and it is also out of the wind. For most landscape and macro subjects, a big, sturdy tripod provides no advantage over a small one, except under windy conditions, which are ill-suited for most subjects in any case.

The lightest tripods have legs made of carbon fiber. As a bonus this material is stiffer and absorbs vibration better than metal. Such tripods are several times more expensive than metal counterparts, but it is an investment that most nature photographers find worthwhile. A tripod should

*Saskatchewan Glacier, Jasper National Park, Alberta (above). Traveling light with a small, carbon fiber tripod facilitates access to remote locations such as this rugged alpine setting.*

**Gimbal-type head (below).** *The Wimberley Sidekick (contact www. tripodhead.com) is a compact gimbal head that attaches to a ball head for steadying super-telephoto lenses. It allows smooth fingertip panning and framing.*

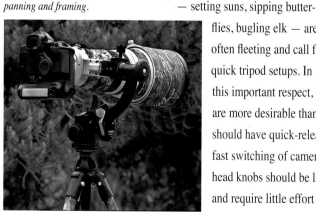

provide plenty of support if its maximum load limit exceeds the weight of your heaviest lens/camera combination by 5 or 6 pounds. (My 500mm f/4 lens with EOS 3, power booster, Wimberley Sidekick and ball head weighs nearly 20 pounds.)

## QUICK IS BEST

You will erect your tripod frequently in awkward spots — riverbanks, boulder fields, bramble patches, sand dunes and beaver ponds — and you will need to make many adjustments before you begin shooting. To complicate matters, many subjects — setting suns, sipping butterflies, bugling elk — are often fleeting and call for quick tripod setups. In this important respect, some tripod features are more desirable than others. Ball heads should have quick-release mechanisms for fast switching of cameras and lenses. Ball head knobs should be large and comfortable and require little effort to lock and unlock.

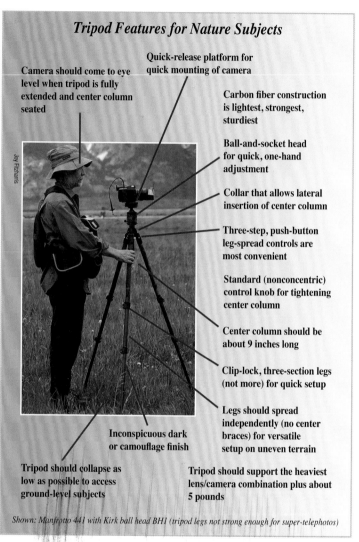

## Tripod Features for Nature Subjects

Camera should come to eye level when tripod is fully extended and center column seated

Quick-release platform for quick mounting of camera

Carbon fiber construction is lightest, strongest, sturdiest

Ball-and-socket head for quick, one-hand adjustment

Collar that allows lateral insertion of center column

Three-step, push-button leg-spread controls are most convenient

Standard (nonconcentric) control knob for tightening center column

Center column should be about 9 inches long

Clip-lock, three-section legs (not more) for quick setup

Legs should spread independently (no center braces) for versatile setup on uneven terrain

Inconspicuous dark or camouflage finish

Tripod should collapse as low as possible to access ground-level subjects

Tripod should support the heaviest lens/camera combination plus about 5 pounds

*Shown: Manfrotto 441 with Kirk ball head BH1 (tripod legs not strong enough for super-telephotos)*

Three-section tripod legs afford faster adjustment of height than four-section ones, which are normally only advantageous when small collapsed size is important (e.g., backpacking, carry-on luggage). The legs should spread independently (no central struts). The leg-length locking mechanisms should ideally

be clips that snap open and shut rather than concentric twist rings. The fastest leg spread controls are three-position, spring-loaded push buttons. The center column lock should be a simple knob rather than a concentric ring (a drawback of Gitzo tripods).

## INCONSPICUOUS COMFORT

Most photographers carry the tripod with camera and lens attached over their shoulders when moving between locations. If you work from a bag, the weight of the tripod on your shoulder soon becomes uncomfortable. Metal tripods also are cold to handle when the mercury drops. Both problems can be eliminated by attaching a set of camouflaged Tri-pads (see www.rue.com/tripods.html) to the upper leg sections. I make my own with a length of foam pipe insulation (available in hardware stores) and a roll of fabric camouflage tape (often available at Wal-Mart). Camouflage material hides you from wary subjects and passersby whose curiosity may interrupt concentration, frighten the subject, or cause a traffic jam if you are working along the roadside.

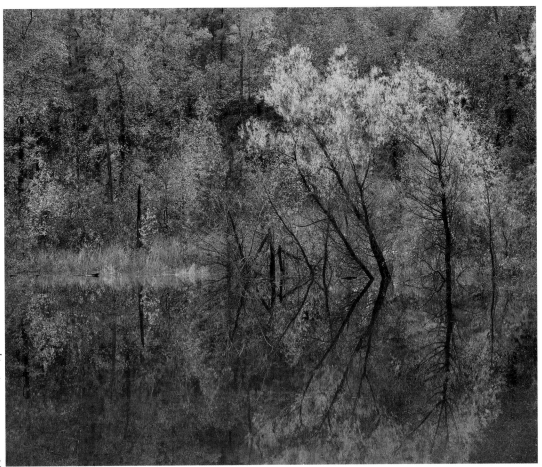

Careful consideration of your shooting style and subject interests will lead you to selecting an appropriate combination of tripod features, size and price. Visit camera stores to try out various models before making a decision. Your choice of tripod is usually just as important as your selection of a camera.

*Gillham Lake, Arkansas (above).*
*On breezy days tripods are a boon when photographing scenes with delicate vegetation or fragile reflections (or both). You can establish the shot and then bide your time between periods of calm.*

# Super-telephoto Lenses

*Ideal features of the most useful (and expensive) lenses for wildlife*

**IN THIS CHAPTER YOU'LL** find out what I think is important in a super-telephoto lens, the big gun in the wildlife photographer's arsenal. The lens you now own or are thinking of buying may not have all these features, but the more of them the better.

## FOCAL LENGTH

If your camera has a full-frame sensor, anything shorter than 500mm is too short and anything longer than 600mm is too long. (Focal lengths between 400 and 500mm work well with less-than-full-frame DX sensors.) Both focal lengths have plenty of reach and produce quality results with 1.4X and 2X teleconverters. A 500mm f/4 is about 4 or 5 pounds lighter than a comparable 600mm and so affords more mobility and less fatigue. It's usually about 25 percent less expensive than its big brother, maximum apertures being equal. The 600mm has greater reach, which comes in handy for small and/or skittish subjects. However, it's not unusual to find yourself overmagnified with either focal length. If you're restless, not terribly big and like to get off the beaten path, then the 500mm is your focal length. If you can crush lens barrels on your forehead, are enamored with tight framing and have the patience to remain still until the subject strikes the right pose or wanders into the right light, then get the 600mm. Some of these lenses cost thousands of dollars, even if purchased secondhand. You can save a lot by combining

*Common merganser (below). This hungry fishing duck was photographed with a 500mm lens and 1.4X teleconverter from a floating blind at a distance of about 15 feet. For small subjects a teleconverter is often added to a super-telephoto lens to achieve increased magnification.*

a 300 or 400mm lens with 1.4X and 2X teleconverters but image quality will be compromised at comparable magnifications. The reduction in light transmission caused by the teleconverters will limit or prevent lens auto-focus as well as stop-action shooting in the weak light of early morning and late afternoon.

## Zoom Telephotos

High quality zoom lenses reaching into the super-telephoto range are becoming more common. In particular, Nikon's 200–400mm f/4 VR (vibration reduction) lens is an ideal choice for super-telephoto nature photography.

## Brand

If you are starting from scratch, or are willing to trade in your equipment, then Canon or Nikon are generally the brands of choice in the super-telephoto field. Other manufacturers (Pentax, Minolta, Sigma) make super-telephotos of high optical quality but none offers a comparable range of image-stabilized focal lengths. Pentax and Minolta offer cameras

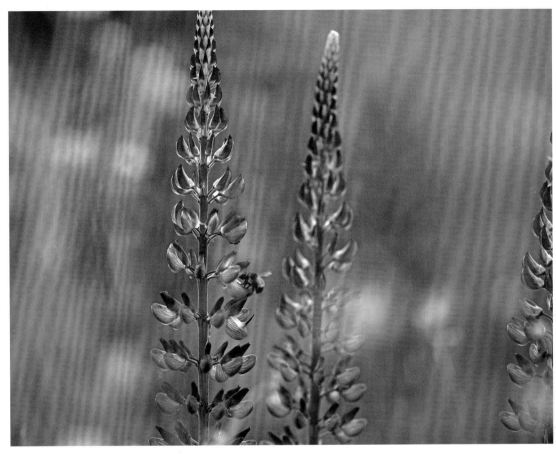

with image-stabilized digital sensors, an approach to stabilization which works with all lenses mounted to the camera. This is an excellent alternative, although the professional cameras available from these manufacturers do not match the resolution or shooting speed of Canon's high-end models.

## Lens Speed

Lens speed (i.e., maximum aperture) isn't as important as it was a few years ago thanks to the

*Lupines (above). Super-telephotos are not just for wildlife subjects. They make great special effects tools for compressing landscape views, isolating water patterns at seaside or creating abstracted impressions of wildflower meadows, as shown here. This image was shot at maximum aperture for the least depth of field in order to blur all of the flower stalks except one.*

*Crowned cranes (right). The development of professional-quality digital sensors reduced the need for a telephoto lens with a maximum aperture greater than f/5.6. These slower lenses are not only less expensive but they are also more enjoyable to use. Being smaller and lighter, they allow you to operate in the field more productively with greater ease. These wary cranes were photographed from a car blind with a manual focus 500mm lens and 1.4X teleconverter.*

*Gimbal head (below). A heavy 500mm f/4 IS lens can be targeted effortlessly once mounted on this special tripod accessory.*

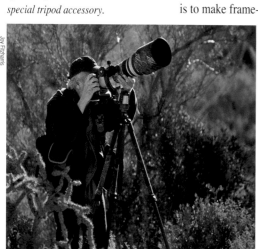

Joy Fitcharris

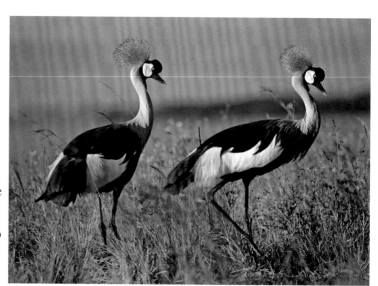

development of digital sensors which produce excellent quality up to ISO 1000. Such cameras allow sunny early morning and late afternoon shutter speeds of $^1/1000$ and $^1/2000$ second at f/5.6 — exposure times adequate to freeze the movement of most wildlife subjects as well as reduce camera shake. Super-telephoto apertures of f/4 and larger deliver faster automatic focusing and/or automatic focusing with teleconverter mounted, two advantages which are worth the extra expense, size and weight.

## CLOSE FOCUSING

The closer your telephoto focuses, the easier it is to make frame-filling studies of puffins, hummingbirds, chipmunks, prairie dogs, fox pups and many other fascinating subjects. Don't take this characteristic for granted as many big lenses cannot record subjects of this size without adding an extension tube. In itself this is not a difficult procedure, but a tube reduces the amount of light reaching the film (which may compromise shutter speed

choice), it may not link fully with the camera's auto-focus system, and it restricts focusing range to close-up subjects. So, as often as not, you keep the tube in your pocket until you get close enough to actually need it. The problem is I can never remember which pocket I put the thing in (Gosh, the sandpiper is looking right at me now!) and when I finally get the camera body released (Uh oh, he's flexing his wings!) and I'm ready to lock on the tube (Hurry it up, will ya!), the front-heavy lens teeters over in a slow-motion swan dive as the subject takes wing (Drat!). Your super-telephoto should focus close enough to just about fill the vertical frame with a human face including ears. If it doesn't do this you're in for some aggravation in the field.

## PRECIOUS GLASS

Super-telephoto focal lengths are prone to

chromatic aberration — a blurring of the color spectrum that degrades image quality. Optical engineers correct this problem at some expense with the use of special low-dispersion (apochromatic) glass. It is given various names depending on the manufacturer: APO, LD, UD and ED are all indications that the lens will produce professional-caliber imagery. Canon's development of diffractive optical elements (designated by DO) not only eliminates chromatic aberration but results in lenses that are three-quarters the size and two-thirds the weight of conventional super-telephoto models.

## IMAGE STABILIZATION SHARPNESS

Image stabilization (IS for Canon) or vibration reduction (VR for Nikon), VR) reduces camera/lens movement and vibration (including that generated by the reflex mirror) during exposure, resulting in an effective increase in shutter speed of two to four stops. (At present Canon and Nikon are the only manufacturers offering super-telephoto prime lenses with this feature.) IS/VR effectively turns your 600mm f/4 into a super-fast 600mm f/1.4 without losing any depth of field. I routinely get excellent results with a hands-on, tripod-mounted 500mm at the following speeds: $1/30$ second with prime lens only, $1/60$ second with

1.4X teleconverter and $1/125$ second with the 2X teleconverter. I don't hesitate to shoot at even slower speeds under weak light. Other professionals report similar, if not better, results. Of course, these shutter speeds have no value in freezing action, but by reducing camera shake they significantly extend the shooting period for static subjects at the beginning and end of each day, peak times for both wildlife activity and beautiful light. IS/VR also improves the sharpness of super-telephoto images taken at even higher speeds.

*Hippopotamus (below). Image stabilization (IS) or vibration reduction (VR) telephoto lenses permit you to make sharp images at shutter speeds two to three stops slower than with conventional optics. This is great in low-light situations (such as this predawn hippo pool) when tight framing of a moving subject makes it necessary to keep your hands on the camera for framing and triggering.*

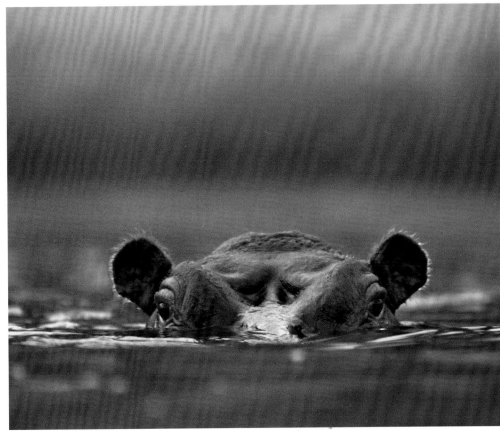

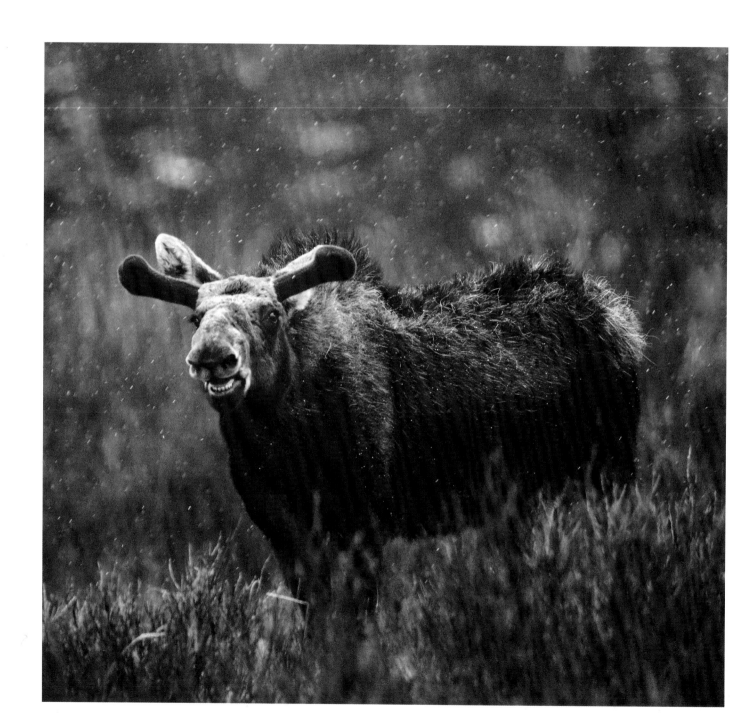

## AUTO-FOCUS

Sometimes it works, sometimes it doesn't. Fortunately, you can turn off auto-focus in situations where it isn't working well and leave it on in others. However, for the switchover to work most effectively in the field, the auto-focus system must offer permanent, instantaneous, manual override. No searching for a niggly button when the sensor refuses to lock onto the subject or isn't discriminating enough to sharpen up moose's eye — just start twisting the focus ring.

## LENS COLOR

Black super-telephotos are classy and white ones are intended to reflect heat but neither paint job is suitable for nature work. As you would expect, camouflage is the lens finish of choice for nature photographers. Camouflage makes you marginally less conspicuous when homing in on wary subjects, but its value doesn't end here. This froggy dressing prevents curious bystanders from spotting your industrial-strength optic and wandering over to find out what all the fuss is about; the fuss they make scares off your rabbit or groundhog. Cover your lens with camouflage tape (available in gun shops and sporting goods stores — get the

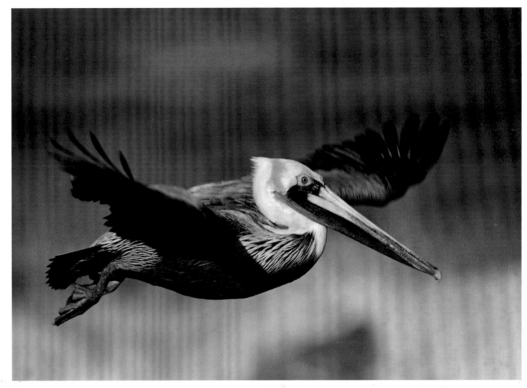

fabric kind). Not willing to gunk up your lens with gooey tape? Canon and Nikon investors can order a wide variety of custom-fit, neoprene skins from www.lenscoat.com.

## SHOOT IN ALL KINDS OF WEATHER

Water-resistant super-telephoto lenses and cameras (professional models made by Canon and others) allow you to shoot during periods of precipitation without resorting to the inconvenience of an umbrella (must be held by an assistant), protective plastic (blocks the viewfinder and controls) or awkward Gore-Tex and Velcro lens rain gear.

*Brown pelican (above).* *This slow-flying giant was recorded with a tripod-mounted 500mm lens and 1.4X teleconverter. For fastest auto-focus response, I only activated the central focusing sensor and tried to keep it targeted on the bird's shoulder.*

*Moose in snow shower (far left).* *Professional-series lenses are often sealed against dirt and moisture, making them ideal for wet-weather shooting.*

# Working in the Field

*Managing your equipment in the field for more enjoyment and greater productivity*

Joy Fitzharris

*The Wave at Coyote Buttes, Arizona (below). A rough 7-mile hike is the only way to access these formations. The route traverses rugged terrain with photo opportunities the whole route. Using the "full nelson" to carry your tripod is a comfortable way to make good time yet stop occasionally to shoot.*

**FOR ABOUT SIX MONTHS** each year I'm in the field shooting. I photograph at sunset and sunrise each day when skies are not overcast. I take down and set up my tripod and change lenses thousands of times. I go through half a pint of lens cleaner and about 10 yards of gaffer tape (used to attach filters) every year. I drive thousands of miles, mostly on back roads and state highways, and hike hundreds more through forests, along beaches and up mountain sides. I've had time to develop and test field practices for managing equipment that allow me to make the greatest number of professional quality photos in the least amount of time with the greatest ease — at least that's the goal. This chapter deals with landscape and other general concerns (for wildlife tips, see Part Three).

## EASIER TRIPOD TRIPPING

When on the trail I carry my tripod (with camera mounted) over my shoulder so that I'm ready to shoot in but a few seconds. Unfortunately on a hike longer than a mile or so, the weight bearing down on one shoulder creates a strain or your spine, hips and side even if you shift the burden periodically from shoulder to shoulder. In such situations you need to apply the *tripod full nelson* to your opponent. This deft move entails grasping your assailant by the throat (either the

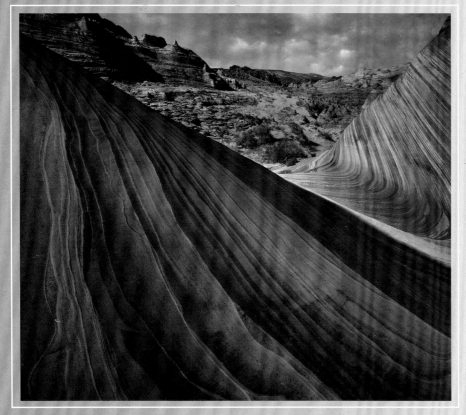

tripod head or the camera's lens or grip) and one leg (let the other two legs flop open a little) and swing the culprit up over the shoulders in one smooth motion. This centers the weight on your spine and even provides some rest for your arms. It works better when the camera is affixed with a small lens, but larger telephotos can also be hoisted in this fashion.

### INVEST IN A VEST

For years I worked from shoulder bags and backpacks. The shoulder bags were difficult to carry for long distances and the backpacks kept my equipment so inaccessible that I often found myself passing up good photo opportunities to avoid aggravation. When photographing, I often wandered so far from my bag that I couldn't find it without a systematic search. At the end of a fast-paced shooting session, my pack would be a mess with little of the equipment remaining in the carefully organized compartments. Everything would have to be tidied and put away before I could close up and move on to a new site, wasting energy and valuable shooting time. This was especially vexing if nice lighting conditions were fleeting.

When I started using a vest about eight years ago, all these problems disappeared and my work became more productive and enjoyable. It seemed like I had grown extra hands and hired an assistant. Many photographers use lightweight cloth vests that are better

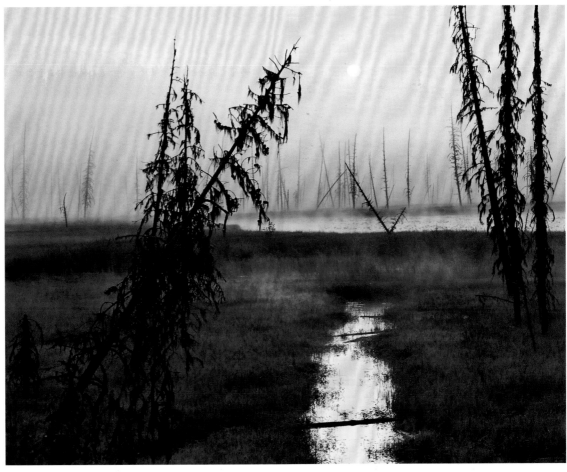

*Sunrise at Bear Lake, British Columbia (above). For this composition I had to wade through the lake shallows. By carrying my equipment in a vest, I had everything at my fingertips for quick access. Mamiya 645 AFD with Phase One P25 digital back, Mamiya Sekor 55–110mm f/4.5 lens, extension tube, ISO 200, 1/8 second at f/16.*

*Lake Jean, Ricketts Glen State Park, Pennsylvania (below).* In *sunrise/sunset situations you need to swap filters quickly as the light changes. Keeping filters organized in fumble-free pouches and cases (see photo on page 45) will boost productivity. Here, I used a one-stop, hard-edge split neutral density filter to increase sky density. Mamiya 645 AFD with Phase One P25+ digital back, Mamiya Sekor 35mm f/3.5 lens, ISO 400, 1/8 second at f/16.*

than bags but don't protect your equipment adequately, especially during travel. My vest preference is the Lowepro Street and Field model, which is built of material similar to a regular bag or backpack and the only vest I know of that offers nearly the same degree of protection. Tamrac makes a modular belt system (as does Lowepro) that is great for carrying less than a full complement of equipment.

The Lowepro system consists of a vest harness to which you can quickly attach and arrange a variety of pouches, compartments and lens cases to suit your particular shooting and equipment situation. Each module is made of dense, closed-cell foam covered inside and out in durable rain-shedding nylon. Unfortunately some modification is required to get the most out of the system. The pouch lids are designed with both a drawstring and a plastic squeeze-clip. Neither are easy to open or close when you need to work fast and change lenses often. To speed things up I cut off both with scissors and replace them with strips of Velcro — not as secure but generally adequate and a breeze to use. To the vest harness you should attach Lowepro's deluxe padded waist belt, which also holds several pouches. This allows your hips to take on a lot of the load (just like with a backpack) saving strain on the back and shoulders during long hikes. Get pouches (not lens cases) that are the same size to fit the largest lens (telephoto zoom) you intend to carry in the vest. When you take a lens off the camera it can go right into the pouch of the lens

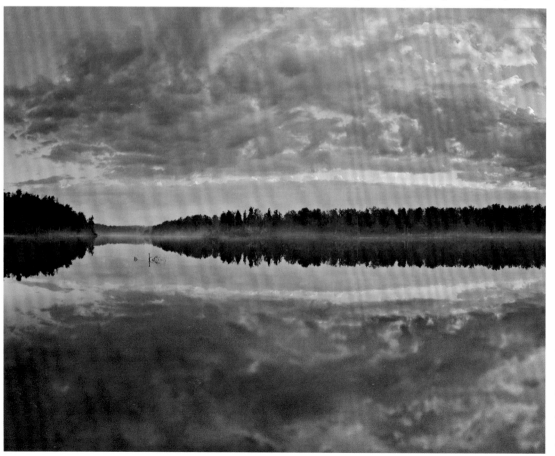

you are exchanging. Using this system keeps everything in the right place and close at hand. It allows you to move around freely and readily access equipment on any terrain including marshes, swamps, lakes and ocean beaches. When you get back to the car, there's no need to repack equipment as you would with a cloth vest; simply lay the entire contraption in the trunk or on the seat. If flying, you can stuff your loaded vest into a carry-on bag or pack it in a suitcase to be checked.

Using a Lowepro vest harness is not cheap — my landscape outfit (I have a separate one for wildlife) costs about the same as an equivalent capacity backpack. For more information go to www.lowepro.com.

## Memory Card Drop

Lowepro offers a handy pouch (called the Film Drop AW) for storing memory cards and batteries. Originally designed for film, it has a secure one-way slot at the top through which you can quickly push the cards. This pouch also has a side zipper (initially designed for extracting spent film cartridges) and it's only a matter of time until you forget to rezip, resulting in precious memory cards dropping in your wake as they go in one end of the pouch and out the other. After losing a few rolls of film this way early on I sewed the zipper closed (you could also use glue). Now I pull the CF cards and batteries back out

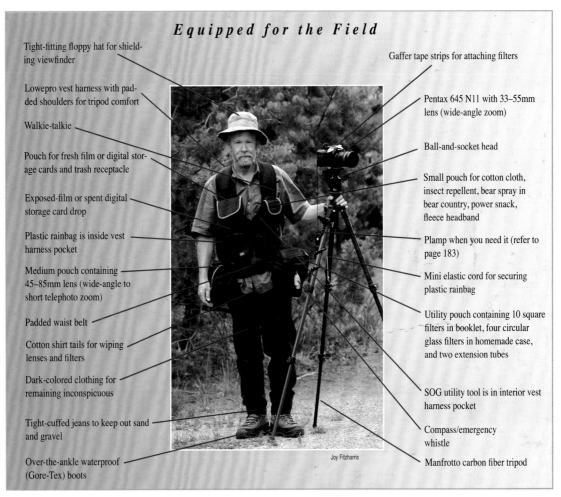

### Equipped for the Field

Tight-fitting floppy hat for shielding viewfinder

Lowepro vest harness with padded shoulders for tripod comfort

Walkie-talkie

Pouch for fresh film or digital storage cards and trash receptacle

Exposed-film or spent digital storage card drop

Plastic rainbag is inside vest harness pocket

Medium pouch containing 45–85mm lens (wide-angle to short telephoto zoom)

Padded waist belt

Cotton shirt tails for wiping lenses and filters

Dark-colored clothing for remaining inconspicuous

Tight-cuffed jeans to keep out sand and gravel

Over-the-ankle waterproof (Gore-Tex) boots

Gaffer tape strips for attaching filters

Pentax 645 N11 with 33–55mm lens (wide-angle zoom)

Ball-and-socket head

Small pouch for cotton cloth, insect repellent, bear spray in bear country, power snack, fleece headband

Plamp when you need it (refer to page 183)

Mini elastic cord for securing plastic rainbag

Utility pouch containing 10 square filters in booklet, four circular glass filters in homemade case, and two extension tubes

SOG utility tool is in interior vest harness pocket

Compass/emergency whistle

Manfrotto carbon fiber tripod

Joy Fitzharris

*Tape to the rescue (top right). I keep gaffer or duct tape strips, used for attaching square filters to the lens, right on my camera for fast access. I use hockey tape to secure the cable release cord to buffer the plug and socket against accidental damage. To save time I keep the release permanently attached to my landscape/macro camera outfit.*

*Easy rain protection (bottom right). This rain-guard system is so small and light that I forget I have it with me until it starts to sprinkle. The plastic bag, kept in my vest, goes over the camera and is snugged up with a small elastic cord permanently attached to a tripod leg.*

through the top — about as easy as fooling with the zipper — and all my hard-earned shots and power resources stay in the vault.

### DUCT AND GAFFER TAPE

I don't use a standard filter holder. Instead I rely on 1-inch pieces of duct or gaffer tape to attach rectangular filters to the front of the lens. Each piece of tape lasts for several shooting sessions. With duct tape you sidestep the problem of image vignetting, common with filter holders. You can attach as many filters as you want and each can be angled separately over the scene, something impossible to do with the standard Cokin holder. I keep a bunch of tapes (with one edge folded over for easy grabbing) stuck to both camera and tripod.

### REFLECTOR ACCESSOR

I use a double-sided (40-inch silver/white) Photoflex brand reflector for adding fill-light to macro subjects (normally with the white side) and occasionally for brightening the foreground of landscapes (either side depending on

conditions). I keep the reflector in its original nylon case on my back, hanging by its strap from my vest harness (Velcro patches keep it in place — see photo below left). When needed, I reach over my shoulder and pull the case around to the front to get at the reflector. When I'm done I replace it in the same way (the Velcro grabs the case when I swing it back). This system usually works

without a hitch. If the wind is blowing the case will come loose and flop around. On blustery days, it's best to leave the reflector behind.

### PLAMP ON HAND

The Plamp (see photos pages 41 and 186/top right) is used to stabilize wind-jostled plants in order to take the blur out of wildflower shots. When in wildflower country during spring and summer, I keep

---

### Equipped for the Field (Rear View)

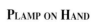

Strap for hanging reflector. Velcro patches on underside to stabilize case

Soft case for double-sided reflector

Lens case for 300mm telephoto lens

Medium pouch for moderate telephoto zoom lens

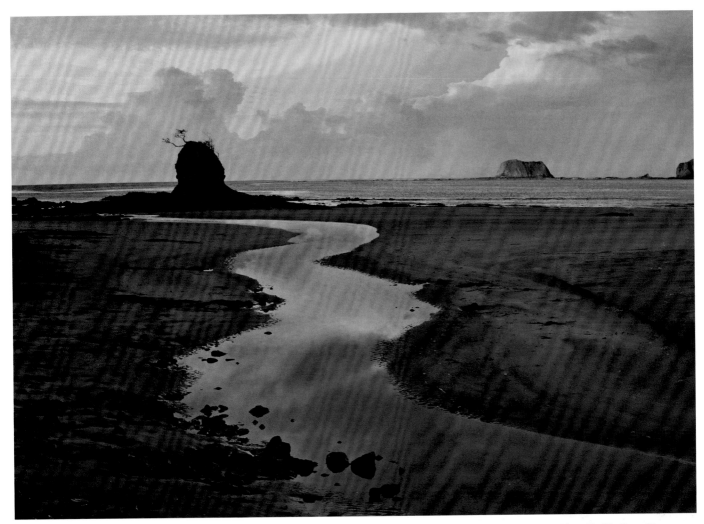

one of these lightweight, snaky gizmos wrapped around a tripod leg. You never know when you might run into an irresistible blossom.

## WET CONDITIONS

I normally don't try shooting in the rain unless I have someone to stand beside me and hold an umbrella. Otherwise, I fix some temporary protection over my equipment (most DSLR cameras and lenses — Canon and Nikon professional series excepted — have zero tolerance for moisture) and make for a sheltered spot to await better conditions. I keep a standard plastic grocery bag (the flimsy kind with handle loops) stuffed into a small pocket

*Playa Carillo Costa Rica (above). It's hard to find a safe place to stow your equipment when shooting at the beach. Keep it dry and handy with a photo vest. Canon EOS 5D, Canon 17–40mm f/4 EF lens, one-stop split neutral density filter, ISO 100, 1 second at f/16.*

in my vest. When rain falls, I slip the bag over the camera mounted on the tripod (the rest of my equipment is protected in the vest) and speedily secure it with a mini elastic bungee cord that is permanently taped to a tripod leg (see photo page 41).

## COMMUNICATION SAFETY

If you shoot alone it's a wise precaution to have a cell phone with you in case you get into trouble, especially if you are shooting near the ocean or cliffs. If you work with a partner, walkie-talkies generally help to coordinate activities or keep you in touch should you choose to split up to cover more territory. On my shooting junkets I travel in a motorhome with my wife and children. When on the trail I carry a small Motorola radio (5-mile range is best) to tap into home base. Most of the time I use it to alert my wife that I'll be back soon and that I'm really hungry, but it regularly comes into more important use. For example, sometimes I return from a shoot in the dark. If I'm bushwhacking, it's easy to get off course (or completely lost). In such cases I ask someone to beep the RV horn so that I can home in on the sound. You'll find all kinds of handy uses for a radio in your circumstances. Single, ultra-compact 5-mile range radios are about the price of a standard polarizing filter.

*Cascading Open-top Filter Pouch*

*Although I don't carry as many filters as I did when I was shooting film, it is still important to have ready access to these accessories. This module, made from duct tape and single cut-down Singh-Ray filter pouches, stays in my vest and allows quick, one-handed access to any filter.*

**Roca Loca Point near Jaco, Costa Rica (left).** *Quick access to numerous filters allowed me to try several combinations while waiting for the sun to appear on the eastern horizon. Canon EOS 5D, Canon 17–40mm f/4 EF lens, ISO 50, Singh-Ray polarizing filter, one-stop split neutral density filter, ISO 100, 1 second at f/22.*

# Winter Photography

*Preparing yourself, your equipment and your mind for the special challenges of cold weather*

*Elk in snow, Yellowstone National Park, Wyoming (below). Snow is a natural reflector, bouncing light into shadow areas to reduce contrast for better color saturation and detail. Contrast in this early morning group portrait was further reduced by a two-stop split neutral density filter placed to darken the sky.*

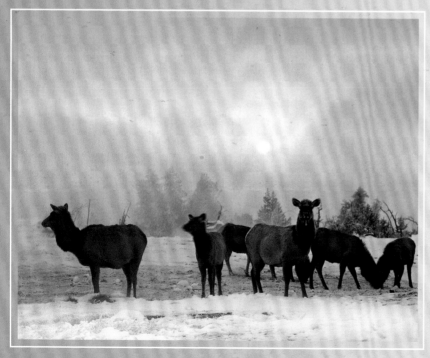

**THE WINTER SEASON CALLS** for modifications to how you dress, how you handle your equipment and how you approach the picture-making process itself.

Staying comfortable during an outdoor sub-freezing shooting session is as much a matter of remaining cool as it is keeping warm, made difficult due to the changing activity level of the process. For a few minutes we may be hiking up a hill or plowing through deep snow. Then all physical exertion ceases as we consider the scene that confronts us.

One minute we may be hot and sweating, the next we're clammy and shivering.

## WINTERIZING YOUR BODY

To remain comfortable, you first need to be dressed so that you can easily regulate the escape of body heat. Second, you must anticipate activity levels in order to make timely adjustments to your clothing. These suggestions work well for sessions lasting up to half a day in very cold temperatures below 0° F (–18° C). When it's not quite so cold, reduce the weight and number of undergarments. If you are new at this, start cautiously (cold weather can kill you) with excursions lasting about an hour until you become familiar with your personal needs.

## ZIPPERS NOT LAYERS

Dressing in layers is a familiar practice for anyone accustomed to working or playing outdoors. Primarily, you insulate yourself to cope with the worst of anticipated weather conditions. Should you become too warm, you can take off a garment or two; when you get cold, you do the reverse. To be avoided is overheating to the point of perspiring which, in addition to being uncomfortable, causes rapid heat loss by both convection and evaporation. This

approach works for hikers and backpackers, but it isn't very practical for nature photographers. Already burdened with equipment, we need to keep our load clear of extraneous garments and our hands free to deal with numerous shooting tasks. Instead of layers that can be taken off and put on, we need layered, stay-put garments that can be vented efficiently and easily. This means clothes with big, strategically located zippers.

## OUTER SHELL

The front line in your defense against winter should be a loose-fitting, non-insulated, wind-breaking and water-shedding, breathable parka (Gore-Tex or a similarly performing fabric is recommended). It should have a two-way front zipper (one that can be zipped down from the top and up from the bottom). The top zipper should zip up and over your chin like a turtleneck. The parka's skirt should cover your bum. Zippers under the armpits are valuable for quickly venting heat from this area. A hood with an elastic drawstring is especially valuable. Velcro closures for zipper flaps and cuff straps are preferable to snaps, which clog with snow.

## PANTS

Much of your shooting, be it wildlife, macro subjects or landscapes, will be done at low level while you are kneeling on snow or ice. You need sturdy, water-shedding, lightly insulated pants with reinforced knees and elastic cuffs (ski or snowboarding

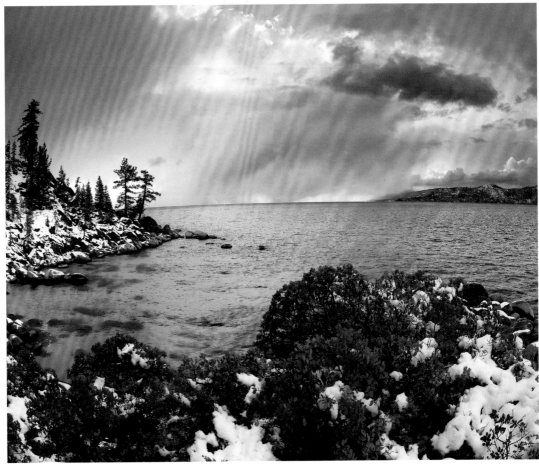

*Memorial Point, Lake Tahoe, Nevada (above). Winter's reduced palette gains vibrancy when set against the whiteness of fresh snow. Your best opportunity to capture this magic at its peak is first thing in the morning when the atmosphere is still and the snow has not been affected by the sun or footprints.*

*American robin (below).* *Frosty temperatures give added interest to wildlife subjects, decorating fur and feathers with white and silver accents. It's usually best to base exposure readings on a close-up reading of an average subject and keep an eye on your histogram. Canon EOS 5D, Canon 500mm f/4 IS lens, ISO 400, 1/250 second at f/5.6.*

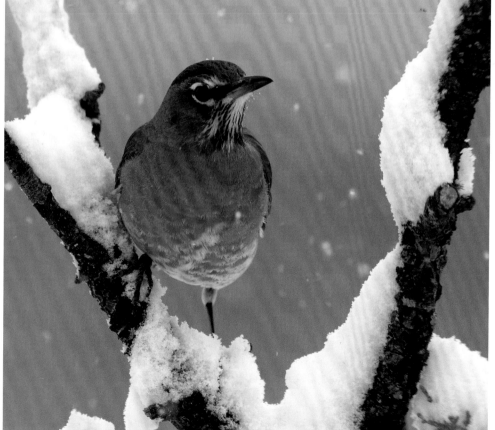

pants are often perfect). The pants should have a suspendered bib front and back to prevent heat loss around your waist and lower back. There should be a front zipper extending from crotch to chest and a zipper along the outside of each leg, preferably to above the knee. To eliminate the need for gators, the pant legs should have stout elastic loops on the cuffs that go under your boots to keep the pants from riding up in deep snow. (You may have to add this feature yourself.)

## HEAD GEAR

As 70 percent of heat is lost through the head, this area is the master valve for temperature control and you should give due consideration to how you insulate it. Many extreme weather veterans recommend a balaclava — a hood that completely covers the head, with eye and mouth openings. These are fine for windy subzero temperatures but they are ticklish and not very temperature versatile in less extreme weather conditions.

I prefer a tailored, polypropylene fleece-lined Gore-Tex hat with Velcro chin straps, insulated ear flaps (which can go up and down as needed), and a flexible bill (for shading the viewfinder). When it's extremely cold or windy you can lower the flaps, raise the hood and zip up the inner turtleneck and outer parka to cover chin and mouth. This funnels warm, exhaled breath up and over the nose to prevent frostbite. If it's not too cold I wear a baseball cap with a headband that I let dangle around my neck or install over the cap and around my ears when more protection is needed.

## FOOT GEAR

If you keep your head warm, you won't have much of a problem with your feet. Ideal boots rise over the ankle and are

made of breathable, waterproof, insulated nubuck leather (or similar performing material), waterproof Gore-Tex liners and Vibram soles. Usually one pair of heavy wool or moisture-wicking polypropylene fleece socks will provide ample insulation, provided your boots are not tight fitting.

## OTHER ESSENTIALS

A full suit of moisture-wicking long underwear (Capilene or similar material) is necessary for warmth and to draw sweat away from your body. Over this I normally wear a regular wool or silk shirt with pockets for stowing my wallet and personal items, then a zippered sweater or jersey (wool or polar fleece of varying weight depending on weather conditions) with a turtleneck collar, next my bib overalls, then the outer parka shell. There are numerous websites where you can buy and find out more about outdoor expedition-quality apparel. One of my favorite websites is www.rei.com.

## WARM HANDS/NIMBLE SHOOTING

Although commonly recommended, I don't find silk

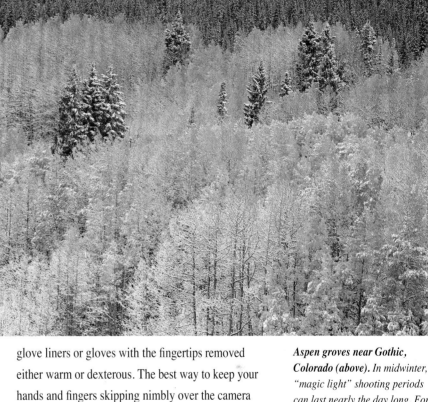

glove liners or gloves with the fingertips removed either warm or dexterous. The best way to keep your hands and fingers skipping nimbly over the camera controls, even in extreme conditions, it to use abbreviated idiot strings on a heavy pair of mittens or gloves (polar fleece-lined Gore-Tex with traction palms). You simply work the camera bare-handed, slipping your paws back into the gloves (which dangle conveniently from your wrists) whenever they need a warm-up. The attachments should be kept

*Aspen groves near Gothic, Colorado (above). In midwinter, "magic light" shooting periods can last nearly the day long. For uninterrupted shooting carry an extra set of batteries in an insulated inner pocket to be switched in and out as needed. Mamiya 645 AFD with Phase One P25 digital back, Mamiya Sekor 105–210mm f/4.5 lens, one-stop split neutral density filter, ISO 100, 1 second at f/22.*

*Aspens near Kebbler Pass, Colorado (below). Soft light from overcast skies combined with natural fill light from re- flected snow lends painterly effects to most winter subjects. Mamiya 645 AFD with Phase One P25 digital back, Mamiya Sekor 105–210mm f/4.5 lens, ISO 100, 1/2 second at f/22.*

*Frozen leaves (far right). Isolate the strongest part of winter close- up studies (usually rich color) with a zoom lens.*

as short as possible (affix the cuffs of your gloves directly to the cuffs of your parka with double-sided Velcro tabs). This enables you to curl up your fingers and squirm your hand into the glove unassisted. For extreme temperatures keep small chemical hand- warming packets in your gloves. (When the mercury falls you can put these in your boots, too.) These packets are inexpensive and widely available.

### ANTICIPATE THERMAL CHANGES

Operating this multi-zippered, ready-vented garment system is simple. If you are working behind the

camera with little physical exertion, you will likely have most or all of your zippers and flaps closed, depending on ambient temperatures. When you need to move from one shooting location to another, open zipper vents *before* you begin your hike. Then, when you start to feel cool, make minor adjustments as you go along depending on internal heat buildup and weather conditions. There's usually no need to take anything off or on, just work your zippers to avoid both sweating and chilling. Your major controls are the central zippers on your parka and bib overalls and the headgear configuration.

### WINTERIZING EQUIPMENT

Cold weather creates two main problems for equipment. The first is battery failure — easily solved by keeping a spare set of batteries in an inner pocket close to your body inside the insulating layer. If you have two identical camera bodies, simply pocket the entire battery pack from the camera you are leaving behind so you can switch packs in and out in a jiffy. If your camera is able to use lithium batteries, these will provide the best performance, especially in freezing temperatures.

Another problem arises when you go back into a warm area

(either indoors or into a heated vehicle). Water vapor will condense on any equipment surfaces exposed to air, including interior components. This moisture can foul electronic components or initiate corrosion of other parts. Avoid this by keeping a large, heavy-duty trash bag in your vest or camera bag. Before exiting the cold, put your entire vest or camera case inside the plastic bag and close it tightly. Leave the contents wrapped up until they feel about the same temperature as other objects indoors.

## Winterizing Your Brain

Winter temperatures not only affect the physical operations of you and your equipment, they also have an affect on the light energy generated by your subjects, which you need to consider in conceiving and realizing the image. Check your histogram readings to make sure none of the data is hanging outside the graph boundaries and try to position the curve to reflect the brightness of the subject. Mostly snowy scenes should show the most pixel density on the bright (right) side of the graph.

## Subject Contrast

Another cold-weather hallmark is reduced subject contrast. Snow and ice work as natural reflectors to throw light into shaded portions of the scene. This usually benefits picture quality and makes it unnecessary to use fill-flash or handheld reflectors. It is sometimes beneficial to use your split neutral density filters upside down in order to darken and retain detail in snowy areas positioned low in the composition. Similarly, a polarizing filter must be used with caution as it may add so much density to blue skies that they become nearly black when exposure is set to retain highlight detail in the snow.

## Light Quality

In northern latitudes during winter the sun remains close to the horizon the day long providing extended opportunities for low contrast, side-lit shooting of both wildlife and landscapes. The dramatic rosy colors of sunrise and sunset similarly hang in the sky longer, making possible more considered compositions

*Rumpled river ice (below).* Look for colorful reflections on ice and snow. This winter river was illuminated by cool light from a blue sky while reflecting the rusty hues of surrounding canyon walls from smooth stretches of ice. Mamiya 645 AFD with Phase One P25 digital back, Mamiya Sekor 105–210mm f/4.5 lens, ISO 100, 1/8 second at f/22.

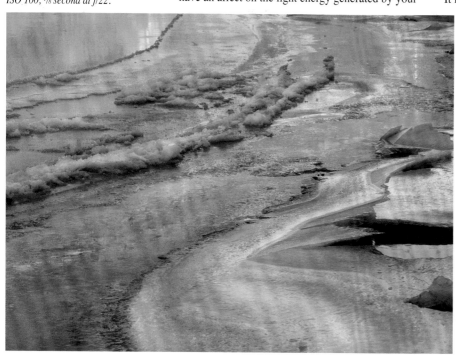

and a leisurely analysis of exposure histograms.

## SUBJECT CHOICES

In general the abundance of attractive nature subjects in winter does not on first consideration seem to match that of other seasons — many birds and mammals are in hibernation or have migrated elsewhere. The color palette of northern landscapes is lacking in fresh greens and the exciting, warm hues of the spectrum. But winter provides its own attractions. Juxtaposed against snow's pure white, even muted colors assume added chroma. Reflections of sunlight off ice crystals and sparkling snowbanks can be incorporated theatrically into compositions. Deep and drifting snow spreads sculpted dunes over landscapes devoid of surface features in other seasons. Although wildlife numbers are lower, animals that are in evidence are usually calmer and easier to approach. Fur and feathers are embellished with frost and flakes, and snow-blanketed terrain is decorated with tracks. Animals caught in action trail spumes of flying powder and snort clouds of photogenic vapor. Frigid temperatures and scarcity of natural food makes backyard

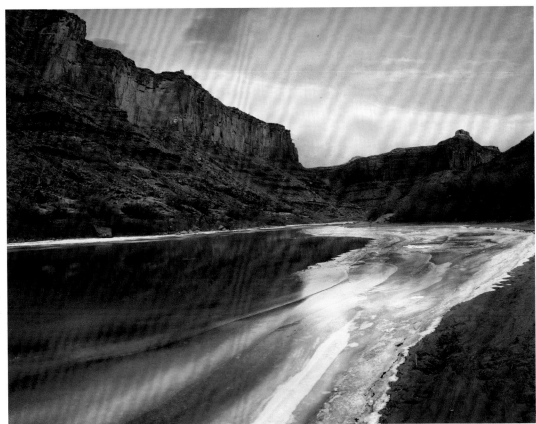

bird feeders buzz with hungry visitors and draws concentrations of animals to hot springs and feeding areas. Plummeting mercury generates moody atmospheric effects — fog, haze and falling snow — which can be used to enliven compositions. Frost, ice rime and icicles likewise add interesting features to solid forms, both animate and still. In short, winter offers plenty of special effects to stimulate your imagination and set your trigger finger twitching. Stay warm and happy shooting!

*Ice on the Colorado River, Cataract Canyon, Utah (above). An ultra wide-angle lens placed low to the ground was used to frame this sweeping path of ice that beckons the viewer into the deep space of the scene. Mamiya 645 AFD with Phase One P25 digital back, Mamiya Sekor 35mm f/3.5 lens, Singh-Ray circular polarizer, ISO 100, 1/2 second at f/22.*

# Nature Photography's Year
*Month-by-month guide to the best North American shooting sites*

*Iceplants, Big Sur, California (below). Pleasantly cool weather, varied seascapes and an enormous elephant seal rookery are the attractions at this coastal hotspot.*

*Osprey (far right, top). Southern Florida is a bird-shooter's paradise during the winter.*

**NORTH AMERICA'S NATIONAL PARKS**, wildlife refuges, wilderness preserves, national forests and other public lands are the most exciting locations for nature photography in the world. Nowhere else can you find such abundant and dramatic combinations of wildlife, wild flora and scenery. Not only is the potential for taking beautiful pictures unmatched elsewhere, but an infrastructure of roadways, lodges, restaurants, campgrounds and stores makes access and logistics a relatively simple matter. Most parks and refuges are patrolled by rangers who safeguard both the natural resources of the habitat and the visiting public. They also provide expert guidance to attractions, trails and natural history. This chapter describes a dozen continent-spanning excursions that promise pleasant weather, comfortable accommodation and the double lure of breathtaking landscapes and confiding wild creatures. Any of them should provide a comfortable, exciting and productive photography experience.

### JANUARY: BIG SUR COAST
California's Big Sur Coast (between Monterey and San Luis Obispo) boasts big-time marine wildlife and sweeping beaches. Inland you will find old-growth redwood forests, twisting canyons and waterfalls. Sandy beaches a few miles north of San Simeon are breeding locales for northern elephant seals. You can see these refrigerator-sized pinnipeds from the Pacific Coast Highway, which hugs a sparsely settled shoreline. Away from the main rookeries are secluded coves where you can shoot seals at close range. Additional subjects include monarch butterflies (Andrew Molera State Park), seabirds, and harbor seals sunning themselves on rocky shoals.

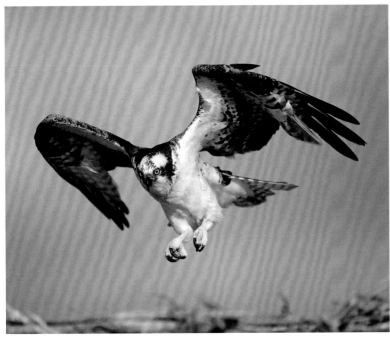

<div style="winter-alternatives">

**Winter Alternatives**

• *Yellowstone National Park, Wyoming: Cold but exciting shooting from snowmobiles of wildlife and snowy landscapes (December through March).*

• *Big Bend National Park, Texas: Superb mountain/desert scenery and great wildflowers (rain dependent) in February/March — call ahead.*

• *Sonoran Desert, Arizona: Beautiful high-desert scenery and vegetation with pleasant weather, snow possible in January, wildflowers (rain dependent) in February/March.*

</div>

the Florida Highway Patrol station off Route 41, a short block north of Jacaranda Boulevard) and little Estero Lagoon near Fort Myers. Top beaches for scenic shooters include Bowman's Beach on Sanibel Island, Bahia Honda Beach and Anne's Beach in the Florida Keys and Blowing Rocks Beach on Jupiter Island.

If you are lucky, you may spot an endangered California condor cruising overhead or scavenging dead animals on the beach. There are plenty of motels, restaurants from rustic to elegant, and state and private campgrounds.

## FEBRUARY: SOUTH FLORIDA

In South Florida, winter weather is predictably warm and sunny. Between shoots, you can stretch out on a sandy patch of snow-white beach. The photographic attraction here is primarily wildlife (herons, pelicans, ibises, spoonbills, anhingas, alligators, turtles) which abounds in Everglades National Park and other refuges further north, including Ding Darling National Wildlife Refuge, Venice Rookery (behind

## MARCH: GRAND CANYON

Arizona's Grand Canyon National Park provides several key elements for great landscape photography: strong color, incredible landforms, sidelight at sunrise and sunset and, with any luck, dramatic skies. In March, snowfalls are not uncommon and you may be able to photograph these plunging cliffs and the surrounding deserts and forests with accents of white for heightened color.

*Wotans Throne, Grand Canyon National Park, Arizona (below). Late winter offers pleasant if cool weather, dramatic skies and a chance dusting of snow to enliven red rock walls.*

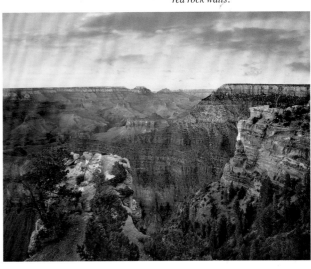

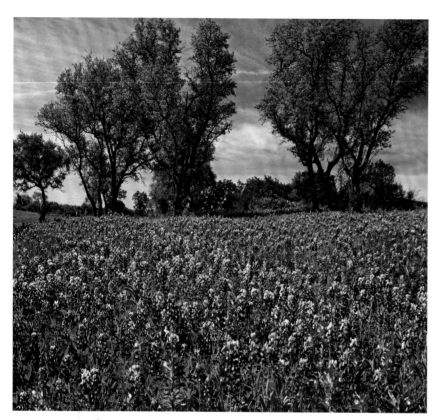

*Bluebonnets and paintbrushes, Edwards Plateau, Texas (above). When conditions are right, the floral displays during April on the Edwards Plateau are unsurpassed.*

*Bison (right). Prairie wildlife is the key attraction at Custer State Park, a beautiful drive-through reserve near Badlands National Park. Colorful eroded terrain and big skies provide plenty of interest for landscape enthusiasts.*

The canyon runs east to west so that both the rising and setting sun illuminate its cavernous 3,000-foot-deep interior. Flagstaff, Arizona, and Las Vegas, Nevada, are good for airport staging. The North Rim is closed until May due to heavy snow but there is plenty of photographic potential on the more accessible south rim. If you need warmer weather and a change of scene, drive south to Sedona, Arizona, a tourist enclave in the heart of Red Rock Country where a collection of streams, cascades, monstrous mesas and jutting pinnacles tinted in fiery hues awaits the lens.

### APRIL: TEXAS HILL COUNTRY

Texas Hill Country bursts into color during wildflower season. The big show is put on by paintbrushes and Texas bluebonnets, which festoon this rolling, oak-upholstered landscape in saturated patches of blue and scarlet. You will also find tempting masses of asters, daisies, wine cups, gaillardias, primroses and others (Texas boasts over 5,000 wildflower species). There are good opportunities for shooting white-tailed deer (common everywhere) and wild turkey at South Llano River State Park campground. For a wildflower forecast (blooming times and abundance varies) contact the Lady Bird Johnson Wildflower Center at 512-292-4200. The area is sprinkled with quaint mom-and-pop eateries, varied accommodations, and campgrounds. Austin is the most convenient fly-in spot.

### MAY: VANCOUVER ISLAND

Vancouver Island is a natural-history jewel off the southwest coast of British Columbia. Air transport to either Vancouver or Victoria will

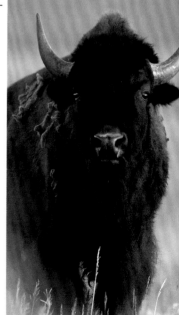

**Spring Alternatives**

• **Tehachapi Mountains, California:** *Extravagant wildflower display (especially poppies) in April — call ahead.*

• **Redwood National Park, California:** *Rhododendrons in bloom among giant redwood trees in late May/early June.*

• **Yosemite National Park, California:** *Surging waterfalls and blooming dogwood, redbud and azalea adorn these magnificent canyons and mountains during April and May.*

leave an easy drive to all major attractions. At this time of year, the rumpled hinterlands are enlivened with the blooms and buds of red alder, big-leaf maple and Pacific dogwood together with many wildflowers. Photograph old-growth temperate rainforests at numerous locations, including Cathedral Grove. Shoot the dramatic beaches and marine wildlife of Pacific Rim National Park on the Island's outer coast or photograph seals, sea lions and orcas in the vicinity of Race Rocks near Sooke. For the latest information on Vancouver Island's natural history attractions, contact the BC Provincial Parks at 250-387-4550.

## JUNE: BADLANDS NATIONAL PARK

Once you've shot all the attractions at Badlands National Park in South Dakota, it's an easy two-hour drive to a couple of other hotspots — Wind Cave National Park and Custer State Park. At Badlands your viewfinder will be filled with stretches of native prairie peppered with wildflowers and the odd buffalo sandwiched between eroded badlands washed in tints of yellow, rose and rust. June offers the chance of dramatic afternoon thunderstorms, which intensify landscape color and create stagy lighting effects and fiery sunsets. Wind Cave National Park and Custer State Park are magnets for wildlife enthusiasts. These rolling hills, wrapped in coniferous forests and native grasses, are the stronghold of confident buffalo, pronghorn antelope and prairie dogs. You can shoot from your car or hike out into the fields for more intimate views. Major airlines fly into Rapid City, South Dakota, your jump-off spot.

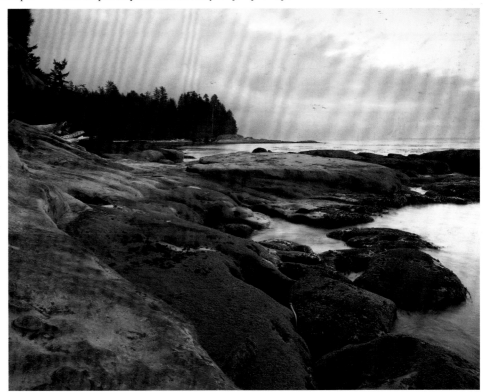

*Botanical Beach, Juan de Fuca Provincial Park, Vancouver Island, British Columbia (below). Wide, sweeping beaches, sunset vantage points, tidepools, wildflowers, marine wildlife and Pacific Coast rainforest top the list of spring attractions on Vancouver Island.*

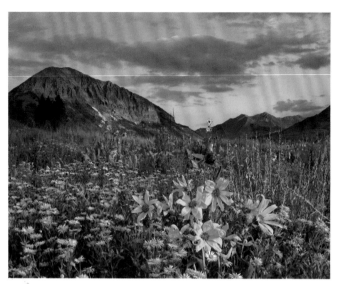

**Gothic Mountain with sunflowers and asters, San Juan Mountains, Colorado (above).** *During summer this range offers a profuse display of subalpine wildflowers together with waterfalls and frothy streams.*

**Mount Moran from String Lake, Grand Teton National Park, Wyoming (right).** *In autumn, you can record the change of seasons, elk rut and numerous geologic phenomena in the Yellowstone and Grand Teton area.*

**Mount Rainier, Mount Rainier National Park, Washington (far right).** *Lush wildflower meadows and outsized landscape features lure shooters to this destination during July and August.*

### JULY: SAN JUAN MOUNTAINS

The San Juan Mountains of southwest Colorado boast some of the most exhilarating alpine topography on the continent. In July these soaring corridors of granite and sandstone are splashed with wildflowers, prime photographic targets in their own right, as well as exciting foreground features for the processions of snow-clad peaks. The San Juan range is crisscrossed with roadways, many of them built during the mining boom of the last century. A two-wheel-drive buggy will transport you to plenty of beautiful locations but a four-wheel-drive chariot will deliver an authentic high-country adventure with access to ghost towns and knee-trembling vistas.

*Summer Alternatives*

• *Katmai National Park, Alaska:* Brown bears fishing for salmon during last half of July, all of August and into September.

• *Jasper National Park, Alberta:* Elk rut begins in September featuring some of the continent's largest bulls. Also fabulous scenery.

• *St. Paul Island, Alaska:* Northern fur seal rookery, denning arctic fox (blue phase), and seabird rookeries including puffins during August/early September.

Telluride and Ouray are famous tourist destinations with varied accommodations and numerous first-class restaurants. Pick up your jeep in Durango, a good fly-in destination with full facilities and scenic atttractions close at hand.

### AUGUST: MOUNT RAINIER NATIONAL PARK

The namesake of Mount Rainier National Park is an active, oversized volcano so large that it creates its own weather system. When surrounding areas are basking in sunshine, the park is commonly wreathed in cloud until midday. For many subjects this provides ideal shooting conditions. August is the peak of wildflower season and subalpine slopes dance with

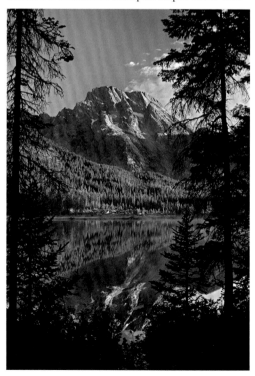

paintbrushes, daisies, arnicas and scores of others that the soft light flatters for a good part of the day. There are creeks, rivers, cascades and waterfalls, and even old-growth rain forests that are also at their best under overcast skies. When the clouds part and the mountain's snow-crowned peak is revealed, scenic compositions are possible from numerous vantage points, the mirrored view from Reflection Lakes being the most famous. Book your flight to Seattle, Washington.

## SEPTEMBER: YELLOWSTONE AND THE TETONS

September is the busiest time of year for photographers in Yellowstone and Grand Teton National Parks. The crowds of summer have dissipated, the aspens and cottonwoods glow yellow and orange, morning meadows are hung with frost, and moose and elk are in rut. The latter attraction brings out platoons of photographers armed with 500mm and 600mm telephotos. Sturdy tripods fence in the willow flats where moose are feeding and corral the open meadows where wapiti bulls lord over harems and bugle their supremacy into the cool atmosphere. Aside from wildlife there are the singular Tetons, the Grand Canyon of the Yellowstone with its stupendous waterfalls, and numerous geyser basins to photograph once you collect enough wildlife trophies. Next door to the park, Jackson, Wyoming, is blessed (?) with tourists' every possible need and served by a couple of major airlines.

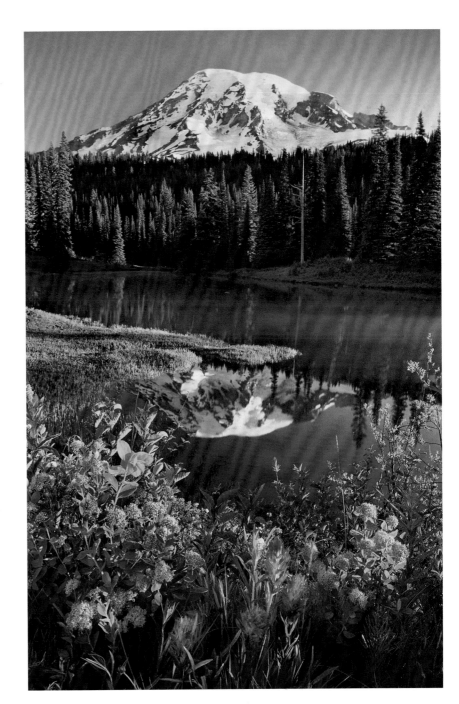

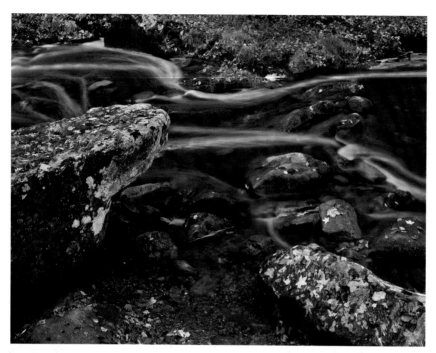

*Laurel Creek, Great Smoky Mountains National Park, Tennessee (above). This park is the continent's premier autumn color destination with peak displays in late October. Also of interest are brooding, fog-shrouded landscapes and waterfalls and streams.*

*Sandhill cranes (right). Birds and more birds with the best shooting lasting from November through January. Blinds are not necessary. Photograph from a vehicle or pondside.*

## OCTOBER: GREAT SMOKY MOUNTAINS

We'll head east a few states to Great Smoky Mountains. If you are impressed by the glamorous but admittedly restricted palette of the cottonwoods and aspens of the West, then your motor drive will overheat in Great Smoky Mountains National Park in Tennessee and North Carolina, where giant deciduous forests, some in virginal old-growth condition, proliferate. Each of the dozens of tree species sports a distinctive autumn hue, from lemon yellow through flaming red to rusty brown. Forests clothe the mountains and valleys, providing endless composition possibilities. Mix this surfeit of color with any of the many streams and cascades, an early sprinkle of snow or a writhing fog bank, and you are in Fujichrome heaven.

*Autumn Alternatives*

• *Yoho National Park, British Columbia: Golden larch display among dramatic peaks and alpine tarns at Lake O'Hara in late September/early October.*

• *Acadia National Park, Maine: Peak fall color in mid-October against a backdrop of lakes and stunning coastal scenery.*

• *Churchill, Manitoba: Curious polar bears (including mothers with cubs) wandering the Hudson Bay shoreline from mid-October to mid-November. Be prepared for arctic conditions.*

Asheville, North Carolina, and Knoxville, Tennessee, are both within easy driving range of the best photo areas. Gatlinburg and Pigeon Forge are both near the park boundary and provide after-the-shoot, country-style sustenance and lodging.

## November: Bosque del Apache

Bosque del Apache National Wildlife Refuge is a 60,000-acre preserve that stretches along the Rio Grande River in central New Mexico. This collection of marshes, deserts and woodlands, set against the backdrop of the Chupadera Mountains, is a winter haven for migratory birds — 50,000 ducks, 50,000 snow geese and about 18,000 greater sandhill cranes, as well as numerous wading birds, owls, eagles, hawks and falcons. The refuge is the year-round home for mule deer, coyotes, wild turkeys, roadrunners and others. There are hiking trails, five viewing platforms and a 15-mile wildlife drive, all of which provide opportunities for photography. Most animals are accustomed to humans and allow a slow approach, making frame-filling telephoto portraits easy. Open from an hour before sunrise to an hour after sunset, the refuge is located 20 miles south of Socorro, New Mexico, about 90 minutes by car from touchdown in Albuquerque.

## December: Maui, Hawaii

This is a great place for shooting landscapes, water-falls and close-ups of plants, but not wildlife (except for sea turtles, which are plentiful in many locales near or on shore). The photography highlight is the Hana Coast of Maui. Here are found the wildest, loneliest beaches, with big surf, interesting shore-line rock formations and lots of tropical vegetation on the fringes. Waterfalls nestled in tropical forest abound all along the Hana Highway. Haleakala National Park's beach region is found here and offers both waterfalls and dramatic beach scenes in a compact area. Aloha and happy shooting!

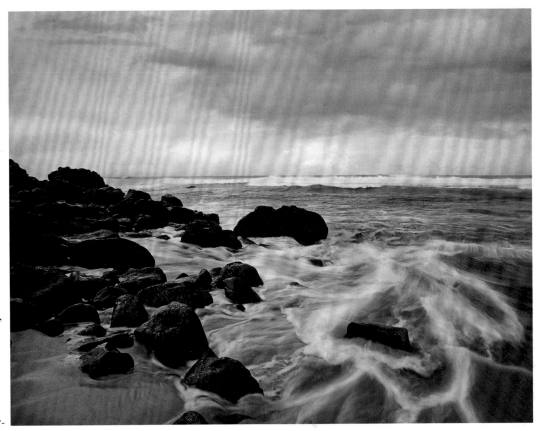

*Ho'okipa Beach near Paia, Maui, Hawaii (above). You can't beat paradise for its combination of pleasant weather and varied natural attractions including towering volcanoes, humpback whales, idyllic seascapes, silky waterfalls, tropical blossoms and lush rainforests.*

*Part Two*

Essential Skills

# Exposure

*Capturing all the image data in difficult situations*

**LEARNING HOW TO MAKE A GOOD EXPOSURE** is the first step in becoming a photographer. Compared to earlier days when the only reliable way of insuring an acceptable film exposure was to take additional frames over and under the target settings, exposure with digital cameras is easy and all but certain thanks to instant histogram readouts. The histogram can be set to pop up on the camera's LCD screen to provide immediate detailed feedback on the accuracy of the exposure. Exposure is based on through-the-lens light meter readings that transmit the luminance of the scene to the camera's onboard computer. Exposure is controlled by aperture size and shutter speed and can be set automatically or manually.

## CHECK THE HISTOGRAM

Attaining correct exposure is a matter of checking the histogram on the LCD screen. The histogram graphs the luminance values in the frame and tells you instantly if all parts of the scene have been recorded on the sensor. Should this not be the case, you simply make appropriate adjustments to aperture and/or shutter speed until the readout indicates correct exposure. With a little practice the process becomes routine. However, in many nature photography situations (e.g., wildlife on the move or landscapes under rapidly changing light) you need to get the exposure right on the first take or you'll miss the shot. It's important to practice good

*Wildebeest, Masai Mara National Reserve, Kenya (above). This exposure was based on a TTL spot meter reading of and average tone of the colorful sky.*

*Sun rising over the Miette Range, Talbot Lake, Jasper National Park, Alberta (left). Recording both shadows and highlights in good detail is exposure's main challenge. The camera's histogram not only graphs the range of tones but on many DSLRs, you can activate a highlight or shadow warning feature which causes overexposed or under-exposed picture areas on the LCD screen to flash. Such warnings indicate the need to reduce scene contrast by the use of filters (see page 70). Here I used a two-stop split neutral density filter to darken the sky and then made further local adjustments to image density in Adobe Photoshop. Mamiya 645 AFD with Phase One P25+ digital back, Mamiya Sekor 105–210mm f/4.5 lens, two-stop split neutral density filter, ISO 100, ¹/₂ second at f/22.*

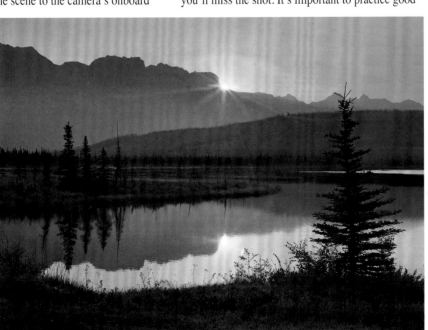

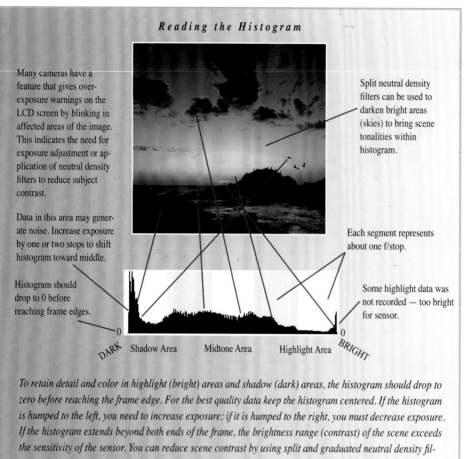

### Reading the Histogram

Many cameras have a feature that gives over-exposure warnings on the LCD screen by blinking in affected areas of the image. This indicates the need for exposure adjustment or application of neutral density filters to reduce subject contrast.

Data in this area may generate noise. Increase exposure by one or two stops to shift histogram toward middle.

Histogram should drop to 0 before reaching frame edges.

Split neutral density filters can be used to darken bright areas (skies) to bring scene tonalities within histogram.

Each segment represents about one f/stop.

Some highlight data was not recorded — too bright for sensor.

DARK   Shadow Area   Midtone Area   Highlight Area   BRIGHT

*To retain detail and color in highlight (bright) areas and shadow (dark) areas, the histogram should drop to zero before reaching the frame edge. For the best quality data keep the histogram centered. If the histogram is humped to the left, you need to increase exposure; if it is humped to the right, you must decrease exposure. If the histogram extends beyond both ends of the frame, the brightness range (contrast) of the scene exceeds the sensitivity of the sensor. You can reduce scene contrast by using split and graduated neutral density filters or by waiting for softer light.*

*Pelicans coming to roost, Big Sur, California (above and right). For this tricky situation, I first placed a one-stop split neutral density filter to darken the brilliant sky. I made a test exposure to check the histogram reading and made further adjustments. Then I was ready to shoot the incoming pelicans. The process only took a few seconds.*

exposure technique and understand how natural light is processed by the camera.

### LIGHT METERS AT WORK

If you're photographing an average scene, light meters work without a hitch. Unfortunately, they operate as if every scene were average. They can't differentiate between snow, which is supposed to be

very light, and an inactive lava field, which is supposed to be very dark. Without some adjustment by the photographer, both are interpreted as average and rendered as neutral gray. Many scenes contain features so light and so dark that when combined they exceed the recording range of the camera's digital sensor.

### METERING PATTERNS

How the light meter measures the scene depends on the metering pattern selected by the photographer. In practice, you can set the metering pattern to evaluative/matrix mode and leave it. Under high-contrast, spotlit or other tricky lighting situations, you may find it advantageous to change mode. Most DSLR cameras offer four or more metering-pattern modes.

### EVALUATIVE/MATRIX METERING

Measures light from 15 to 30 different spot locations in the frame and generates a compromise exposure based on real-situation algorithms that accommodate spotlit and backlit scenes. This is the best general-purpose mode and should be your default setting. It will give you a usable exposure in all but the most difficult circumstances.

### AVERAGING METERING

There is rarely, if ever, a situation when this mode

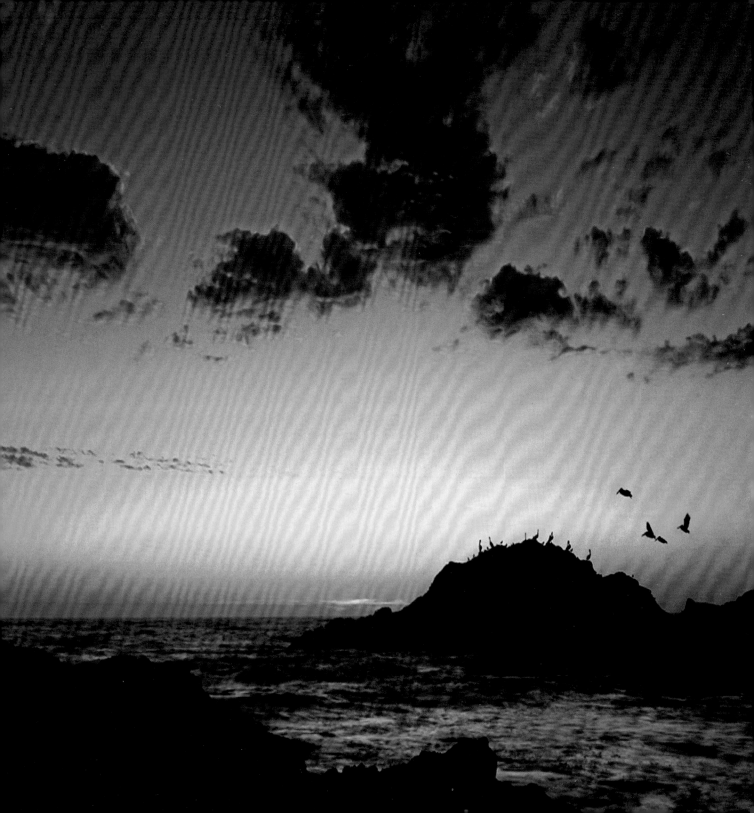

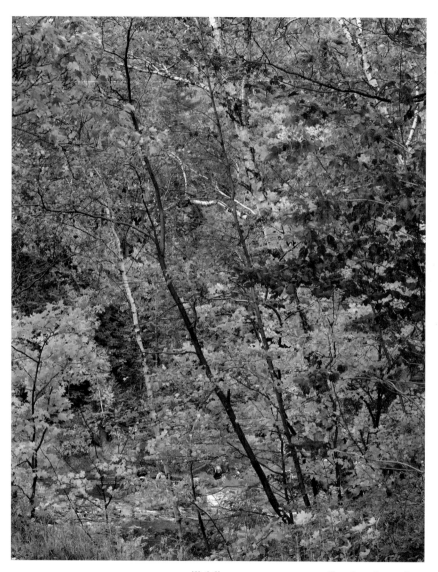

will deliver a more accurate reading than the evaluative/matrix mode. Don't bother with it.

### Spot Metering

Bases the entire reading on a central spot usually representing about 6 percent of the picture area. It's very useful for making exclusive readings of spotlit center-of-interest picture elements. Most useful when shooting wildlife to insure proper exposure of the all-important head/eyes region.

### Center-weighted Metering

Measures the entire field but gives about 75 percent priority to the central picture area, which is, unfortunately, seldom where you want to position the most important elements of the composition. As such, its usefulness is limited.

### Exposure Modes

Once scene brightness is measured, it's necessary to control the amount of light that hits the sensor by making adjustments to its duration (shutter speed) and intensity (aperture). This can be done automatically or manually by setting the exposure mode. There are three basic options:

#### • Aperture Priority (AV) Mode

You choose the aperture and the camera sets the corresponding shutter speed. This is the best mode for all subjects because it gives priority to depth of field, a key component of composition. For landscapes, the aperture is normally set at its smallest or next-to-smallest size for sharp focus throughout the picture area. For wildlife, especially portraiture, the aperture is normally set at its largest or next-to-largest size, which allows the scene to be recorded at its fastest/ next fastest shutter speed for sharp, frozen motion

captures of the subject.

**• Shutter Priority (TV) Mode**

This mode allows you to set the shutter speed while appropriate aperture is chosen by the camera. It's normally of little use to nature photographers.

**• Manual Mode**

In this mode you set both shutter speed and aperture based on light meter readings visible in the viewfinder. It's most useful when shooting landscape or static subjects when exposure compensation (see below) is necessary. If your camera lacks a fast-acting exposure compensation button, manual mode should be your choice for landscape shooting.

### Exposure Compensation

Scenes of unusual brightness or darkness require a bit of meter tinkering for best results, although even these normally will surrender a usable exposure when read with evaluative/matrix metering and captured on a wide dynamic range sensor. Keep in mind that a meter can only measure light; it cannot distinguish a snow field from a coal field and it always indicates settings for an average subject. If you were to follow strictly an averaging meter reading in such instances both snow and coal would turn out gray.

You can readily improve the accuracy of the base exposure and improve your chances of attaining a well-centered exposure first time around by compensating for the meter's failings through utilizing the camera's exposure-compensation feature — usually a convenient wheel or button you can operate without taking your eye from the viewfinder. To retain the snow's whiteness, you would give the film more exposure than the meter indicates by increasing exposure by a half stop to a full stop. For unusually dark subjects taking up most of the picture area, you would reduce exposure by the same amount.

*Lackawanna Lake, Pennsylvania (above). This contrasty scene requires evaluative metering, subsequent histogram checking and exposure compensation to center the data in the histogram.*

*Autumn colors along Chippewa River, Ontario (far left). Low-contrast scenes under overcast light with no sky in the frame receive even illumination of all picture elements and can be reliably metered with an evaluative or averaging meter pattern.*

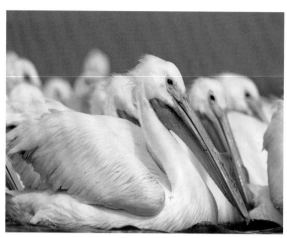

*White pelicans (above) and black bear (right). Picture-dominating subjects that are either very dark or light require special exposure compensation to retain detail in highlight and shadow areas. The best procedure is to make exposure adjustments that center the data on the histogram and then correct overall density toward the light or dark bias in postprocessing.*

### Bracketing

*For high-contrast, fast-action situations, it's often best to "bracket" exposures rather than checking the histogram. To do this, make two or more additional captures in one-stop increments over and under the base exposure. You can do this most quickly using auto-exposure bracketing. Spot readings of average tonalities (see small black bear photo) make good starting points for the base exposure.*

## DIFFICULT EXPOSURE SITUATIONS

For frontlit, sidelit and softly illuminated subjects of normal brightness, good exposures can be expected from an evaluative meter reading. It can be more difficult, however, when confronting scenes dominated by unusually light or dark subject matter or those composed of a mix of the two. It gets worse when there is limited time to reshoot due to changing conditions of sky or subject matter — sunset/sunrise, spotlit landscape features or scenes incorporating wildlife on the move. Following are descriptions of difficult situations and how to deal with them.

## BACKLIT SUBJECTS AND SCENES

Digital sensors cannot usually record both the highlights and shadow areas of scenes lit from behind. You have to decide which tonal area is key to your

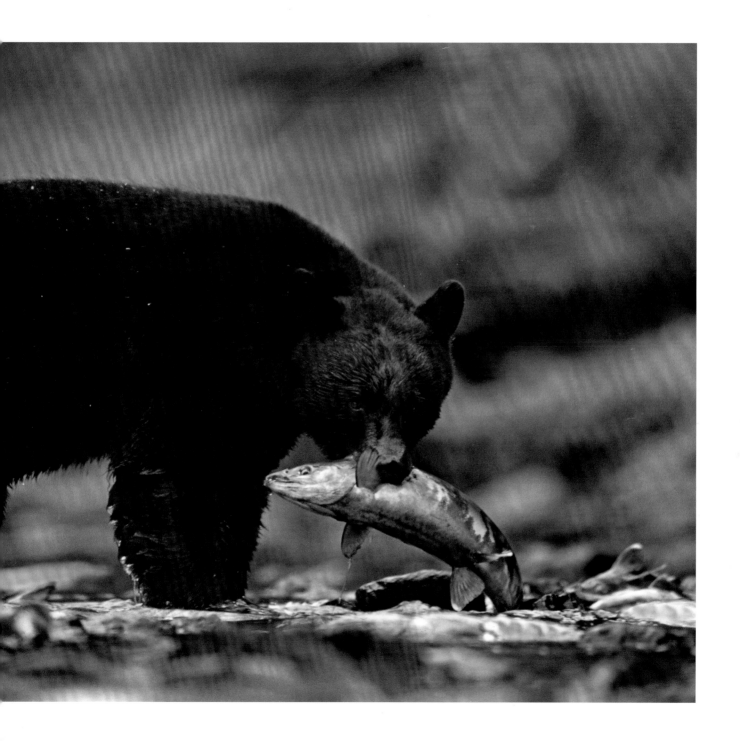

***Exposure with Filters***

*Making an accurate exposure is tricky with scenes having a combination of very bright and dark areas. Split neutral density filters can be used to hold contrast within the dynamic range of the sensor. Fine-tuning of tonal ranges can be made during computer postprocessing.*

*A one-stop ND filter was placed at an angle to match the slope of the terrain along the Blue Ridge Parkway, North Carolina.*

*A two-stop ND filter was aligned with the top of the flamingos before this evaluative meter reading was made.*

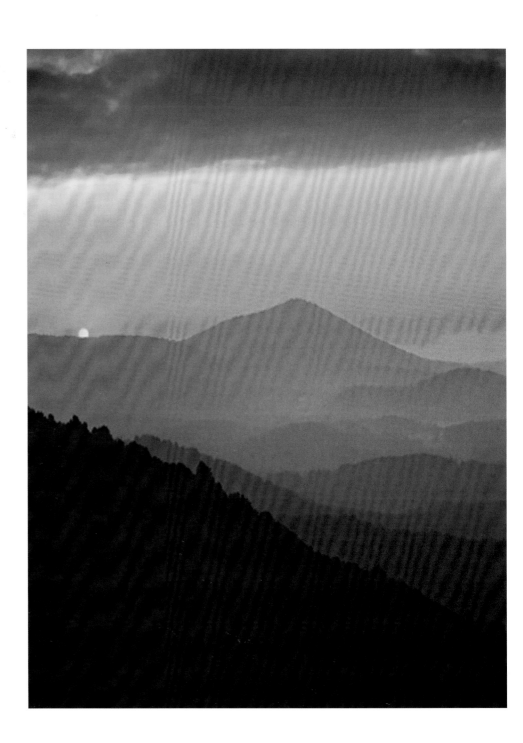

composition and then give it exposure priority. If it is a region in shadow, I take a spot reading on the center of interest and then decrease exposure (using the exposure-compensation feature) by about one stop to maintain the backlit mood and retain as much detail as possible in the glowing peripheries, flare areas, etc. I check the histogram to make sure the dark areas of the scene fall comfortably within the graph and that the highlights are not overly clipped off at the other end.

## WHITE AND LIGHT SCENES

Predominantly white scenes (e.g., snowy landscapes) record as neutral gray if shot without exposure compensation. I increase exposure by one stop to two stops over the meter reading to maintain these light tones. If the main subject of the scene is white to very light colored and occupies less than a quarter of the frame (e.g., bear grass blooms), I decrease exposure of average and evaluative readings by a half stop to prevent overexposure of the main subject. Then I check the histogram to make sure I have captured these small but critical white highlights.

## BLACK AND DARK SCENES

Very dark scenes (e.g., coniferous forests in shadow) will record as a midtone if exposure is made without compensation. To retain density, I decrease exposure by one stop. If the main subject of the scene occupies less than about a quarter of

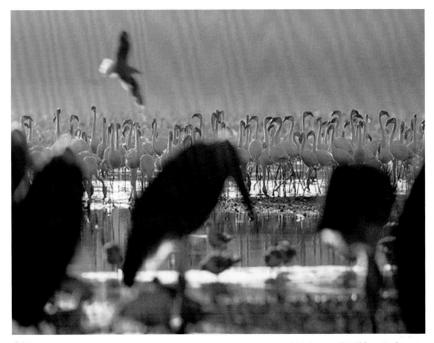

the frame I increase exposure by a half stop to reveal detail in the subject, and carefully check the histogram for results.

## SUNRISE/SUNSET

Due to the brilliance of the sun, these dramatic tableaux generate wide-ranging exposure readings depending on how the scene is composed. For consistent results I make a spot meter reading of a midtone section of the sky that excludes the sun. Using these settings, I reframe the scene and take the picture and verify exposure on the histogram.

*Shining Rock Wilderness from Blue Ridge Parkway, North Carolina (far left). Before metering this scene, I placed a two-stop neutral density filter to reduce the brightness of the sky. This brought contrast within the dynamic range of the sensor for a full capture of the picture data. Regional tonalities were later adjusted in Adobe Photoshop to distinguish the range of perspective planes.*

*Flamingos and marabou storks, Lake Nakuru, Kenya (above). Contrast was selectively controlled in this scene by tight framing to exclude the bright sky.*

# Reading the Light

*How to recognize and use different types of light*

**ONCE YOU HAVE A GRASP** of exposure basics the next exciting step in picture making is learning to record the type of light best suited to your theme, subject and camera. In nature's studio, we can't adjust reflector umbrellas or power-up strobe units, we use a get-into-the-right-position-and-wait-for-the-dramatic-moment method of passive control. Tuning into the subtle variations of light and how it is reflected or absorbed by the subject is the key to making exceptional pictures. Light should be considered in terms of its quality (soft or hard), its color and the angle at which it strikes the subject.

## STAY OUT OF THE MIDDAY SUN

On cloudless days the light generated by the sun from a couple of hours after sunrise to a couple of hours before sunset casts dense, well-defined shadows and generates brilliant highlights, producing a contrast range that may span a dozen stops — more than a digital sensor can record in one capture. In such light much of the subject's detail will be lost to excessive contrast. Being daytime creatures, we are accustomed to high noon lighting and find it commonplace. Shooting during these sunny midday periods is usually a waste of effort. Conditions improve when clouds break up the sky. Although direct overhead sunlight is still the main light source, some of the light is

*Botanical Beach, Juan de Fuca Provincial Park, Vancouver Island, British Columbia (below).*
*Getting into the right position and waiting for a dramatic show of light is standard procedure for top landscape photographers. In photographing this scene, finding an arrangement of tide pools that would reflect the rosy hues of sunrise to accentuate the textured terrain was an important consideration. Mamiya 645 AFD with Phase One P25 digital back, Mamiya Sekor 45mm f/2.8 lens, two-stop split neutral density filter, ISO 100, 1 second at f/22.*

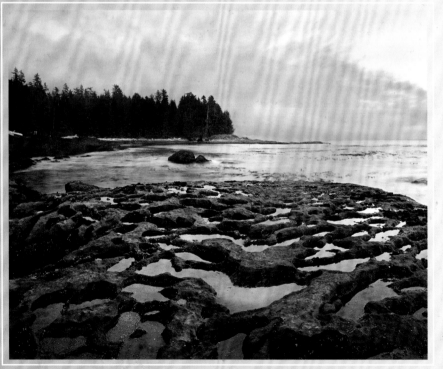

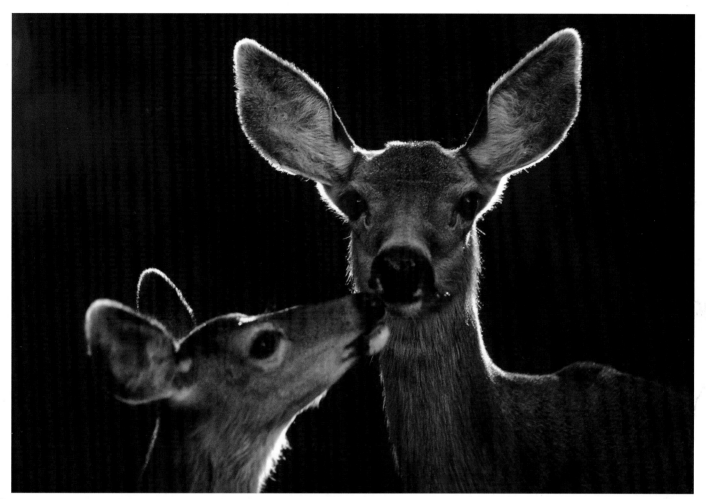

scattered as it passes through clouds and is deflected into shadow areas to lower contrast and improve color saturation. In general, the visual and photographic appeal of natural light improves the closer the sun is to the horizon and these are the periods when your shooting will be most productive. Keep this in mind as you read through these descriptions of lighting situations.

## FRONT LIGHT

Shoot with the sun behind you, and you are using front light. Due to its direct and even illumination, front lighting is recommended when you wish to portray saturated color, contrast between different colors and fine detail in all parts of the scene. It is best for photographing birds and mammals early and late in the day when a definitive picture of the

*Mule deers (above). Although backlighting is the riskiest directional lighting to use, it offers the most potential for exciting imagery. Here I reduced exposure by one stop from a spotmeter reading of the deer's muzzle to retain the natural density of the shaded elements and capture more of the highlight halo detail.*

*Rio Chama near Abiquiu, New Mexico (below). Sidelight is the best all-around illumination for most subjects, particularly landscapes. Here, shadows are brightened by clouds overhead producing excellent detail throughout the image. Mamiya 645 AFD with Phase One P25+ digital back, Mamiya Sekor 105–210mm f/4.5 lens, Singh-Ray circular polarizing filter, two-stop split neutral density filter, ISO 100, 1/8 second at f/22.*

species is desired. Due to the high relative intensity of front light it is normally used when you wish to make stop-action images of animals at brief shutter speeds. Exposure readings are reliable under front light and bracketing can be kept to a minimum.

### SIDELIGHT

When the sun illuminates the scene from the side it reveals form and texture. Sidelight produces long, deep shadows that reveal the wrinkles, dimples, ridges and other details of a surface in greatest

relief. Because sidelit subjects are a mixture of highlight and shadow, exposure should be based on a midtone and checked with the histogram. If clouds are present they will refract and reflect light into shadow areas and serve to reduce contrast. In determining the best exposure, it's better to give priority to highlights to retain their detail and allow shadows to block up if contrast surpasses the sensor's dynamic range. It's normal for us to come upon subjects too dimly lit to see clearly, but it rarely happens that detail is blocked in brightly lit subjects.

### BACKLIGHT

Like other types of directional illumination, backlighting varies in degree, and is most extreme when the sun is directly behind the subject. Backlighting's effect is dramatic on subjects with indistinct, shaggy peripheries — furry and feathered animals in particular. When the subject is translucent — plumes of a spoonbill or leaves

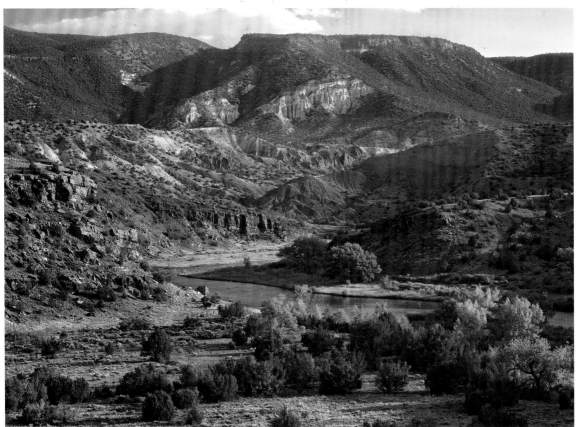

of an autumn maple, for example — backlight projects through, imparting to such elements an inherent luminosity. Backlighting is the most abstract and dramatic type of illumination. Its inherent high contrast is accentuated when photographed and produces a novel effect not fully accessible to normal human vision. If the main subject is photographed against a bright background that receives exposure priority, it will be underexposed and appear as a silhouette. If the subject is softly edged, it will be outlined by a halo of golden light. If exposure priority is given to the main subject (take a close-up reading of the shaded side) the back-

ground will normally wash out due to overexposure unless you can position the camera to capture a background that is also in shade. Attractive effects are possible anywhere between these two exposure extremes. With static subjects, you can make a two-or-three-capture series and combine them in Adobe Photoshop using the HDR (high dynamic range) editing feature.

## BEWARE OF LENS FLARE

Photographs made in backlight may lose quality due to lens flare. This occurs when the rays of the sun strike the front lens elements directly, resulting in a loss of color saturation, contrast and the appearance of octagonal hotspots caused by light reflecting off the interior diaphragm blades of the lens aperture. Flare can be eliminated or reduced using a lens hood when photographing wildlife. When shooting landscapes, the need to affix and adjust filters to the front of the lens makes it more convenient to shade the lens with your hand or hat just prior to making the exposure. You can check for flare by peering

*Goldenrods and sumac, Cassatot River Valley, Arkansas (above).*
*Soft light from an overcast sky is often the best illumination for detailed studies of plants, animals and tight takes of the landscape where the sky and horizon are excluded. Overcast light and yields fine detail and saturated color throughout the picture area.*

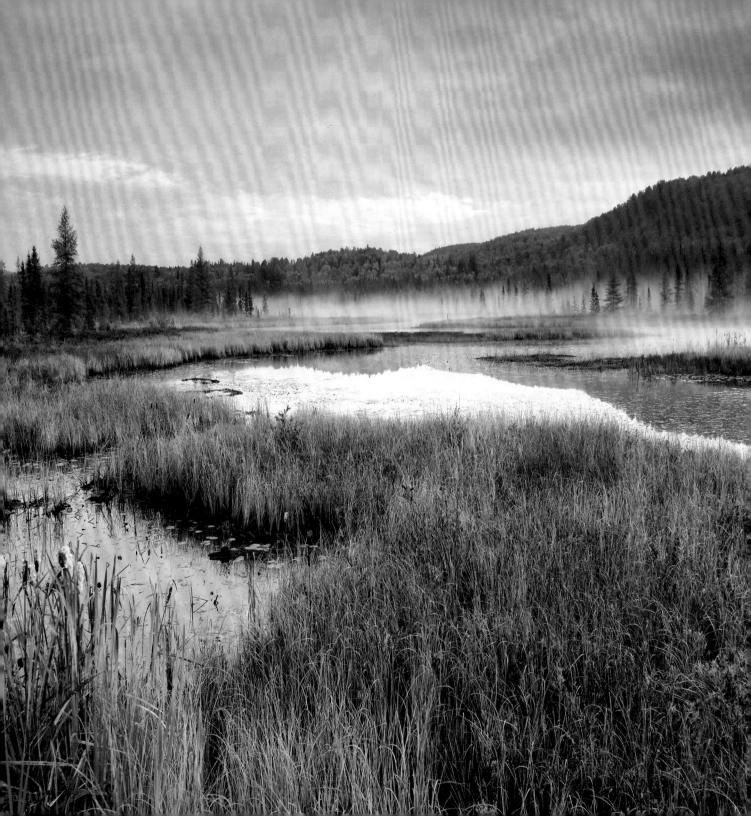

through the viewfinder or simply by making an exterior examination of the lens itself to be sure that it is shaded. You can also tame lens flare by taking a camera position so that the sun is not directly in front of you or by using a picture element, including even the subject itself, to block the sun. To ensure that flare has been avoided, check the scene at shooting aperture (use depth-of-field preview) if you have a chance.

## TWILIGHT

When the sun is just below the horizon, only the light from the glowing sky overhead illuminates the scene. If clouds are present they will reflect additional warmer, directional light into the scene, which will help to give more defined shape to terrain contours. Although twilight calls for long exposures (several seconds to a minute are common at low ISO settings), this is one of the premier times for landscape shooting, not only because the scene's contrast range can be accommodated by

the sensor, but because the light source casts rosy hues onto the terrain. If present, clouds are painted in fiery, rapidly changing tints and add compelling structure and visual interest to the composition.

## OVERCAST LIGHT

Overcast skies produce soft light that illuminates the subject evenly without noticeable shadows. Soft light allows you to record the complete range of tones of most scenes, serving up saturated color and fine detail in both the brightest and darkest parts of the picture area. Exposure is easy to determine and changes little regardless of where you point the camera (sky areas excluded). For close-ups of animals

*Costello Creek, Algonquin Provincial Park, Ontario (far left).* *The soft, rosy illumination of twilight is superb for landscape shooting, especially when there are clouds above the subject to absorb and reflect the rays of the sun coming from below the horizon. As with all scenic work, a tripod is essential as exposure times may be extended to a minute or longer. Mamiya 645 AFD with Phase One P25+ digital back, Mamiya Sekor 35mm f/3.5 lens, ISO 100, 2 seconds at f/22.*

***Immature rufous hummingbird (left).*** *This early morning portrait was illuminated by full sunlight coming from behind and to the side of the camera. Its high frontal intensity permitted an action-stopping shutter speed while its obliqueness modeled the subject for strong representation of texture and shape. Canon EOS 5D, Canon 500mm f/4 IS lens, extension tube, ISO 800, 1/1000 second at f/5.6.*

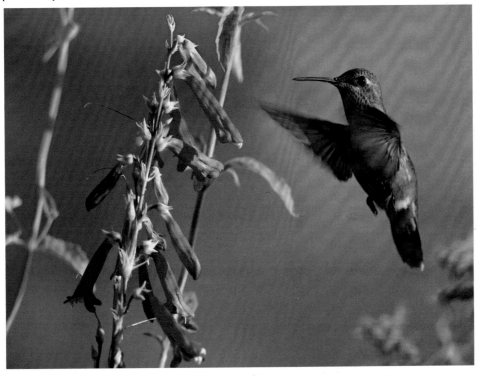

and plants and tight shots of the landscape, overcast light is hard to beat.

## SPOTLIGHTING WITH CLOUDS

One of my favorite effects depends on a sky full of broken, distinctively shaped, fast-moving clouds and a low sun. The wind-propelled cumulous clouds throw dappled patterns of sun and shade onto the scene. Because the sunlight is diffused by clouds, shadows are lighter than usual and do not block up. For wide views of the landscape, including those featuring wildlife, take a position on high ground if

possible and bide your time until a distinctive patch of terrain or interesting wildlife subject is picked up in the spotlight. Then with all speed, make a series of bracketed exposures (see page 68) before the drama fades. A zoom lens is the ideal tool for working out these compositions quickly.

## SUNSET FLASHES

One of the most seductive types of landscape illumination is also the most brief. These heavenly moments occur when the sun is bisected by the horizon (either on the way up or the way down) and its energy arrives in refracted form — colorful and breathtakingly soft. This light has enough definition to model topographies and plenty of warmth to paint clouds in delicious tints of mauve, crimson and peach. The duration of the show is only seconds so you have to be ready and then shoot as quickly as possible if you're going to bracket and swap filters.

## ELECTRONIC FLASH

For me, the use of artificial light (i.e., electronic flash) to depict wild subjects often contaminates the beauty of the natural theme. I'm not fond of photos where long-range project-a-flash is used in combination with a super-telephoto lens to beam a sheet of garish fill-light into the shadow side of a bird or strike a phony highlight in its eye, or when multiple strobes are used to paint up hummingbirds so they look like pastries on display at the Donut King. I like spiders, butterflies and bumblebees to be illumi-

nated by the real sunlight of their natural setting.

Electronic flash makes it possible, however, to shoot small creatures with lots of depth of field at stop-action exposure times when a scientific record is needed. I also like it for shooting nocturnal animals (bats, owls and tree frogs) when light fall-off from the strobe yields a black, "night timey" background. Otherwise, electronic flash announces, with its retail-store lighting, the presence of the photographer and his or her gangle of equipment. In the next chapter you'll learn how to control light in natural ways that will help you avoid the use of flash.

*Blacktail jackrabbit (left). Backlighting (see page 74) is ideal for wildlife species with shaggy fur or feathers, which are transformed into dramatic transilluminated halos outlining the subject. The main precaution with backlight is to use a lens hood and adjust camera position to avoid flare. Color saturation, subject detail and contrast will all be degraded if the sun's rays are allowed to strike the front lens elements.*

*Gray Rock, Garden of the Gods, Colorado (far left). Landscape photographers must work quickly to catch nature's momentary displays of dramatic lighting, most likely to occur at sunset and sunrise. Not only must you be adept at setting exposures quickly but you should have a good idea of your tripod position and framing well before the decisive shooting period begins. Here, two exposures were made and later combined in Adobe Photoshop using the HDR (high dynamic range) feature. Mamiya 645 AFD with Phase One P25+ digital back, Mamiya Sekor 55–110mm f/4.5 lens, Singh-Ray circular polarizing filter, ISO 100, 4 seconds at f/22 (for terrain portion) and 1/2 second at f/22 (for sky portion).*

# Depth of Field

*How to control and use in-focus picture areas for dramatic effect*

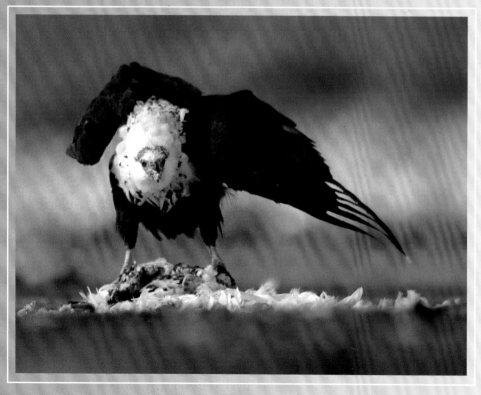

*African fish eagle (below). By shooting at maximum aperture to limit depth of field and focusing on the eyes, I was able to make this fierce subject stand out from its more colorful background.*

**WHILE THE MARABOU STORK** and fish eagle squabbled over the dead flamingo, I grew anxious about getting the camera into the right position. I struggled through the tropical ooze, shoving the floating blind along with dangling feet. From my beach-level vantage point, the marabou's legs rose like posts through a viewfinder filled mostly with fish eagle crouched over prey, its dark wings hooding a little pile of twiggy bones and tattered feathers.

The weakness of the early morning light called for maximum aperture and, combined with the high magnification of the telephoto lens, there was little depth of field. To record both eagle and stork sharply, I needed to position the camera equidistant from both birds. So I squirmed through the mud while the birds sparred. Every few feet, I checked the viewfinder until the shooting angle was right and the fierce eyes of the two subjects snapped with equal sharpness from the softness of the distant background — a blurry wash of pink flamingo flocks against the walls of the Great Rift Valley. I managed a few exposures before the eagle took wing, leaving the remains to the marabou stork.

The problem of establishing appropriate sharpness in a composition is a challenge for nature photographers. Whether you

are shooting an encounter between avian predators, a bouquet of wind-jostled daisies, a red-eyed tree frog or a hardwood forest, the twin issues of point of focus and depth of field require careful consideration.

## DEPTH-OF-FIELD PRIMER

Depth of field is that part of the image that is rendered in sharp detail. The best way to evaluate it is to use the camera's depth-of-field preview feature. This mechanism closes the aperture to the f/stop that you have set for actual exposure, allowing you to see what is sharp and what is not. Otherwise, the lens diaphragm stays open and the viewfinder remains bright to make focusing and composition easier.

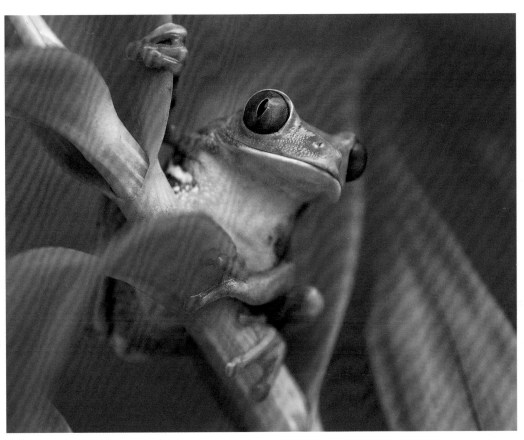

## FROM HERE TO ETERNITY

When shooting landscapes, setting depth of field generally guides other camera adjustments, like exposure and point of focus. Landscape images are conceptual composites. They are judged by how the various elements of the scene relate to one another, particularly in terms of color, light and perspective. To reveal these relationships effectively, it is routine to record as much detail as possible from foreground to horizon. And so the attainment of total depth of

field is the starting point for setting up the capture, even insofar as what you choose to include or exclude from the composition.

In a nutshell, depth of field exhibits two characteristics critical to the composition. First, its extent is dependent on magnification of the subject and aperture size in this way: the greater the magnification (regardless of lens focal length), the less the depth of field; the smaller the aperture, the greater the depth of field. Secondly, its position in the scene is dependent on the point of focus, with

*Red-eyed tree frog (above). The depth-of-field zone is critical to the success of an image. Here I focused on the frog's eye and shot at wide-open aperture to blur the remainder of the picture. A careful positioning of the camera surrounded the central picture element with blurred swatches of color for a painterly effect. Canon EOS 5D, Canon 70–200mm f/4 IS lens, extension tube, ISO 400, 1/250 second at f/4.*

*Storm clouds over Medicine Bow National Forest, Wyoming (below).* *Depth of field was established to include all picture elements from foreground to horizon by careful focusing to about ¹/₃ into the picture space and use of small aperture. Mamiya 645 AFD with Phase One P25+ digital back, Mamiya Sekor 35mm f/3.5 lens, Singh-Ray circular polarizing filter, ISO 100, 1 second at f/32.*

about one-third falling in front of the focus point and two-thirds falling behind. Armed with these two facts you can adjust the camera to attain total field sharpness at an appropriate shutter speed. Setting the lens' hyperfocal distance is the term used for this procedure.

### SETTING HYPERFOCAL DISTANCE

I set hyperfocal distance by viewing the scene at shooting aperture (by activating the depth-of-field preview mechanism) and focusing to and fro until both the horizon and the nearest picture elements are sharp. With the lens stopped down, the viewfinder can be dim and difficult to evaluate and you must give your eyes time to adjust. A floppy, full-brim hat that shields eyes and the viewfinder from stray daylight facilitates this process. If the depth of field is too limited to span both near and far elements, you have two options: either close the aperture further or decrease magnification of the foreground by backing up.

### SHARPENING A HERON'S BEAK

If a landscape photograph is generally an expression of theme, then a wildlife portrait is an expression of thing, with its composition drawing structure from the main subject. You hope to reveal the nature of the beast by emphasizing its unique and appealing characteristics and playing down other elements. Priority shifts from a consideration of depth

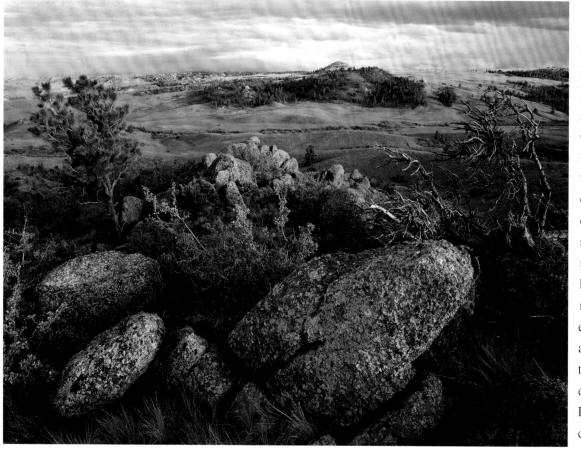

of field to setting the point of focus.

The point of focus for frame-filling wildlife subjects, from spiders to giraffes, is almost always the creature's eyes. (Whales photographed breaching, etc., are an exception. For these subjects, almost any body part will do, with the tail flukes, flippers and blowholes being primary among focus targets.) The reason that eyes are important, even for such creatures as bears and elephants, for whom sight is secondary to smell, is simple. We humans communicate most nonverbal information through our eyes. When we view a wild-life photograph, especially a portrait, we don't feel we know fully what it is about until we have seen the creature's eyes. In fact, what the viewer really wants to see is the entire head in high detail, although this is often difficult to capture. With active subjects, the most practical approach is to work for sharp focus on the eyes and hope for the best on the rest. If there is more than enough light for a shutter speed brief enough to stop the movement of the animal

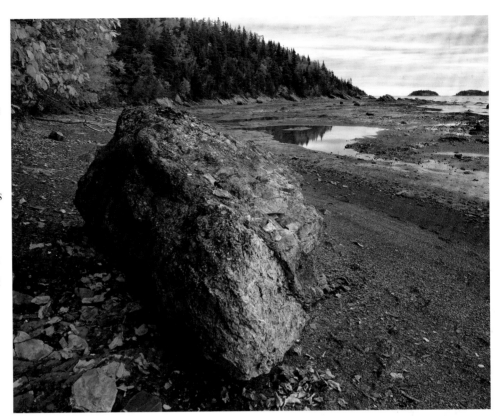

and arrest camera shake, then use the extra luminance to move to an aperture smaller than maximum to take advantage of the additional depth of field.

### HIGH-TECH OPTIONS

In wildlife photography, where super-telephoto lens work is the norm and high shutter speeds are necessary to freeze action and reduce camera

---

***Maximizing Depth of Field for Landscapes***

• *Shoot at the smallest or next-to-smallest aperture.*
• *Focus on the closest foreground element, then refocus a little beyond this point deeper into the picture space.*
• *Stop down the lens to shooting aperture and allow sufficient time for your eyes to adjust to the reduced brightness of the viewfinder. (Shield the viewfinder from stray light.)*
• *Make sure the most distant and closest elements in the scene are sharp. If not, focus further into the scene and check again.*
• *If you are not able to bring both foreground and background into the depth-of-field zone, you are too close to the foreground elements. Adjust camera position and try again.*

---

*"Île Brulée et Île du Massacre, Parc national du Bic, Québec"* **(above).** *To ensure sharpness over the entire picture field and highest magnification of the foreground sedges, I set the lens at its smallest aperture (f/32) and focused at the hyperfocal distance. For the latter I examined the scene at shooting aperture while adjusting focus to the nearest point that held the distant islets in sharp detail and then positioned the camera as close to the foreground boulder as possible without causing blur.*

*Black bear cub (right).* When *making medium to close-up shots of wildlife, you want to shoot at, or near, maximum aperture to minimize depth of field. This will surround your subject with blurred color and emphasize its sharpness. The point of focus rarely should be anywhere except on the eyes. In this portrait the eyes are not only the sharpest part of the image, but are also dramatically illuminated by a shaft of sunlight.*

vibrations, most professionals work in the aperture priority, auto-exposure mode. This offers a number of advantages. In the many instances when you are shooting wildlife near sunrise or sunset, you will find that there is seldom enough light to easily accomplish your pictorial goals. Much of the time you will be forced to shoot at maximum aperture to achieve a shutter speed of sufficient brevity. So you select maximum aperture and let the camera set the correct shutter speed. If I am working on a tripod and finger-tripping the shutter then I am fairly confident of sharpness at 1/125 second at any focal

length up to 600mm or 700mm when using image-stabilized lenses. However, I will not begin to close down the lens to benefit from the extra depth of field until the shutter speed exceeds 1/250 second.

## DESIGNING FOR BLUR

I seldom close down the lens more than one full stop because I do not want either background or foreground elements to lose the smooth blur that contrasts so dramatically with the sharply rendered center of interest. In fact, these areas of blur are highly desirable design elements if they can be

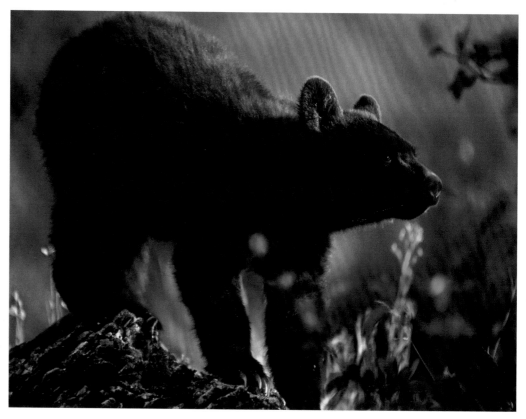

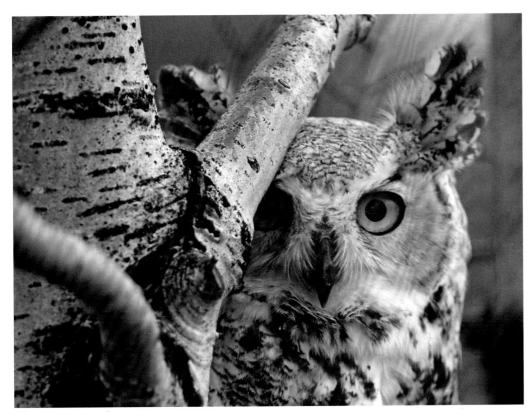

***Depth of Field
for Wildlife***
*Although depth of field falls
roughly two-thirds behind
and one-third in front of the
point of focus for normal
magnification (hyper-
focused) landscape images,
for close-up studies of wild-
life it is about evenly divided
front and back. Depth of
field is also quite shallow,
extending only an inch or
two at standard shooting
apertures (f/4 to f/8) when
capturing tightly framed
birds or head shots of mam-
mals. Focus carefully!*

***Northern saw-whet owl (below)
and great horned owl (left).*** *Set
up your camera angle with atten-
tion to background and foreground
blur. Use these design elements to
isolate and strengthen the in-focus
components and hold attention
within the picture space.*

placed appropriately in the scene. Moving them
around is not easy when shooting wildlife as either
the subject or camera position must be altered.
These blurs should fall in the bottom or side of the
frame when the creature is tightly cropped so that
the viewer's attention does not follow the animal's
extremities out of the picture area. Peripheral blur-
ring contains and strengthens the central picture area
and accentuates elements that are rendered sharply.

## AUTOMATED ARTISTIC CONTROL

The best high-tech option (only available to digital
shooters) for controlling the pictorial effects of
both shutter speed and aperture is automated ISO
selection (to date available on a limited number of
professional models.) You select
a combination of aperture and
shutter speed that best suits your
artistic purpose and the camera
makes continuous, shot-by-shot
adjustments of the ISO setting to
render the proper exposure.

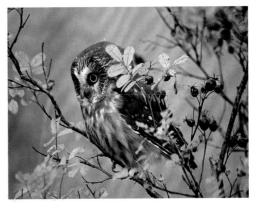

# Motion Effects

*Using shutter speed and camera movement to control the effect of motion*

*African white pelicans (below). For this abstraction, a slow shutter speed (¹/₄ second) and panning the camera with the moving flock created speeding streaks of soft color.*

*White-faced tree ducks (right). A brief shutter speed (¹/₂₅₀ second) froze the movement and captured a balanced arrangement of these birds.*

**THE DURATION OF EXPOSURE,** or shutter speed, affects the photograph in two ways. In concert with aperture, it is used to control the amount of light that reaches the film. Of artistic importance is its effect on motion, that of the subject, or the camera or both acting simultaneously.

## SHUTTER SPEED'S RULE OF THUMB

Whether or not it is necessary to use a tripod to arrest camera shake and vibration during exposure is normally prerequisite to artistic concerns of how shutter speed affects motion. As discussed earlier, using a tripod is general practice for nature photographers due to its numerous benefits to image making. However, there are infrequent but regular instances when handholding the camera is beneficial. To avoid blur due to handheld camera shake, you should shoot from a comfortable, well-balanced position and set the shutter speed no slower than the inverse of the lens' focal length (e.g., ¹/₂₀₀ second for a 200mm lens). If using image stabilizer type lenses you can extend exposure times by an additional two to three stops (consult the lens manual).

A photograph can interpret motion in many ways. At one

extreme, all action is frozen by the use of a brief shutter speed. At the other extreme, a slower shutter speed allows the motion of the subject to be registered as a blur on the sensor's surface.

## FROZEN MOTION

Whenever you are photographing a moving subject, it is necessary to consider the movement relative to the sensor during exposure, rather than what the subject is actually doing. Suppose a small flock of sandpipers is winging *toward* the camera at top speed. By observing the scene in the viewfinder (i.e., as it affects the sensor's surface) you would notice that the animals, though moving swiftly, appear to be relatively stationary but growing slowly larger. A moderate shutter speed of $1/125$ second would likely be brief enough to arrest much of the flock's motion (wings excepted).

On the other hand, if you were to photograph the flock moving *laterally* to your field of view, the sensor would perceive the subject entering stage left and exiting stage right (or vice versa) in a flash of

time. A much faster shutter speed, dependent on how much the flock is magnified, would be needed to arrest motion — varying anywhere from $1/250$ second for a long shot to $1/2000$ second or faster for a tight frame-filler.

The selection of an action-stopping shutter speed is dependent on the magnification of the subject, the speed of the subject and the direction of the subject's movement relative to the sensor. All of these factors are interrelated. Different parts of the subject also

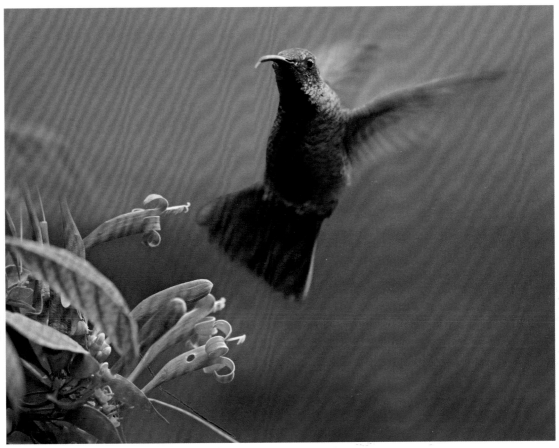

*Green-breasted mango hummingbird at flame vine (above).* *Generally speaking, the smaller the bird, the faster the shutter speed needed to arrest its motion. For hummingbirds, $1/1000$ second stops most of the wing motion, leaving just enough blur to generate an apt impression of high-energy flight. Canon EOS 5D, Canon 500mm f/4 IS lens, extension tube, ISO 800, $1/500$ second at f/5.6.*

move at different speeds. Sandpipers, for example, fly at a certain velocity while their wings move not only at a different speed but in a different direction.

## PEAK ACTION SHOOTING

There are several ways that you can improve the action-stopping property of any shutter speed. One way is to coordinate the moment of exposure with a break in the movement of the subject — the apex of an impala's leap or the moment just before an eagle lands with wings spread and toes extended. You catch the subject when it is stopped or slowed,

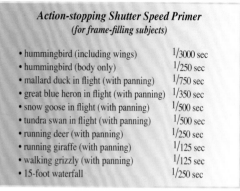

**Action-stopping Shutter Speed Primer**
*(for frame-filling subjects)*

| | |
|---|---|
| • hummingbird (including wings) | $1/3000$ sec |
| • hummingbird (body only) | $1/250$ sec |
| • mallard duck in flight (with panning) | $1/750$ sec |
| • great blue heron in flight (with panning) | $1/350$ sec |
| • snow goose in flight (with panning) | $1/500$ sec |
| • tundra swan in flight (with panning) | $1/500$ sec |
| • running deer (with panning) | $1/250$ sec |
| • running giraffe (with panning) | $1/125$ sec |
| • walking grizzly (with panning) | $1/125$ sec |
| • 15-foot waterfall | $1/250$ sec |

however briefly, and thus project an impression of stop-action. Such situations normally happen in a fraction of a second and are difficult to time precisely. For best results, study the behavior of your subject in order to better anticipate its movements. Shoot with your motor drive at top speed and be persistent.

Choosing the slowest shutter speed that will stop the action of your subject is usually an educated guess. The slowest setting is desirable as it affords the smallest aperture, hence the greatest depth of field and the most tolerance for focus error — an advantage when working with active subjects. The chart above provides some basic starting points.

## PANNING THE CAMERA

Another way to reduce blurring

*Scarlet macaws (below). The flapping wings of the closest parrot were captured (luckily) as they changed direction and were relatively still. (Improve your chances by shooting action in high speed bursts.) In addition, the camera was panned along with the bird's body to further reduce apparent movement. Canon EOS 5D, Canon 500mm f/4 IS lens, ISO 400, $1/250$ second at f/5.6.*

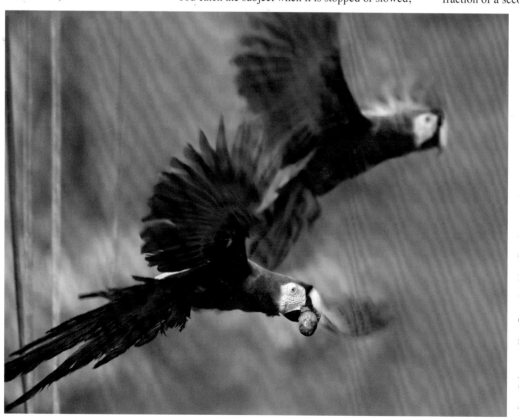

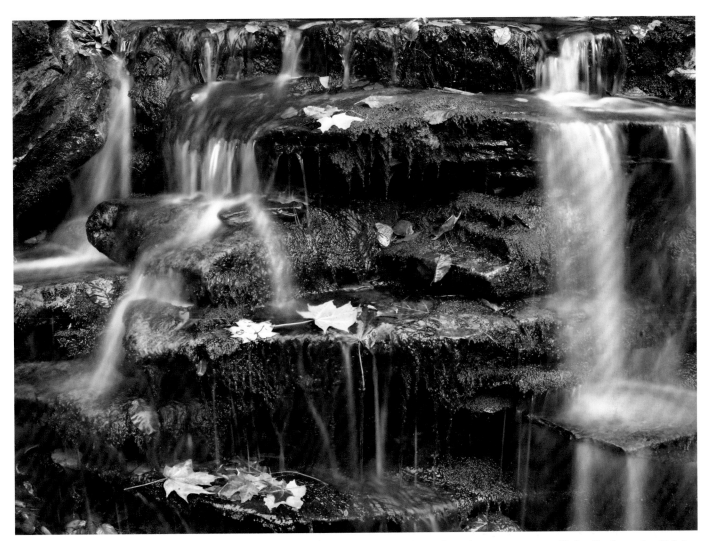

is to track the subject as it moves, trying to keep its position in the viewfinder stationary. Of course this will not help much to slow the movement of wings or legs but it will reduce blur of the gross subject. Panning is most effective if you keep the camera moving smoothly through the shot, both before and after exposure. The tendency is to stop panning as soon as you hit the trigger which can disrupt the process at its most critical moment due to the delay between actually pushing the button and the release of the shutter curtain. Panning is most smoothly done from a tripod-mounted camera with

***Kitchen Creek cascades, Ricketts Glen State Park, Pennsylvania (above).** When making blurred motion shots of waterfalls, try including sharply rendered comparison elements to contrast with the blur of the rushing stream.*

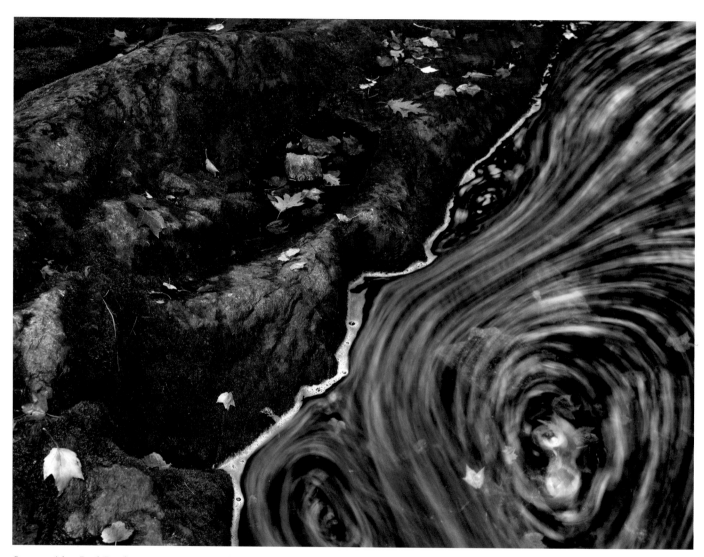

*Stream swirl on Duck Brook, Acadia National Park, Maine (above). Sharply rendered and blurred detail creates a dynamic composition. Slowly swirling water beneath a cascade was recorded at a shutter speed of 15 seconds.*

the controls loosened using a ball head or a gimbal head. Panning helps reduce blur in the main subject while stationary elements in the scene will become streaked (often beautifully) due to the camera movement. This streaking of the background infuses the picture with a compelling impression of motion.

(More specialized tips on stop-action shooting are provided in the chapter *Animals in Action* beginning on page 126.)

### BLURRING FOR EFFECT

Choosing an exposure time that produces obvious

blur in a moving subject is an exercise full of potential for producing beautiful abstract imagery whose precise formulation is normally difficult to predict. It is most commonly used when photographing streams, rivers or waterfalls to enhance the sensuous movements of the liquid. You will be pleased with such attempts at any exposure time of 1/4 second or longer for scenic-size magnifications. When framing is tighter, faster shutter speeds are possible.

## BLURRING DIGITALLY

Digital cameras allow you to judge the blurring effects of shutter speed on the LCD monitor immediately after exposure and then make the necessary adjustments. Aperture and

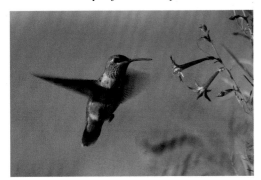

shutter speed are normally selected first for the ideal rendering of the subject and then the ISO speed is set to achieve correct exposure.

You can use blurring techniques for any moving subject — falling snow, a zooming hummingbird, galloping zebras or stars in the night sky. The key considerations are exposure duration and relative speed of the various moving components — camera, main subject and secondary subjects. Exploring motion with a still camera offers unlimited possibilities and many surprises.

*Zebras (above).* A blur of confusing stripes is thought to be a zebra herd's defense against the charge of a lion. This effect was captured with a handheld camera panned to match the motion of the fast-moving herd at a shutter speed of 1/15 second.

**Broad-tailed hummingbird at scarlet gilia (left).** A 1/500-second shutter speed arrested most of the motion of this hummer.

# Modifying Natural Light

*Using filters and reflectors with natural subjects*

***Rocky Mountain columbine at American Basin, Colorado (below).*** *In this subalpine study of wildflowers a matt white reflector was used to bounce light into the foreground bouquet, producing stronger color and improved detail.*

IN NATURE PHOTOGRAPHY a faithful record of the scene is normally desired. Filters are used primarily to reduce subject contrast and enhance color. The small selection of filters described here is about all you need to develop a full, professional portfolio. Filters are mostly used in photographing the landscape and other still life subjects such as trees and wildflowers. They are rarely used for wildlife, insects and other invertebrates. There are many different brands of filter and most are similar in quality and effect. Except for color-enhancing filters, prestige brands provide little if any improvement in quality over less expensive types. For professional applications in particular, however, high-end filters offer more variety of types and sizes as well as extra-thin filters for use with wide-angle lenses to prevent vignetting.

## ONE SIZE FITS ALL

When developing a filter system, it's best if all filters fit your largest diameter lens(es). Appropriately sized step-up rings can be permanently attached to your smaller lenses to accommodate the larger filters, thus eliminating the need for carrying a variety of sizes. Extra filters are not overly burdensome, but rather difficult to keep track of and organize during high-paced shooting.

## POLARIZING FILTERS

I keep polarizing filters attached to my lenses most of the time. They produce greater color saturation by reducing or eliminating reflected glare from non-metallic surfaces like leaves, grass and water. They also add color density to

blue skies when photographed at a right angle to the sun. These filters reduce scene brightness by one to two stops depending on how they are adjusted. Less expensive polarizers are thick and may cut off part of the view in the corners of the frame (vignetting) especially when used with ultra wide-angle lenses. Before you buy, attach the filter and view a bright light source with the lens stopped down to minimum aperture. Darkening in the corners of the viewfinder indicates vignetting and it will be even more extensive in the captured image. When shooting with a wide-angle lens at right angles to the sun, be aware that the lens takes in so much sky that the darker polarized area in the center will be flanked unnaturally by areas of brighter sky. It's often better in such circumstances to put aside the polarizing filter and increase sky density with a split neutral density fil-

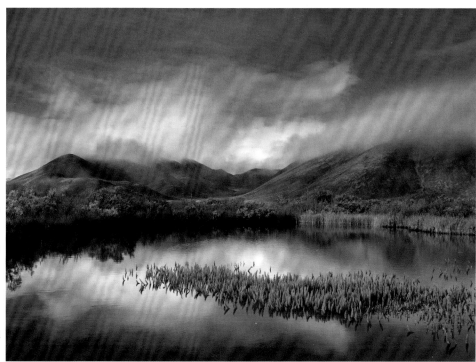

ter. Alternatively, you will have to do a lot of image correction on the computer to restore the scene to its natural state. Most current model cameras require circular (rather than standard) polarizing filters for accurate operation of the light meter and auto-focus system. Your camera manual should provide this information. You can modify the amount of polarization simply by turning an adjustable ring on the filter. The effects can be monitored in the viewfinder.

### SPLIT NEUTRAL DENSITY FILTERS

The split neutral density (ND) filter is one of the landscape photographer's best friends. Half of this square (or rectangular) filter is clear and the other

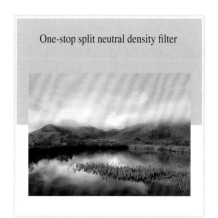

One-stop split neutral density filter

*Ogilvie Mountains, Tombstone Territorial Park, Yukon (above).*
*To retain the rich color of the sky and also capture the detail in the foreground vegetation, I used a one-stop split neutral density filter (see illustration at left) to reduce contrast in the scene to a level within the dynamic range of the sensor. Mamiya 645 AFD with Phase One P25 digital back, Mamiya Sekor 45mm f/2.8 lens, Singh-Ray circular polarizing filter, one-stop split neutral density filter, ISO 100, 1/8 second at f/32.*

## Combining Filters

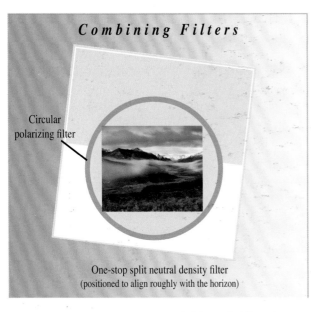

Circular polarizing filter

One-stop split neutral density filter
(positioned to align roughly with the horizon)

half is neutral density (gray) which darkens the part of the scene over which it is placed to a degree dependent on the strength of the filter. These plastic resin filters are used mostly in high-contrast landscape situations when the sky is brighter than the terrain. The filter is mounted in a special holder so that it can be moved up and down and/or tilted to fit the topography. Cokin filter holders are the standard holders used for many brands. Filters and holders are offered in two sizes — a small amateur size (A) and a larger professional size (P). Serious photographers will want to invest in the P series which will accommodate both small and large diameter lenses. I don't use filter holders. I attach the filters directly to the lens using duct or gaffer tape. This eliminates vignetting problems and allows greater versatility when using more than one filter at a time (see illustration on this page).

The dark part of the filter is positioned over the bright part of the image (usually the sky) by examining the effect in the viewfinder. Study the scene at stopped-down aperture to be sure of placing the filter precisely. Each aperture will show a different effect as depth of field changes. Avoid overlapping the gray area onto the land (snow-capped peaks ex-

*Tombstone Range in fog, Tombstone Territorial Park, Yukon (right). Two types of filtration were combined to make this image (see illustration above). A Singh-Ray circular polarizer generated saturated color in the autumn terrain and increased sky contrast. A one-stop split neutral density filter was placed over the sky, reducing overall contrast to fit more easily into the dynamic range of the sensor.*

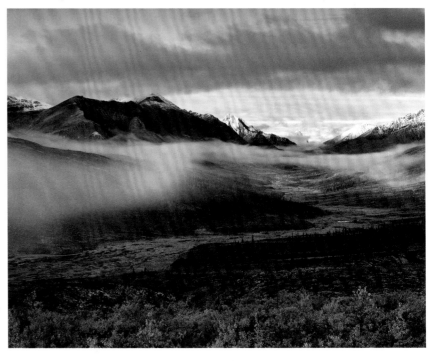

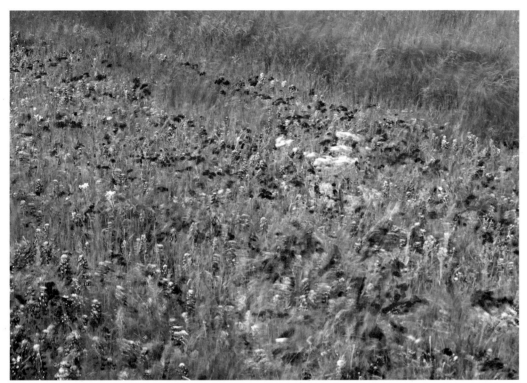

**Bluebonnets and Drummond's phlox in the wind (left).** *A variable neutral density filter (Singh-Ray's Vari-ND) was used to reduce scene brightness and allow the extended exposure time needed to record this saturated blur of spring blooms. Mamiya 645 AFD with Phase One P25 digital back, Mamiya Sekor 55–110mm f/4.5 lens, Singh-Ray Vari-ND neutral density filter, ISO 50, 15 seconds at f/16.*

cepted) as this will darken the top edge of the land unnaturally. Leaving too much space will generate a bright margin along the horizon. Both problems can be corrected easily in Photoshop. Meter the scene in the normal way with the filters in place. One-stop filters are suitable for 90 percent of landscape work carried out with digital cameras, as further density can easily be added in postprocessing provided you make sure the image data is well centered on the histogram at the time of exposure. Hard-edge filters (those with an abrupt border between clear and dark halves) are generally more useful than soft-edge types, although you may wish to carry both.

## GRADUATED NEUTRAL DENSITY FILTERS

Often the region where land meets sky does not match the straight border of the split ND filter. The horizons of many topographies are interrupted by trees, cacti, rock pinnacles, mountains, hills or all of the above. Here the only way to lower the density of the sky without leaving a telltale underexposed swath of terrain along the horizon is to use a graduated neutral density

**Mexican hat wildflower (below).** *A handheld, matt white reflector was used to brighten shadow areas in the creation of this low-contrast study of pastel color.*

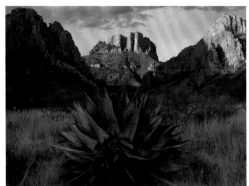

*Agave and Casa Grande, Big Bend National Park, Texas (above and right). A large (40-inch diameter) silver reflector was used to bounce light onto the giant agave in the foreground to better display its details and improve the impression of deep perspective by giving more prominence to this important cue. I held the reflector with both hands and tripped the shutter using the self-timer. The take above shows the unadulterated version.*

filter. With this filter, the transition between clear and dark regions is gradual and spans the length of the filter. Its effect is beneficial but not as defined or dramatic as that achieved with split ND filters.

## Standard ND Filters

Full-frame neutral density filters are used most often in creating blurred motion imagery. They reduce light intensity throughout the picture area when an extended exposure time is not accessible because brightness levels are too high — even with the lens' smallest aperture. These are available in various strengths but the most useful is Singh-Ray's variable model (Vari-ND) which provides from two to eight stops of dial-in density.

## Color Modifiers

Color-enhancing and warming filters, once in widespread use for film photography, are not generally used by digital shooters who can correct and adjust color balance and saturation more precisely during computer postprocessing.

## Blue/Gold Polarizing Filters

Like other polarizing filters these alter light only from reflected surfaces. They are used on sunny days (not effective in overcast conditions) to reduce glare, bump up color saturation on land and water, and boost

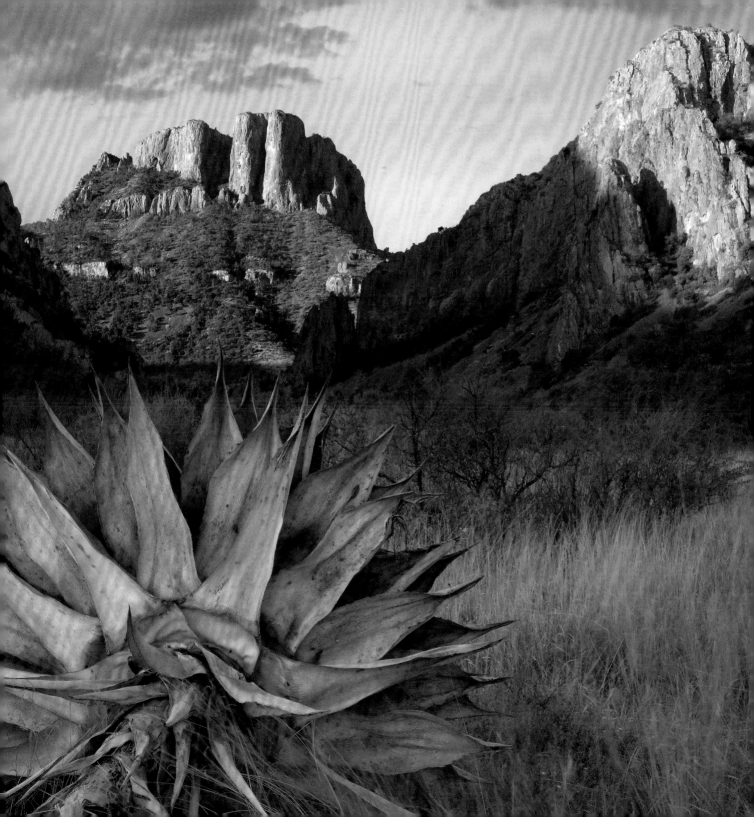

density and chroma of the blue sky. They can be adjusted between gold and blue extremes. Effects vary from tinting reflections a garish blue and washing a sky in saturated cyan to casting the scene in a soupy-looking mix of metallic gold and green to anywhere in between (most natural). This filter does a good job during midday periods when skies are hazy by increasing cloud/blue sky contrast and color saturation of terrain, if you adjust it carefully to avoid outlandish effects.

## PORTABLE REFLECTOR

I sometimes carry a portable reflector suspended from a strap on the back of my vest (see page 42). This reflector is a large (diameter 40 inches), circular, fold-up model manufactured by Photoflex. It is double-sided with a soft white surface (most useful)

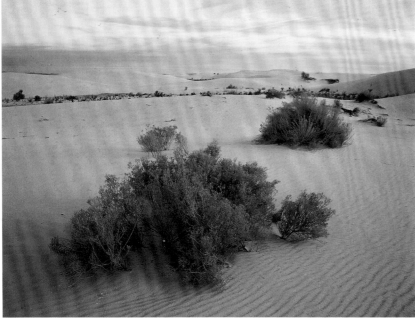

Two one-stop split neutral density filters
doubled-up and aligned with skyline and foreground

and a highly reflective silver surface. I use the reflector in two ways, most often for bouncing light into the shadows of close-up subjects (usually wildflowers) to enhance color saturation. I normally use the soft, white side and keep the reflector far enough away to avoid any artificial effects (i.e., disappearance of natural shadows or creation of shadows within shadows). Sometimes, I use this reflector for landscapes to throw more light onto foreground elements that are shaded or illuminated by harsh sidelight. In such situations, I use the silver side of the reflector for greater intensity as the target elements may be several yards or more away. When working in this way, I release the shutter with the camera's self-timer to keep two hands free for accurate angling of the floppy reflector as well as to prevent camera shake.

## FILL-IN FLASH

You can use fill-in flash for much the same purpose as a portable reflector — as a light source auxiliary to the natural illumination to help brighten shadow areas. Unless you are shooting digital, however, you can only guess at the results until you get the film developed. Cameras with onboard pop-up flash normally provide automated settings for fill-in flash allowing you to choose the intensity of the fill. Normally a setting between minus one and two stops works best. Regardless of the type of flash used, be it built-in, off-camera TTL automatic, off-camera automatic or off-camera manual, you need to adjust the camera for a normal exposure and then set the flash for an exposure that is one to two stops less. A simple way to do this, in the absence of an automated fill-in feature, is to set the flash ISO speed at double (one stop less) to quadruple (two stops less) the actual ISO speed in use.

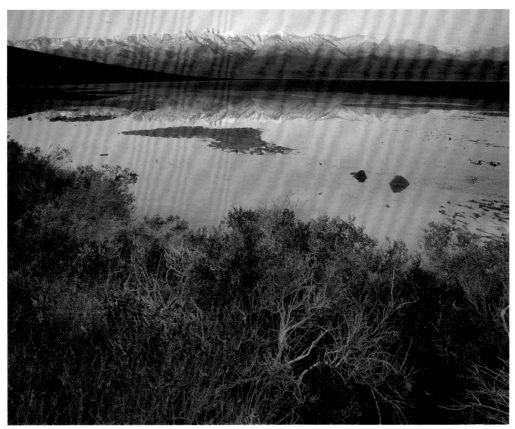

**Badwater, Death Valley National Park, California (above).** *Two one-stop split neutral density filters modify this high contrast scene. One filter was angled to darken the sky and water, the other the sky only.*

**White Sands National Monument, New Mexico (both far left).** *These shots were made using a blue/gold polarizing filter adjusted for different effects.*

# Designing the Picture Space

*How to manage image features to achieve clarity of expression*

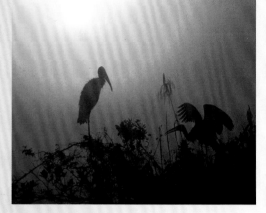

*Giraffes, Masai Mara National Reserve, Kenya (below). The brightest, most clearly defined feature in a composition is the most attractive. If such an element is not intended as the center of interest, it should be eliminated or subdued by changing camera angle, focus point, aperture size, etc. Here the sun is the strongest visual element; timing the exposure to link it to the passing giraffe silhouettes preserved the unity of this digitally composed image.*

**IT IS NECESSARY TO** master the principles of picture design, or composition, to effectively express yourself through photography. A knowledge of picture design lets you clearly communicate experiences in the natural world that you see and feel.

Composition is the way you arrange the elements of a picture, that jumble of lines, shapes and textures that appears in the viewfinder. By giving order to these elements you are able to relate a clear message. Composition is the key that unlocks the emotions of the viewer. It is a universal language that reveals the photographer's message to anyone who can see.

## DOMINANCE

Learning to use the language of composition is hardly more difficult than learning to make a correct exposure. All design is based on the premise that some elements are visually dominant, catching the eye more than others. The systematic use of this principle of dominance will help you decide how to manage the graphic features of a scene.

Many compositions are organized around a single, striking element (a visual center of interest). More complex compositions are based on a number of elements working together to create a theme or visual impression.

Establishing visual priorities for picture elements is based on an intuitive sense that renders these kinds of conclusions: red is

more attractive than yellow; large draws more attention than small; difference draws more attention than conformity; jagged lines are more striking than curved ones; diagonal lines are more attractive than vertical ones; sharpness is more attractive than blur; and, most significant for photographers, light is more attractive than dark. This list is a sample of the myriad elements that can be compared and objectively evaluated.

The view that confronts you at the edge of a lake is not as simple as the examples cited above. The complexity of visual elements more often requires you to compare a curved red line with a jagged yellow one; a gray diagonal, rough texture with one that is chartreuse, vertical and smooth. These visual comparatives seem difficult to evaluate when described in words, but our eyes intuitively make such assessments with speed and accuracy. This evaluation process starts unconsciously as soon as you look in the viewfinder and begin manipulating picture elements by asking your subject to smile or to move a little closer to the camera.

Newcomers to photographic composition evaluate the elements they see in the viewfinder based on the intellectual or emotional identity of these features rather than their graphic import. When photographing a moose, an inexperienced photographer understandably fails to notice a hotspot or telephone pole that mars the background. Such elements go unnoticed until the full sensory experience of the field is transferred to sensor, and they appear

*Pie-billed grebe with young (above). This composition has no single center of interest but uses the repetition of graphic features to express concept over over subject matter. Canon EOS 3, Canon 400mm f/2.8 L lens, 1.4X teleconverter, Fujichrome Provia 100F, 1/250 second at f/5.6.*

*Wood storks (far left, top). Precise timing and careful framing give a unified structure to this courtship mini-drama.*

*California poppy meadow (right and below). These compositions are primarily studies in pure color distinguished by the absence of a visual center of interest, focus priority, scale or setting. Color attains heightened brilliance through the pairing of complementary hues (orange/purple).*

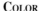

enlarged on the computer screen, with vision the sole frame of reference and plenty of time to analyze the scene. The moose is a still, brown shape hardly discernible from the surrounding vegetation, while the out-of-focus highlight is a brilliant pool that attracts immediate attention.

To avoid these oversights, photographers wisely train themselves to ignore the identity of elements in a scene and perceive only in graphic terms. The photographer sees his center of interest — the moose — as a furry, brown shape rather than the planet's largest deer. Before making the exposure, he adjusts the camera to eliminate the bright highlight, adjusts aperture to reduce depth of field and blur the surrounding vegetation, and waits to catch a highlight in the subject's eye.

## COLOR

Color evokes the greatest emotional reaction

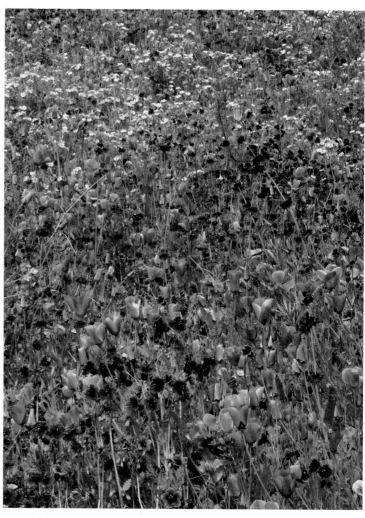

of any graphic element. Its presence significantly influences every design. More often than not, it is this aspect of a scene that induces a nature photographer to stop and set up the camera. Color not only projects a visual force all its own but it is also an integral part of other picture elements — shapes, lines, textures — that we find in a photograph. Our

reaction to color is spontaneous and instinctive. Color control is achieved primarily through a process of subject selection, framing and camera angle, particularly as it is applied to the relationship of differing hues.

Each portion of the color spectrum evokes a distinct emotional response. The most attractive, but not necessarily the most appealing color, is red. Being the color of blood and fire, it is simultaneously a signal of food and warmth, danger and death. It is rare for red to be used effectively in a photograph unless it represents or supports the center of interest. Red, yellow and orange, the warm colors, have more visual power than cool colors — the blues and greens. The appeal of a particular hue is specific to each viewer depending on his or her experience, mood and inherent tendency. We can be subjective in the use of color in our designs so long as it is premised on the universally distinctive qualities of warm and cool hues.

In assessing the relative strength of color you also need to consider its purity. A color is most powerful when it has not been diluted by either white or black. Color purity is inherent in the subject matter, but it can also be affected by the intensity and the angle of illumination. Colors

in shadow areas have more black and are less brilliant; in highlight areas they become washed out. Exposure and filtration can be used in selected parts of the scene to control color saturation and contrast.

The strength of a color is greatly determined by its relationship to other colors in the picture. Colors gain apparent strength when juxtaposed with an opposite or complementary hue (green with orange, red with blue, yellow with purple). Fiery autumn foliage appears more intense if set against a blue sky or when mixed with the green of conifers.

Intense, vibrant colors are more attractive than

*Desert bluebells and agave (below). This floral portrait's strength resides in its unusually restricted palette of cool muted hues played out through an ironic combination of soft focus and sharp elements.*

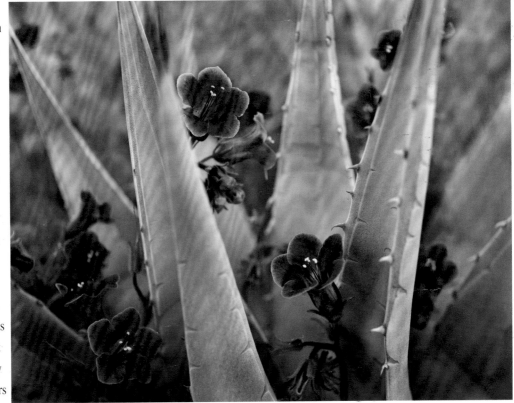

## *The Bonfires of Autumn*

**Steestachee Bald Overlook, Blue Ridge Parkway, North Carolina (below).** Mountain locations are always a good bet for exciting fall shooting. Even if your timing is off and you miss the main show, the changes in elevation cause a staggered display of fiery pigment with the earliest color generally appearing on high, north-facing slopes and subsequently moving down to the valleys and riversides.

*North America's deciduous forests present the planet's most spectacular show of seasonal color. These recommendations will help you record this luxury palette in clean, saturated hues with zippy contrast full of detail in highlights and shadows.*
*• Mind your histogram. Make sure all the data is centered and contained comfortably within the histogram (use split or graduated neutral density filters if necessary).*
*• Use a polarizing filter to eliminate reflections from wet or waxy surfaces of leaves. These shiny highlights mask the true pigmentation of the vegetation.*

*• During conditions of rapidly changing light (partially overcast sunrise/sunset periods) bracket your exposures and choose the image with the best histogram after the shooting session.*
*• Plan for the best light. The ideal time for capturing tight forest shots (lots of trees but no sky) is usually on a cloudy day during mid-morning. On sunny days you will achieve the richest color with front lighting in the early morning and late afternoon. However, be aware that when the sun nears the horizon, light has a warm color temperature that corrupts clean greens and blues and lights up reds and oranges with an unworldly neon brilliance.*
*• Shoot when the vegetation is wet with rain or dew. In combination with a polarizing filter, the soaked look mazimizes color saturation.*
*• Schedule your session to coincide with the peak of color. This is easy to do by consulting an appropriate Internet website. You can easily find these sites by doing a search using the name of the place followed by the words "fall color." If I am visiting a faraway location, my preference is to err on arriving late in the season rather than early. This approach increases the chance of encountering a photogenic dusting of snow or frost and there are also more leaves on the ground and in streams and pools, which make for interesting still-life shots. With fewer leaves in the canopy*

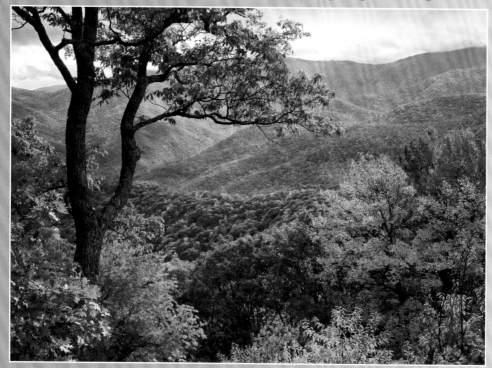

*you can show more than just a wall of vegetation; the openings allow the camera to peer into the forest itself for more varied design possibilities. If you must choose in advance among several destinations, keep in mind that elevation is as important as latitude in kindling autumn bonfires. Mountainous locations are generally your best bet as they offer autumn's spectrum in various stages of readiness, depending on what part of the mountain you're aiming for. Should you arrive too early for attractive color in the valleys and lower slopes, you're sure to find more advanced development higher up, and vice-versa.*

*• Look for compositions that team autumn's warm hues with their complementaries (opposites) — combinations such as green/rose (white pines/sugar maples), or blue/red (clear skies/hardwood forests). By bringing complementaries together, each color appears by contrast to be more intense. Due to the absence of color, black (silhouetted trunks and branches) and white (snow and frost) strengthen the apparent intensity of adjacent color elements.*

muted ones, but they are not necessarily more desirable. The color scheme of a photograph should support the main theme. A design that incorporates intense, contrasting colors is visually exciting, causing the eye to bounce back and forth between competing hues. A contrasting color scheme suits dynamic picture themes that express action, conflict, joy, anger or celebration; it is not usually suitable for portraying passive, introspective themes.

Harmonious color schemes are those composed of one or two similar hues, such as blue and turquoise or brown and maroon. They may be made up of contrasting colors like red and blue if an intermediate hue (purple) is included to create a smooth transition. A picture structured on color harmony produces a coherent visual effect. Color harmony suits images with peaceful themes and those incorporating horizontal lines and smooth shapes.

The effect of color on the image is pervasive. It helps to distinguish and identify the subject of a composition, it communicates mood and emotion, and in many pictures its sensory appeal is strong enough to

*Oak and aspen leaves (left). Autumn foliage gains intensity when wet. Wet weather portends soft light and saturated color.*

***Tombstone Range, Tombstone Territorial Park, Yukon (below).*** *In this composition, strong foreground elements (tree grove) bring the viewer into the picture space, leading the eye into the distance to the unusual and compelling arrangement of autumn color and pattern spilling down the distant mountainside.*

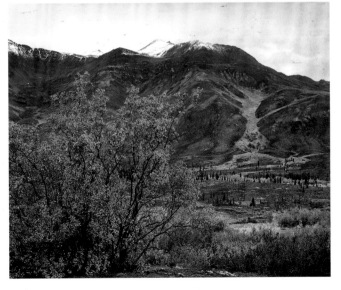

*Raccoon (right). Simplicity is often the key to effective design. Because of the soft background and strong leading lines, it was possible to place the center of interest (head and flower) low in the frame, away from the center.*

***Roche à Bosche and Roche Ronde, Jasper National Park, Alberta (below).*** *Obvious use of leading lines strengthens an otherwise undistinguished matrix of subdued color and poorly modeled terrain. Mamiya 645 AFD with Phase One P25 digital back, Mamiya Sekor 35mm f/3.5 lens, one-stop split neutral density filter, ISO 100, 1 second at f/32.*

act as the central theme. Color is an integral part of our perceptive process, our dreams, our memories and our personalities. It will work best in your photographs if you approach it intuitively, using it in a way that feels right to you. An openness to new color experiences will keep you in touch with your color instincts.

## THE CENTER OF INTEREST

Most photographs have a visual center of interest — one element that dominates the composition. In its most simple application, it is a picture of something — a

cheetah, a maple leaf, an otter, a canyon or lake. The center of interest orchestrates the design. It determines the nature and arrangement of all other picture elements.

In wildlife photography the composition process is primarily one of elimination. You frame and focus on the center of interest and then examine the rest of the scene for elements that may detract from it. This includes anything that is brighter or of a more interesting shape. These elements can be eliminated or subdued in a variety of ways, such as changing the camera angle or moving in closer to the subject. Less often you may incorporate new elements in the scene that reinforce or support the center of interest. In the case of a portrait of a speeding roadrunner, it might be a cactus (to show habitat) or a streaked background (to show movement).

## PLACING THE CENTER OF INTEREST

Where to locate the center of interest within the frame can only be determined in the context of the other design factors. The prime real estate of any picture is the center. This is where the eye is most

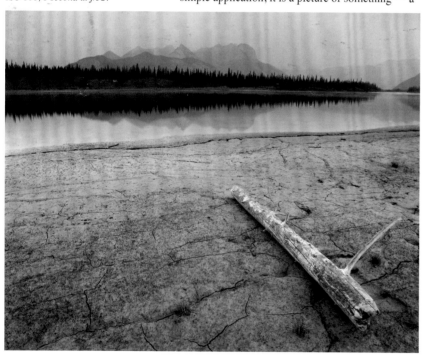

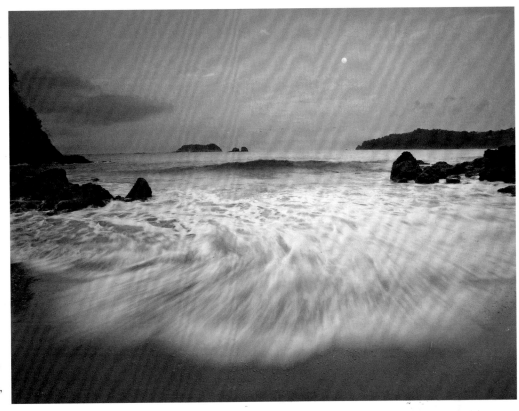

likely to begin its exploration of the image. If you place the center of interest in this position it creates a static design — an effect that is rarely desirable. The eye settles on the center of interest, scrutinizes it periodically and then scans the remainder of the frame for anything else of interest. As it has already found your most compelling element, it soon returns for another look, grows bored and asks you to turn the page or move along to another exhibit.

Suppose you leave the most valuable area of the frame empty and place the center of interest elsewhere. The eye enters in the middle, finds nothing of interest and begins to scan the frame. Sooner or later it finds the center of interest but on the way it has come across other attractive elements. When all is seen, the eye gravitates back to the center of the frame, but again it finds nothing and begins the search anew, perhaps this time taking a different path to the main subject. The dynamism of this process excites our visual sense and sustains interest in the composition.

The visual power of the main subject determines how far from the center it can be placed. If there are other equally powerful visual elements, then it can become dominant only by occupying the central area of the frame. A main subject that has strong visual properties can be placed almost anywhere and it will be discovered by the eye. However, if it is kept too near one edge and the remainder of the composition has little to sustain visual interest, the composition becomes unbalanced.

### RULE OF THIRDS

If you prioritize the features of a scene based on their visual dominance, you can be pretty sure of a strong composition if you follow the well-known rule of thirds (see right). This guide calls for the

*Moon over Playa Espadilla, Costa Rica (above). Color harmonies, blurred motion and the rule of thirds work to create this idyllic impression.*

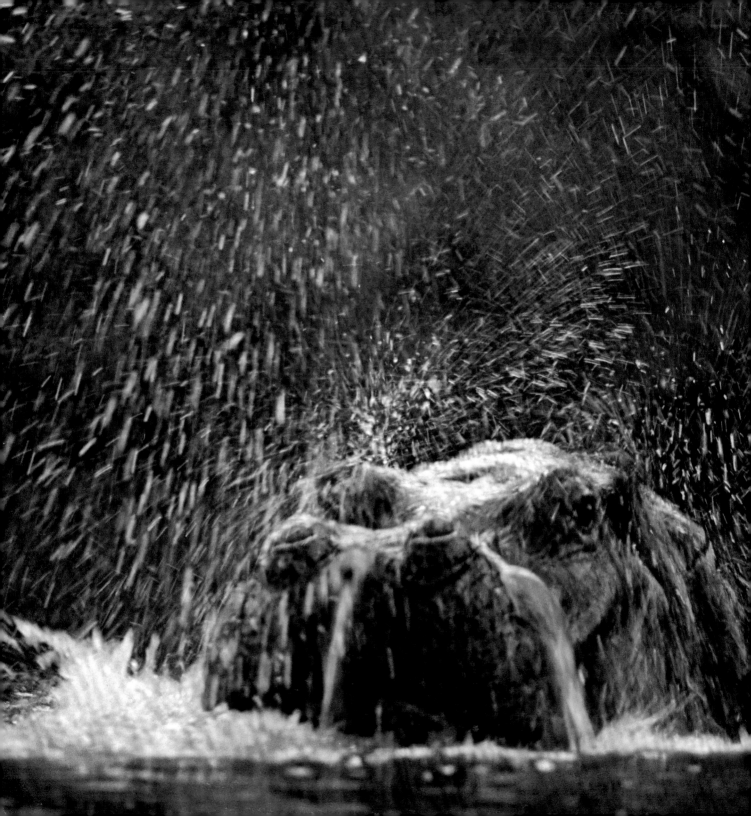

center of interest to be placed one-third of the way from the top or bottom of the frame and one-third of the way from either side.

## Thematic Centers of Interest

The organization of many images, particularly landscapes, is based on theme rather than a single dominant subject. Such pictures attempt to project an idea, relationship or concept through the collective impact of diverse picture elements. The success of a theme such as "peace" might be expressed by flowing shapes, pastel colors, horizontal lines, fair skies and calm pools. Some themes are purely visual, finding full expression as provocative patterns, expressive colors, stimulating textures or abstractions of line and form. Some compositions incorporate a visual center of interest as a component of a thematically organized design. This twofold method of shaping the viewer's examination and feelings can be especially compelling.

There are many ways of controlling, modifying, emphasizing and locating the features of a scene in the development of a composition.

• Select a subject that expresses your intent.
• Choose the precise season, time of day and moment of exposure.
• Set the camera-to-subject distance.
• Adjust for an appropriate angle on the subject.
• Use filters and reflectors to modify lighting.
• Select focal length to control magnification and perspective.

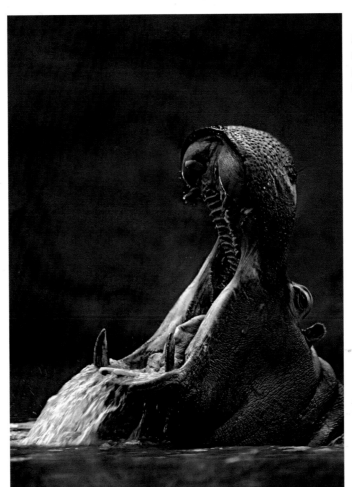

• Set depth of field by adjusting aperture.
• Control motion, sharpness and blur by setting shutter speed.

Learning how to put the principles of design to work in your photography will help you make the most of photo opportunities you encounter in the field and allow you to more clearly express your feelings about nature.

*Hippopotamus spraying water (far left). Shutter speed ($^1/_{30}$ second) was key to expressing the connection between Africa's "river horse" and its environment. The exposure time wasn't planned; it was the fastest speed I could generate given the weak twilight, maximum lens aperture and film speed. Nevertheless, the water wrote its story over the emulsion in compelling fashion.*

*Hippopotamus yawning (left). A little later in the morning at the same site as cited above, shutter speed ($^1/_{250}$ second) creates a different effect, strong but not nearly so dramatic. The timing and duration of the exposure recorded the hippo's threat display caught at its maximum point of intimidation.*

# Photographs as Impressions

*Easy departures from realism toward subjective imagery*

*Lesser flamingos, Lake Bogoria, Kenya (below). That this is a subjective study of pattern and color, rather than a literal representation of flamingo as subject, is signaled by unusual camera position (water level), telephoto compression of perspective and simple repetition of key graphic elements.*

**NORMALLY, PHOTOGRAPHERS** strive to make an accurate visual record of the natural world. But there is just as much truth to photographing in a way that expresses your feelings about nature as there is in operating your camera as if it were a photocopier of wilderness. One way presents a generally objective reality, the other a subjective one. Realism can provide as much insight into the sentiments and philosophy of a photographer as more subjective approaches, especially when a body of work, rather than a single image is considered. But a subjective approach speaks more immediately; it's a voice that offers commentary about the photographer's feeling on an image-by-image basis. We know this because each picture offers unmistakable graphic cues that signal a departure from objective visual convention.

This chapter describes some of the ways you can announce your intentions to express what you feel rather than what you see. These graphic techniques are the tools for making impressionistic imagery. Using them won't make you any more of an artist than you already are, although their novelty might provide enjoyable short-term diversion. If art is in one sense a search for truth, these techniques may provide stepping stones for your journey.

The techniques that follow are generally methods for bringing abstraction into your imagery. They are ways to reduce or eliminate the links between the visual reality of a scene and the graphic features of your

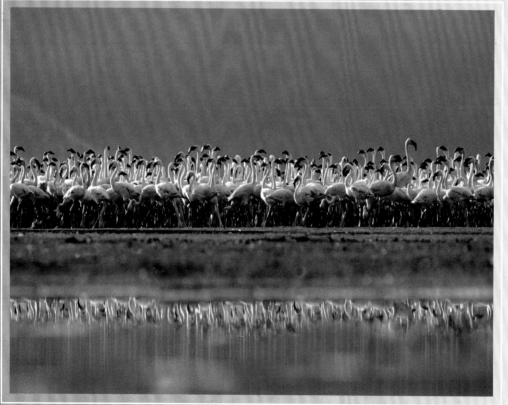

composition. Any technique that moves away from conventional procedures (normal exposure density, camera position at eye-level, sharp focus on the main subject, one-point perspective cues, etc.) is a move toward impressionism.

## COMPUTER-GENERATED EFFECTS

Impressionistic effects can be generated on the computer using image manipulation software like Adobe Photoshop. With a little experience you can duplicate (often with greater control) some of the in-camera techniques described below. However, you'll find that recording these effects in the field imparts an authenticity difficult to generate on the computer and provides an inspirational foundation for computer imagery you may later develop.

*Lesser flamingos, Lake Magadi, Kenya (above). A lack of sky and horizon, typical of aerial views, creates an immediate abstraction. Adding to the effect is the unusual hue of the dry lake bed and the formal pattern of flying birds and their offset, mirrored shadows.*

*Flamingos (below and far right). Quite different abstracted approaches are exemplified in these depictions of similar subjects. One keys its surreal effect to strategically placed, out-of-focus blur, an impression not accessible to normal vision. The other relies on highly selective framing to record a near mesmerizing expression of symmetry in projecting its other-worldly motif.*

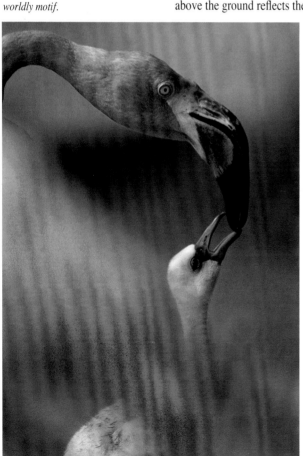

### Subdue Perspective Cues

You can exclude or mask cues from the composition which signal three-dimensional space, such as the horizon, clouds, overlapping topographic planes, size-cue comparisons, etc.

### Alter the Angle

Any view that shows the scene from an angle different from our normal vantage point 5 or 6 feet above the ground reflects the photographer's subjective bias. The most abstract angle is usually from directly above, but any framing that establishes a vantage point unlikely to be visited by the viewer in normal circumstances works.

### Zero In

Frame the details of a subject rather than including features that signal its identity. Shoot the textures evident in the bark of a tree rather than showing the contours of the trunk or even the entire tree. In this way the viewer sees the photograph as an expression of sensation rather than a presentation of fact.

### Selective Focus

This simple technique uses sharp focus and shallow depth of field (set the lens aperture at or near its maximum size) to cast a focus spotlight on restricted areas of a scene. This constitutes a personal announcement of what the photographer thinks is important. It also creates a visual impression not available to human vision (we can only sense blur by *not* looking at the target subject).

### Isolate a Pattern

An integral component of many natural phenomena, patterns comprise one of the most alluring features of the environment — the cadence of a galloping pony, the petals of a sunflower, the momentum of ocean surf, the trumpeting of an elephant. A pattern is generated by a rhythmic repetition of accent and interval, varying from a single uniform accent repeated at regular intervals (sand grains on a beach) to those more complex such as repetitions of accelerating sequences (flight of a jackrabbit). Visual rhythms occur everywhere in infinite variety and they are readily incorporated into realistic imagery. Impressionistic effects result when the pattern is isolated and refined to the extent that subject identity is either lost or assumes only secondary importance. When setting camera angle and magnification, try to capture the most distinct rhythms in the pattern by

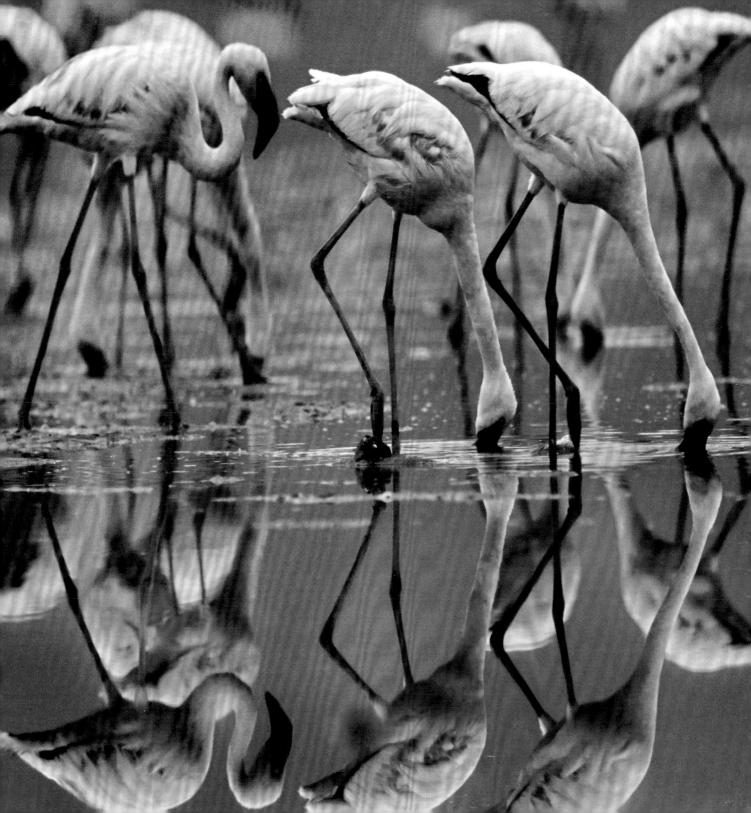

***Panorama Software Sources***
• *Both Photoshop CS and Photoshop Elements have panorama stitching programs.*
• *Panorama Maker is simple and reliable. Trial download at www.arcsoft.com/en/products/panoramamaker/.*
• *For more information on the panorama world go to www.panoguide.com.*

selective focusing and framing. Zoom lenses work well in capturing such effects.

### SET THE CAMERA IN MOTION

As realistic imagery is normally rooted in showing detail, you can create subjective effects by recording the scene indistinctly. One way to do this is to move the camera during exposure by swinging the camera on a tripod, handheld movements or zooming during exposure. You can't easily tell what the results will be so it's advisable to vary movements over several attempts. See pages 90–91 for more.

### WIDE VIEWS

Digital cameras make it easy to create wide views of the natural world that exceed what we perceive only indistinctly with our peripheral vision. Several in-line captures of a scene can be joined using

panorama software to create intriguingly expansive and highly detailed views of the landscape.

## CREATE A PHOTO MONTAGE

Sandwiching images together is a classic photographic procedure of combining two or more images (accomplished through slide sandwiching or making multiple darkroom exposures). The components are unconnected in time, place, size and perspective.

The montages are structured on the interactive properties of color, texture, theme and concept. If you edit images on the computer, you can quickly learn to combine images in an infinite variety of ways.

Nature photography is as much about how you feel as it is about what you see. Savor the sensations and thoughts that are stimulated by a walk in the woods. Allow your instincts to bring these feelings to the attention of your photographic self.

*Eastern Sierra Nevada from Alabama Hills, California (above).* Constructing ultra-wide images from computer assembly of several digital captures creates a single image that is, in its panoramic embrace, unavailable to normal human vision.

*Part Three*

# Adventures with Wildlife

# Getting Close

*Techniques to draw within camera range of wild subjects*

**I'M SITTING COMFORTABLY** on a ledge far up the mountainside in Oh-be-joyful Pass in the Raggeds Wilderness of central Colorado. In front of me is one of Canon's 500mm IS lenses supplemented by a 1.4X converter. My vest pockets are bulging with Fujichrome Provia 100F. The dramatic peaks, the morning sun and the rustle of aspen leaves confirm my sense of well-being. I feel certain I'm going to get some good photos. I've done my homework.

Flashes of fur appear between the loose, clattery rocks of the slope and descend toward the stream. The dab of fur hippity-hops across the water and disappears into a clump of paintbrushes, daisies and other flowers. The arrangement trembles and a fireweed blossom topples and disappears. The fur ball comes back into view (fireweed attached), hippity-hops across the stream and addresses the slope. In a few minutes the animal materializes (as I thought it would) about 5 yards away. It's a pika, a high-mountain relative of the rabbit about the shape and size of a furry softball. While I quietly study the pika through the viewfinder, its mouth opens to sound a nasal bleat that echoes through the jumble of boulders. My motordrive chatters and a handful of frames streaks from the cassette. Over the next hour, I take pika portraits, pika vocalizing and pika

**Pika (above).** *By researching information about the behavior of this species, I discovered several facts about its behavior and habitat that were essential to making this photograph. Canon EOS 3, Canon lens 500mm f/4 IS, 25mm extension tube, Fujichrome Provia 100F, 1/500 second at f/5.6.*

**Northern jacana (left).** *This intimate view was recorded from a distance of about 15 feet. Although made uneasy by my closeness, the bird continued to forage normally due to the concealment of my presence in a floating blind. The aim of most wildlife photography is to capture typical behavior that reveals the natural history of the subject. Canon EOS 5D, Canon 500mm f/4 IS lens, ISO 400, 1/1000 second at f/5.6.*

munching on vegetation. Getting close enough to record a pika in high detail is easy if you know where and how to look. As with most wildlife species, there are no magic formulas, just common sense procedures and techniques that can be easily mastered by anyone who regularly sets foot afield.

## WILDLIFE RULES

As a rule, you can photograph at close range only at the subject's forbearance. Except for the photography of birds from blinds, the senses of wild animals are too keen for you to shoot undetected for more than a few seconds. Generally you must seek out animals that don't mind being near you. These critters fall into two groups. The first includes those that

have no instinctive fear of humans, either because we don't find them appetizing (marmots, pikas, raccoons, chickadees, hummingbirds) and leave them alone, or because they evolved in environments where there were few humans to deal with (small sea islands, polar regions). In the other category are animals that have learned that in certain settings (wildlife parks and nature preserves) humans are mostly harmless.

Not only do you need to get close to the subject, but you also need to remain there for more than a few seconds. Being around an animal for hours or even days (not necessarily continuous) you will come up with exceptional images. Regardless of the circumstances, most wildlife retain some apprehension of human presence that must be overcome before you can rack up a series of trophy photos.

## DO YOUR HOMEWORK

We need to study the natural history of the animals we wish to photograph. For a quick reference on individual species, search the Internet using the name of the animal. Academic diligence will help you recognize your subjects, locate their favorite hangouts, and interpret and predict their behavior. From such references I learned that the pika inhabits only mountainsides covered with loose rocks (talus slopes), that its presence is nearly certain if there are caches of hay

*Leopard (below). In national parks, many subjects are not alarmed by the approach of a vehicle. With the photographer inside the car, the subject is able to remain calm and carry on its normal activities. It's difficult to predict when the best opportunities will arise but one thing is sure — patience and persistence pay off and result in better pictures. This photo was taken from a Suzuki jeep with the camera on a tripod set up over the passenger seat. Canon EOS 3, Canon lens 500mm f/4 IS, 1.4X teleconverter, Fujichrome Provia 100F, $^1/_{250}$ second at f/5.6.*

(gathered by the pika for winter food) scattered over the slope, and that you'll hear its calls long before you spot the creature itself. Armed with such facts, you will know where, when and how to set up a camera.

## INDIVIDUALISTIC ANIMALS

I once attempted to photograph marsh hawks at the nest. In succession I found three nests on the ground hidden in stands of bulrush, set up a blind, and retreated to observe the hawks' reactions through binoculars. With the first two nests, the hawks dived repeatedly at the camouflaged structure, forcing me to abandon the attempt. At the third nest, the hawk appeared, vole dangling from its talons, and dropped onto the nest without a glance at the blind. As soon as the bird left I got into the blind and was ready to photograph when it returned. The lesson is that animals are individuals. If one seems to have a distrust of photographers, you are better off finding a subject that is more accepting.

## KEEP YOUR DISTANCE

Telephoto lenses work wonders in keeping animals

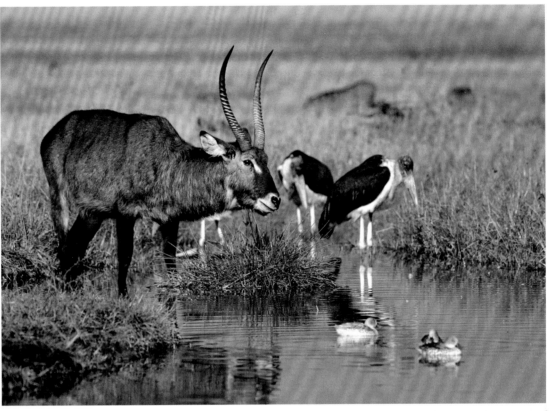

relaxed by letting you shoot at a nonthreatening distance. For serious work, a 500mm lens provides ample power while being easy to carry and set up in the field. Add 2X and 1.4X teleconverters to provide extra reach and framing options. Image stabilizer-type lenses yield sharpness unmatched by standard lenses (including tripod work) when you need to frame and shoot the scene quickly with hands on the camera.

## STALKING STRATEGIES

When approaching an animal, stay low and move

*Water buck and marabou storks (above).* *Shooting from inside a vehicle allowed me to approach this normally wary African menagerie and make an unhurried series of images as the animals moved about the water hole.*

*Elegant terns (above).* *I approached these terns by crawling across packed sand while pushing the camera ahead of me. The terns observed my efforts with detachment, taking flight only when spooked by a dog.*

slowly and quietly while the subject is not looking at you. This is best done by knee-walking while shoving the lowered tripod ahead. Should you attract attention, remain still but relaxed rather than motionless until the subject resumes its normal activity. Every few steps, rest and sit back on your calves. With this technique you can move at a slow, steady rate, appear small and harmless, and are ready to shoot at any time. Plan your advance over easy, noiseless terrain. Anticipate the lighting conditions at the shooting site and modify your approach vector accordingly. Normally you will want to arrive at the shooting position with the sun at your back. If you are working with dangerous animals (elk, bison, bear), you must always have quick access to an escape route.

## Avoid Intimidation

The most successful stalks usually occur when the animal is aware of your presence but isn't particularly worried about it. You can put the subject at ease by taking a circuitous route to the target area (as if you are a grazing herbivore) so that the animal thinks you are preoccupied. Once the subject is aware of your presence, act relaxed but avoid making loud or abrupt sounds or sudden movements — slowly fiddle with your gear or swivel your head to look at something in another direction.

## Don't Fence Them In

When stalking, avoid a course that will block the

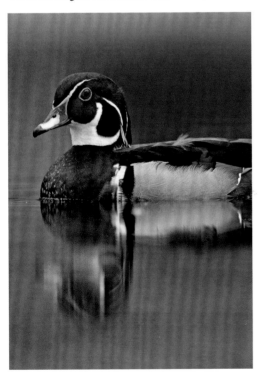

animal's escape route as this will make it nervous and precipitate flight. For example, pelicans, cranes and other large birds prefer to take off into the wind — it gives them more lift. Move in on these creatures with the wind in your face so that they retain this escape advantage. Bighorn sheep flee predators by bounding uphill, so leave them this option by approaching from downslope. In short, anticipate the movement of the subject. If you know a bison herd is heading for a water hole, set a leisurely pace to meet them there.

## Vehicles Make Good Blinds

A structure that hides your presence from the subject can sometimes allow you to shoot at a range far closer than is possible when working in the open. Blinds are especially effective when photographing birds. I once photographed prairie falcons at the nest from a distance of one yard using a makeshift blind

*Great kiskadee (above). This subject hung around the lodge where I was staying to munch on bananas from the birdfeeder. Taking up a position near a subject's food source is a reliable way to shoot at frame-filling range. Canon EOS 5D, Canon 500mm f/4 IS lens, ISO 400, 1/350 second at f/5.6.*

*Wood duck (left). Found in a park where pedestrian traffic was common, this handsome drake was photographed at close range with a 500mm lens. Most wild animals quickly become accustomed to people if they are not hunted.*

set up in a small grotto on the cliff beside them. Birds have landed on top of my blind (while I was in it) on many occasions. I prefer to use a cheap homemade blind, rather than an expensive commercial model, that can be left in position (a necessity with most subjects) over the course of several days or weeks without worrying unduly about someone walking off with it.

You've seen the bumper stickers . . . *My other car is a bird blind*. Well, it's true. One of the most effective blinds of all is sitting in your driveway. Mammals and birds have less fear of a car than of a human on foot. The roadways of national wildlife refuges, national parks and other wild areas are great for cruising and shooting out the window. I set up a tripod over the front passenger seat and anchor it with bungee cords. This way I can stay behind the wheel to position the vehicle just where I want it. Car window mounts can also be utilized although you may find them a little flimsy for heavier optics such as a 500mm lens with teleconverter, the best focal length for this kind of shooting. Also, when these brackets are attached, you can't roll up the window or work the camera controls unobtrusively. Sometimes I hang a piece of camouflage netting over the passenger-side window to hide my movements. You need to shut off the engine when you are shooting to avoid camera vibration, and have the camera controls set and ready to fire the instant you are in position as your subject will not stay around for long once you stop the engine.

## OTHER BLINDS

Blinds that you set up on the ground or in trees can be of practically any configuration or color. Usually they are made of camouflaged fabric stretched over a rigid frame of wood, tent poles, tree limbs, etc. The blind should be large enough to conceal photographer and equipment including a set-up tripod. Here are a few tips for building your own blinds.

• Use inexpensive materials so the blind can be left unattended without worry about theft.

• Make the blind portable so that you can carry it along with your camera equipment. Use lightweight materials — ripstop nylon and stiff, plastic

plumbing tubing are easy to assemble.

• Be ready to make new openings in the blind to suit each shooting situation. Overhanging limbs, rocks, uneven terrain and other features of the natural setting often force modifications to the standard setup.

• Match the color and pattern of the fabric (camouflage material is best) to the terrain. An inconspicuous blind is less likely to be disturbed or investigated by humans whose presence will frighten your subject and attract predators.

Stationary blinds work best for photographing birds at the nest. They are not very effective for mammals because they can't hide the photographer's scent or sound or be adjusted to suit the often unpredictable movements of the subject. Some animals may be more spooked by a blind (which

*Northern shoveller (left).* Recorded with 700mm of telephoto power, this duck, photographed in an area where hunting is common, was wary of my silent approach in a floating blind. You will have better luck shooting in locales where hunting is prohibited.

*Snowshoe hare (far left).* This bunny was photographed from inside my tent, which worked like a blind. The subject was lured into position by dabbing peanut butter onto the fireweeds.

*Vehicle as blind (below left).* Many animals are tolerant of vehicles. Camouflage mesh fabric is used to screen the photographer's movements.

*Bag blind (below).* This blind can be stuffed into your camera bag. It works in settings where animals encounter humans rarely and better with birds than mammals, as they rely more on smell than sight to avoid danger. It is not effective in hiding your movements.

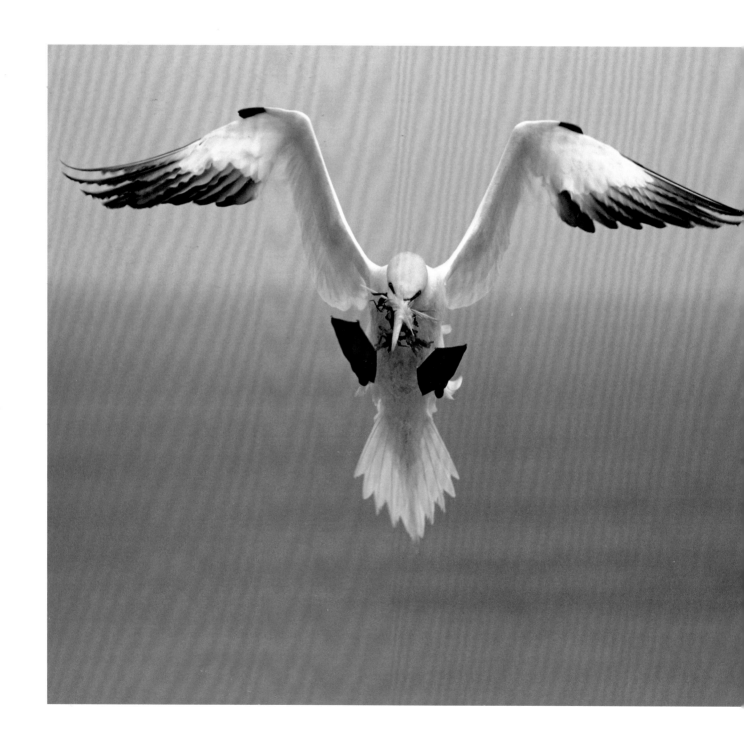

they have never seen) than a human (which they have encountered often). I have mostly given up photographing birds at the nest because of the danger to the subject. Sometimes just the appearance of a blind causes the bird to desert the nest. More commonly, the scent, sound and view of your activity draws predators (jays, crows, skunks, raccoons, magpies, snakes, chipmunks) to the site for an easy meal of eggs or nestlings. I work usually from mobile blinds (either a vehicle or a self-propelled floating contraption) at sites where wildlife congregates (usually feeding or loafing areas) remote from sensitive nesting or denning locations and locales where other people congregate.

Some photographers carry pocket blinds or bag blinds (see page 123) when on wildlife shooting excursions. Made with camouflaged fabric or netting and patterned after a poncho, this blind simply drapes over you and your tripod without any supporting members. It is effective for birds at close range and mammals at greater range where the sound of the motor drive or your scent is not so strong. The only drawback is that your hand and arm movements are not completely hidden because the blind is supported in part by your body.

## PEANUT BUTTER INCENTIVES

You needn't always go to the mountain — sometimes it will come to you. I like to use peanut butter to draw subjects toward the camera. This creamy concoction is attractive to birds and mammals of all kinds, from gray jays to bighorn sheep. Often they are not interested in actual consumption but just in taking a good whiff. You can smear peanut butter unobtrusively on a flower, a tree or right on the ground to coax the animal into a photogenic setting. It's not for every situation, but keeping a film canister of Skippy in your vest adds one more trick to your bag. Keep in mind that using bait of any kind in national parks is *not* allowed and that in bear country it's not very prudent to walk around smelling like a peanut-butter sandwich!

## PATIENCE AND PERSISTENCE

Making close-up photos of wild animals requires patience and persistence. The planning and preparation phases usually require more time and effort than actual shooting. Learn to enjoy this part of the process — it is just as critical as pressing the shutter and it will keep frustration to a minimum.

*Eastern bluebirds (above). This stick was set up near the nesting site in front of the blind to provide a handy perch lacking in the natural setting. The birds took to it immediately.*

*Northern gannet (far left). Like many seabirds, nesting gannets are unafraid of humans. This specimen was shot at a wildlife sanctuary with a 200mm lens.*

# Animals in Action

*Creating a stage and other techniques for recording animals in action*

*Lesser flamingos (below). Wildlife activity recorded as a blur reflects the impression of the moment as accurately as a stop-action approach, both revealing more than can be perceived by the naked eye. This flock was shot with a panning 500mm lens at 1/30 second.*

**I'M LYING ON A SLAB** of styrofoam sandwiched between two sheets of plywood. My camera is mounted on a ball head screwed to the plywood. Camouflage netting is draped over the whole affair (me included), which is floating in the marshy shallows of Lake Bogoria in Kenya. I'm completely surrounded by flamingos, tens of thousands of them parading steadily past my camera in a pink and crimson stream at a distance of 10 to 15 yards.

I try to capture the swirl of exotic color, panning along with the slow-moving birds, releasing the shutter gently, trying to stay on track as the mirror flips up and the viewfinder blackens for a long 1/15 second, enough to blur and swirl the shapes and colors in the viewfinder. The mirror comes down, the scene reappears and after tweaking focus, I go into the next shot. After the shutter releases, I check exposure and adjust framing; then a few more pictures.

I boost shutter speed to 1/30 second and chatter through another dozen frames without pause. So it goes for the next 10 minutes until something frightens the flamingos and they move to another section of the lake. I wasn't sure what I had recorded, but I had recorded enough images to be certain of some great photos.

Birds and mammals provide photographers with exciting action-shot opportunities. They can be recorded vocalizing, yawn-

ing, ruffling feathers, scratching, stretching, taking wing, running, walking, fighting, performing courtship displays, bathing, fishing and hunting.

## KNOW YOUR HABITATS

But where do you find opportunities for such imagery? The best place to start is at a nearby national park, bird sanctuary or wildlife refuge. There are hundreds of these throughout North America. (To find out about U.S. federal wildlife sanctuaries, consult *Guide to the National Wildlife Refuges* by Laura and William Riley.) In such places, animals are accustomed to photographers, so approaching to

within telephoto range is not a problem provided you move slowly and deliberately. Many refuges have driving tours that pass through rich habitats where photography can be done from your vehicle. Becoming familiar with the type of terrain that birds are drawn to within the refuge will make it easy for you to find similar habitats elsewhere ideally with less restrictions and better access. Although such rural areas are being steadily lost to development, they may provide equally productive shooting.

Wildlife activity is seasonally dependent. Spring is the best time to photograph reproductive behavior such as courtship and care of young; fall provides opportunities to shoot masses of birds and mammals on the move and rutting moose and deer; winter in the south is a period of rest and relaxation and provides opportunities to record feeding and socialization, especially of migratory birds. During midsummer, wildlife activity is low for most species except for rutting bison and the fauna of alpine habitats, arctic regions and offshore seabird nesting islands, where it is at its highest.

*Speeding bighorn sheep (above). These rutting bighorns were kept on the move by passing hikers. I timed the shot to catch the sheep passing a dark stand of spruces which formed a contrasting backdrop for the rams. It's pleasing to leave a cushion of space in front of moving subjects to absorb its visual momentum. Canon T90, Canon lens 500mm f/4/5 L, Fujichrome 50, 1/15 second at f/11.*

*White pelicans and laughing gulls (below). Shooting birds first thing in the morning usually provides the best results, but there are exceptions. In coastal habitats, the most productive photography occurs at low tide regardless of the time of day. With very dark or light subjects, like these snowy pelicans, overcast light around midday does the best job of reining in contrast and providing plenty of light for brief exposures. For this photo I fashioned a quick stage on the pelicans, leaving the top of the frame empty to hold the passing gulls.*

### BE ON SITE BEFORE THE SUN RISES

The typical wildlife routine is different from our own. Appreciating this fact is crucial to successful photography. A marsh or woodland that is teeming with bird life at sunrise will seem quiet by 9:00 am and desolate by noon. With the approach of sunset, animal activity resumes. You will experience the best action-shooting opportunities during the first and last hour of the day when, coincidentally, the light is at its best.

You may be waiting for a September sunrise at Moraine Park in the Rockies to photograph bull elk in rut, or perhaps the setting is McNeil River Falls in Alaska in August when the river is crowded with fishing brown bears. Whatever the scenario, you've done your research, made your preparations, arrived on site in a timely manner, and now you're ready to set up your equipment and get to work.

### LOWER THAT TRIPOD

A tripod is necessary to steady the camera and support the heavy lenses required to keep a long enough distance from your subjects to avoid disturbing their normal activity patterns. I like to sit or kneel on the ground with the camera positioned at eye level. This provides an intimate, eye-to-eye view of the majority of wildlife subjects. The low angle throws the background into soft focus, making the subjects of stop-action photos jump out of the frame dramatically. In this position, your reduced size is

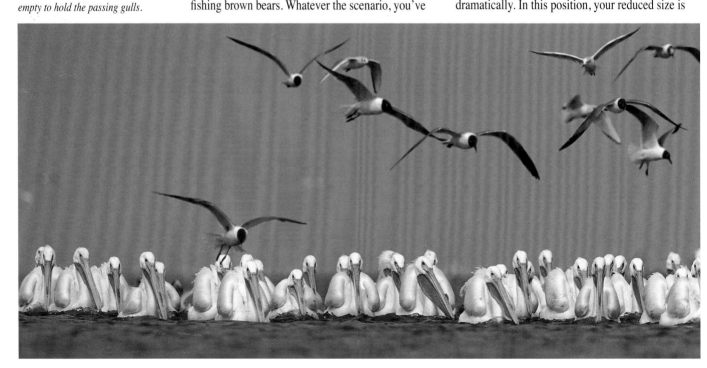

less intimidating to animals and less noticeable to curious passersby who might frighten your subjects. When low to the ground, you can move about inconspicuously, shifting the tripod position a foot or two at a time to improve composition. A low tripod is also less susceptible to wind disturbance, resulting in sharper pictures. Perhaps most important, the kneeling posture is comfortable for long periods, affording you the patience to wait for dramatic action.

To avoid camera shake and maximize sharpness for a stationary subject, tighten all tripod controls once framing is established and trip the shutter with a cable release; for a moving subject, loosen the controls so that you can pan the camera smoothly to follow the action.

The most useful lenses are in the 500–600mm range, enough power to yield a frame-filling photo of a flying eagle or heron at 100 feet. A 300mm lens matched with a 1.4X or 2X teleconverter also provides satisfactory magnification and is best used with sensor ISO speeds set to the 400+ range.

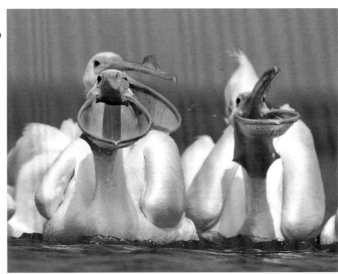

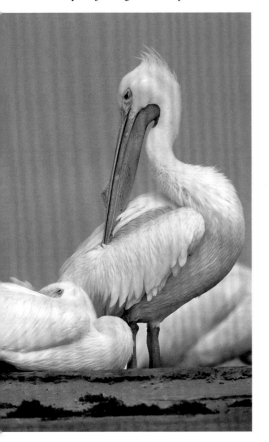

### SHOOT FIRST, EDIT LATER

Once the subject initiates an activity that you wish to record and you are sharply focused and satisfactorily framed, shoot without delay at a rapid rate. For action sequences so quick that you cannot follow details readily with the naked eye (flying crane, bounding giraffe, fishing pelican, courting egret) you will only capture one out of 20 or so frames that is of publishable quality. If this seems like a poor ratio, keep in mind that things go wrong: heads are obscured, an eye is closed, limbs are foreshortened, wingtips leave the frame, a hot spot looms in the

*White pelicans fishing (above).*
*I used the trap focus method to shoot this close-up. Waiting in a floating blind, I set focus a few feet in front of the birds and followed their approach in the viewfinder, releasing the shutter when they appeared sharp. I repeated the process several times firing five or six frames in each sequence. Despite the number of pictures taken, none were without flaw.*

*White pelicans preening (left).*
*This composition frames the scene so both the preening and sleeping birds are positioned to divide the picture space into pleasing one-third–two-third proportions on both the vertical and horizontal axes.*

*Snowy owl (right).*
*Unable to fly, this owl*
*was photographed at*
*a rehabilitation center*
*for injured raptors.*
*Perched on a wobbly*
*log, the bird raised its*
*wings periodically to*
*regain its balance. I*
*photographed during*
*these moments in high-*
*speed, motor driven*
*bursts of five or six*
*frames using manual*
*focus and manual expo-*
*sure settings.*

*Masai giraffes (far*
*right). For a few min-*
*utes I observed this*
*high-energy youngster*
*sprinting about the*
*veldt, returning once in a while to*
*stand at its mother's feet. Using*
*this behavior cue, I formulated a*
*simple stage by framing the mother*
*tightly, setting focus and exposure,*
*and waiting. A few moments later,*
*the calf appeared to complete the*
*composition.*

background, critical features are blurred, exposure is off. When the action starts, I shoot at maximum capture rate, usually in five- or six-frame bursts, allowing myself a brief peek every few bursts to check the histogram, making exposure compensation adjustments when needed.

### Sharpen Your Focusing Technique

In many situations it's impractical or impossible to set lens focus in advance, making it necessary to focus on subjects moving unpredictably.

You can use auto-focus for a general fix on the target and then, time permitting, do a manual tune-up so that the subject's eye is razor sharp. On most automatic systems, quickest focusing is achieved when only the central sensor is activated. For close-up magnifications that show detail in the eyes, you will normally have to do a manual fine-tune in

order to bring this feature into sharp focus. Newer AF lenses have instant-touch, manual override designed for this very purpose. This is almost always faster than selecting a sensor that falls over the eye. Sometimes it is fastest to lock in sharp-eye focus by partially depressing the trigger and then reframing for the best composition. Behavior such as nursing, singing, stretching, squabbling, yawning, mating or preening can be recorded easily with manual focusing techniques provided you have the animal framed and in focus before the action begins. Sharp focus comes from being prepared and waiting for the right moment to make the exposure.

### Shooting Tips for Birds in Flight

• Keep the camera on a tripod. Keep your hands on the camera with the tripod controls loosened.
• The smaller the bird, the faster the shutter speed needed to stop its motion.
• Pan along with the bird, squeeze off the shots gently and follow through.
• Don't restrict yourself to stop-action pictures. Experiment by slowing the shutter speed to produce blurring effects.
• The flight path is most easily framed just after take-off. Set camera controls, frame the standing subject, and be ready for the action.
• Study the flight patterns of individual species as well as travel routes to and from nesting sites, roosting areas or other gathering places.
• Station yourself at right angles to the flight path to gain more focusing time.
• Be aware that birds (especially large species) prefer to take off into the wind.
• Use a high-speed motor drive and (in open terrain) predictive auto-focus with only the central focusing sensor activated. Try to keep the sensor on the flying bird's shoulder.

Focusing is more difficult when you try to capture a crane on the wing or an antelope in full stride. If the subject is moving across the field of view so its distance from the camera is constant, both manual and auto-focus are readily achieved because there is more time to lock onto the subject. If the bird is moving obliquely or directly toward the camera, trap-focusing may work where auto-focusing doesn't. With this technique, you prefocus at a magnification that results in comfortable framing of the subject (not too tight for a flying bird or bounding deer). Then watch through the viewfinder as the subject approaches your zone of focus. Trip the shutter just before it arrives to allow for the $^1/_8$- to $^1/_4$-second delay between when you press the release and when the shutter curtains actually open. For auto-focusing, set the camera in predictive focusing mode and

keep the active-focusing sensor(s) on the target. Both methods have greater success if you cross your fingers, set the motor drive at its fastest speed, stop the lens down (lighting conditions permitting) so that increased depth of field compensates for focusing error, and shoot extra frames — mistakes are unavoidable.

## Build a Stage to Capture Action

Recording dramatic action shots is among nature photography's greatest challenges and biggest rewards. Three main tasks confront you. First, you must focus accurately on the subject — not easily done on a moving target either manually or automatically. Second, the subject must be comfortably framed and portrayed clearly (no hidden limbs or

*Green violet-ear hummingbird (above). A brief shutter speed of $^1/_{500}$ second creates a partially blurred rendering of this high-energy nectar sipper. The flowers are near a hummingbird feeder visited by the bird. Canon EOS 5D, Canon 500mm f/4 IS lens, 25mm extension tube ISO 800, $^1/_{500}$ second at f/5.6.*

*Sandhill crane (left). As the sun rose one crane after another flew over my hidden position chosen for frontal illumination near a habitual early morning flight path. Despite the large, relatively slow-moving subjects and predictive auto-focus only a small percentage of frames were satisfactorily framed and sharply focused.*

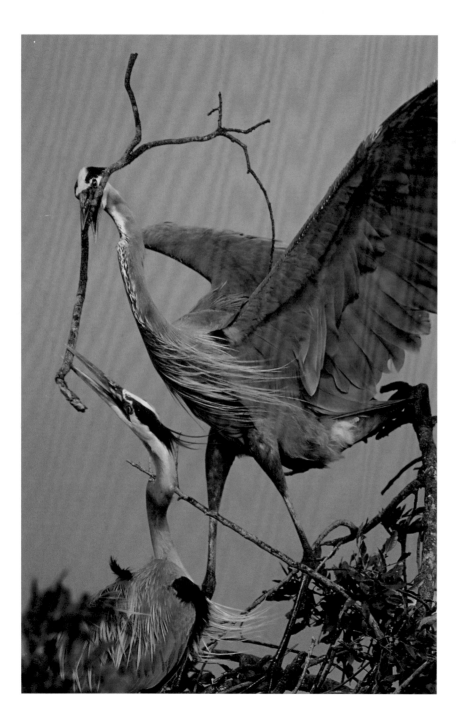

closed eyes). Third, the setting (background primarily) must be simple and in supportive harmony with the main subject. If you make enough captures you'll come up with images that satisfy these criteria. You can improve your rate of keepers by using staging techniques.

Staging is a process of creating picture environments (stages) that either directly or indirectly control and/or anticipate the animal's behavior in preparation for photography. The staging process normally breaks down into two parts — setting the parameters of the composition in advance of the subject's appearance and devising ways of controlling or modifying the subject's activity that do not compromise its normal behavior. The most successful stages are usually those that already exist in nature and are incorporated into the photographic process by pre-establishing subject magnification, camera angle, lighting angle and focus distance.

Consider this example. To photograph a large bird in flight, you can create a stage by choosing a particular lens focal length and a focus distance. This fixes a frame of a specific size (magnification) to hold the subject. The bird is tracked in the viewfinder and the picture taken when the subject moves into the focus zone. The stage can be further defined by choice of camera position — perhaps one that will record the subject against the blue sky or an autumn forest. You can further refine the stage by restricting shooting to periods when the subject is ideally illuminated (front, side, etc.).

Consider a more contrived example. To photograph a ground squirrel amid colorful subalpine blossoms you need to first find a suitable locale (colonial burrows) and then decide on lens focal length and working distance (use an object the same size as the ground squirrel as a stand-in to help you establish magnification — in this case a baseball cap would be about right). Next, experiment with various camera positions to establish how the wildflowers will frame the subject and fill up the background and foreground.

Finally, you can indirectly control the subject's movement within the set by using bait such as sunflower seeds or peanut butter strategically placed. Lastly you may set up a reflector to improve the lighting within the set. When all is ready, sit back and wait impatiently for the action.

## STUDY BEHAVIOR

Most animal activity occurs in repeated patterns. By becoming familiar with wildlife habits, your chances of capturing interesting activity greatly increase. A white pelican, for instance, raises its wings slightly a few seconds before takeoff; an American oystercatcher screams and fans its tail when other out-of-territory oystercatchers venture

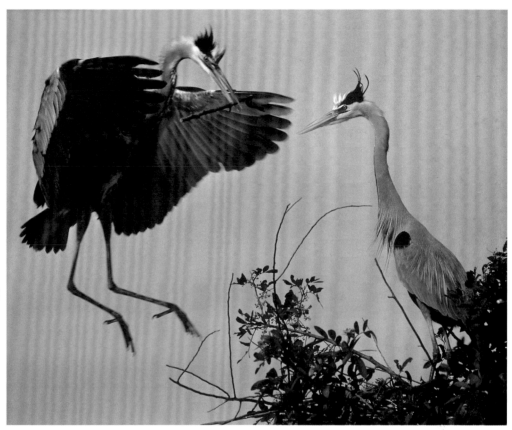

near; a blue-winged teal exercises its wings just as it finishes preening; a great blue heron flips its fish so that the meal can be swallowed head first; snow geese babble excitedly as a buildup to mass takeoffs. Being familiar with such behavioral clues will allow you to prepare the camera and yourself ahead of time so that you are ready to capture the action.

*Great blue herons (above and far left). If you had looked in my viewfinder a second before the frame above was shot, you would have seen an out-of-balance composition — an empty stage in waiting. I timed this shot by watching the approaching bird with my naked eye. At far left, many frames were shot to capture this balanced arrangement of two birds and a giant courting stick.*

# Wildlife Portraits

*Layering the picture space and other techniques for expressive portraiture*

*Red-eyed tree frog (below).*
*Telephoto lenses are essential*
*for dramatic portraiture. Their*
*shallow depth of field blurs*
*backgrounds and foregrounds,*
*emphasizing the subject.*

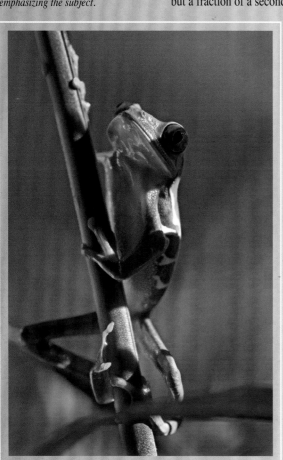

**MAKING A COMPELLING** portrait of a wild animal is not as simple as it may at first seem. There are numerous factors critical to the picture's outcome, which you need to process efficiently and often in but a fraction of a second should the subject be on the move. Some attempts may be actively pursued by the photographer while just as many must be passively embraced (with the necessary patience) at nature's whim. The suggestions that follow provide a foundation on which you can fashion a personal and expressive imagery. For top results you need a 35mm SLR with a telephoto lens in the 300–600mm range, a 1.4X or 2X teleconverter (or both) for adjusting subject magnification, and a sturdy yet easily portable tripod with a ball head or gimbal head.

## LEAVE WIDE-ANGLE LENSES IN THE BAG

Although some wild animals (particularly those in national parks, arctic regions and deep sea islands) have little fear of humans, close-up wide-angle lens work should be avoided for reasons both practical and artistic. The fish-eye-in-the-muzzle approach often has negative consequences for the subject and may set unfortunate precedents for nature photographers generally. Exaggerated perspective cues that signal an abbreviated working distance generate a sensationalist, photocentric effect. By contrast, the telephoto approach records the undistorted dignity of the subject from a nonintrusive distance. Getting too close to large wild animals endangers the photographer and, when it results in injury, may call for the animal to be destroyed or transported out of its home range away from the public. In national parks and other regulated areas conflicts between animals and humans result in the development of policies and rules that limit subsequent viewing and shooting access for everyone. A frame-filling, wide-angle shot may present the subject seemingly unaffected by the photographer's presence, but it does not tell the entire story. Close-range shooting has an impact on the greater picture environment. The photographer's lingering scent,

disturbance of vegetation, or actual presence near denning and nesting sites telegraph such locations to predators and usually deter one or both parents from carrying out vital reproductive activities such as bringing nesting material or food for the young, or standing guard.

## TELEPHOTO ADVANTAGES

Maintaining a safe, nonthreatening distance by using a telephoto lens allays such problems and provides aesthetic benefits more harmonious to the subject. The telephoto's narrow angle of view allows significant changes in the composition of background and foreground areas with only slight adjustments to camera angle or position. Its relatively shallow depth of field permits ready blurring of distracting elements not crucial to subject development, which accentuates by contrast the sharpness and importance of the center of interest. When not stressed by the close approach of a photographer, the subject will project a relaxed demeanor and be more likely to engage in behavior typical of the species.

## BUILD A THREE-LAYER PICTURE SPACE

Conditions permitting, I like to set up the picture space in three planes — foreground, midground and background — with each fashioned to support the main subject. Foregrounds are usually comprised of out-of-focus grasses, limbs and leaves, wildflowers or other features of the animal's environment. Three considerations will keep your foregrounds in order. First, take a camera position that places foreground elements well out of the depth-of-field zone. Dreamily blurred foregrounds are unobtrusive and serve to contain the viewer's attention to the subject, while those just out-of-focus appear distracting and even technically amiss. Second,

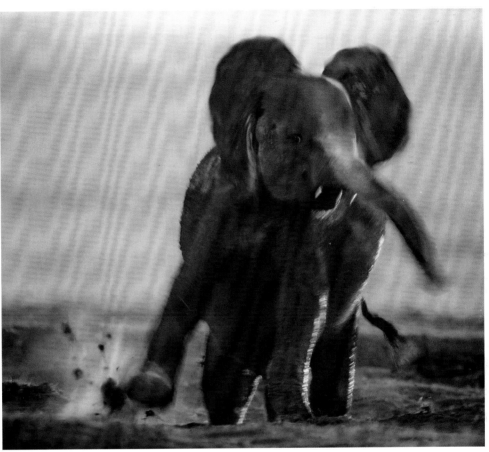

*African elephant mock charging (above). The telephoto lens makes for easy modification of background features. For this image, I merely moved my safari vehicle forward a few feet to bring a featureless but colorful background into the composition. Canon T90, Canon lens 500mm f/4/5 L, Kodachrome 64, $^{1}/_{125}$ second at f/5.6.*

## Anatomy of a Wildlife Portrait

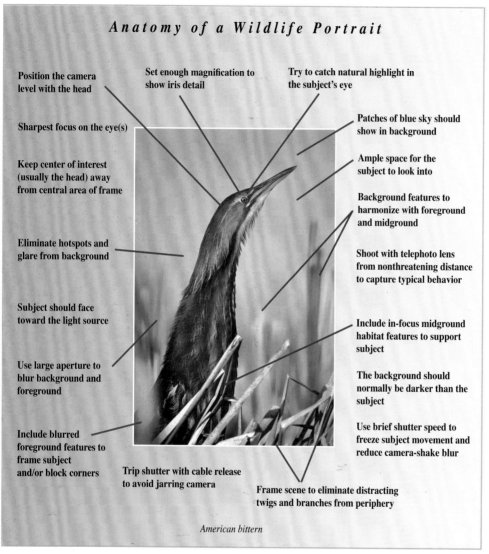

Position the camera level with the head

Set enough magnification to show iris detail

Try to catch natural highlight in the subject's eye

Sharpest focus on the eye(s)

Patches of blue sky should show in background

Keep center of interest (usually the head) away from central area of frame

Ample space for the subject to look into

Background features to harmonize with foreground and midground

Eliminate hotspots and glare from background

Shoot with telephoto lens from nonthreatening distance to capture typical behavior

Subject should face toward the light source

Include in-focus midground habitat features to support subject

Use large aperture to blur background and foreground

The background should normally be darker than the subject

Use brief shutter speed to freeze subject movement and reduce camera-shake blur

Include blurred foreground features to frame subject and/or block corners

Trip shutter with cable release to avoid jarring camera

Frame scene to eliminate distracting twigs and branches from periphery

*American bittern*

unity and more pleasing harmonies if daisies are evident in either or both of the other two planes (nirvana if the bird is perched atop one such flower). Third, foreground elements are used most effectively when they fill up the corners of the frame, where their lack of detail absorbs the visual momentum of straight and converging boundaries that lead the viewer's eye out of the picture.

The picture's midground is of course dominated by the subject (discussed in detail in the next section) which floats buoyantly amid the blurry seas of foreground and background. In order to anchor this most important element to its environment and fix it within the image space, it's beneficial to have a few key components of its habitat in sharp focus — grasses sprouting around the subject's feet, foliage framing its head or berries being grasped by hungry lips.

Under ideal circumstances the background plane can itself be processed in three sub-layers. Just behind the main subject should appear a few patches of out-of-focus habitat elements, obviously blurred but not to the extent that their identity cannot be matched up with some of the environmental features sharply rendered in the midground area. Next come large swathes of blurred pigment preferably in har-

strive for a camera angle that captures foreground features that are the same as at least some of those in the midground and/or background. For example, if you are shooting a bobolink through a patch of yellow daisies, the composition will exhibit greater

mony with the color motifs of other layers. Last to appear are patches of blue emanating from the blur of sky. This most favored of nature's hues enlivens and expands the atmosphere of any wildlife portrait. In practice, you won't encounter it regularly but be prepared to capture the sky's magic by taking a low camera position and shooting at right angles to the sun (for maxing the blue) when possible. For heavenly color saturation together with action-stopping shutter speeds, shoot under sunny conditions with an ISO 400 film and polarizing filter.

## SIZING UP THE SUBJECT

With the picture space (theoretically) structured, we can turn our attention to the actual subject. Early in my career, I didn't discriminate between beautiful, robust specimens and those not quite so blessed by nature. But I soon discovered that editors were not too interested in publishing female cardinals in drab plumage or elk with puny antlers no matter how skillfully illuminated and composed. Now I recommend that photographers interested in seeing their work published give priority to those subjects with the most brilliant plumage, the shiniest fur, the longest tusks and the widest antlers.

How big should the animal be in the frame? Many factors, including the animal's behavior, affect how you treat this aspect of the photograph. As a rule of thumb for

portrait making, use enough lens power to show detail in the eyes (a clearly defined iris being ideal). Of course, circumstances frequently dictate other priorities. A dramatic display of courtship feathers, a salmon vised in dripping jaws, wildebeest trekking past a rising sun or the battle-worn trunk of an elephant seal trumpeting over his harem are among a multitude of dynamic factors that may call for a revision to standard magnification and framing practices.

## FACIAL FEATURES IN FOCUS

To a human the animal's face represents the most important part of its anatomy and you should make sure that these features are in best focus and well

*Black-necked stilts (below). A near water-level camera position filled the background with the fresh tints of the marsh as a wash of color, accentuating the sharp focus of the main subjects. Every portrait need not exhibit all the features described in the chart opposite, but usually the more the better. Canon EOS A2, Canon lens 500mm f/4/5 L, Fujichrome Velvia, 1/250 second at f/5.6.*

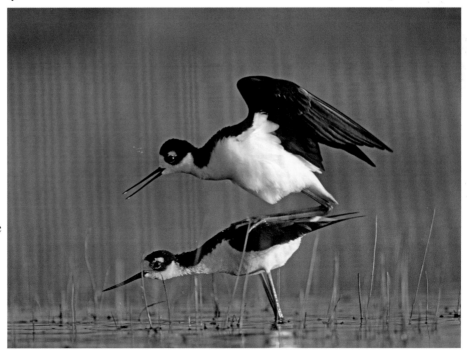

lit. For the most revealing and dramatic interpretation, try to catch the subject looking into the light. The eyes should be wide open, clearly illuminated (see preceding paragraph), and show a small, twinkling, natural catchlight (a contrived catchlight from electronic flash is usually worse than nothing). Ears should be fanned forward in curiosity rather than laid back in fear or tilted askew. The nostrils should be flared and not leaking. Antlers and horns should be angled to show clear separation of the branches. Presented with a choice, record the head aimed back over the animal's body into the picture frame to generate a circular (rather than linear) flow of visual interest. Whiskers should be splayed, in focus, and set up against the blur of background. If showing only a portion of the animal, avoid cropping at joints

*Red fox (below). When shooting portraits of animated creatures like this fox kit, focus carefully and shoot at your highest capture rate. The more images you make, the better your chances of coming up with one in which the subject is both well posed and in focus.*

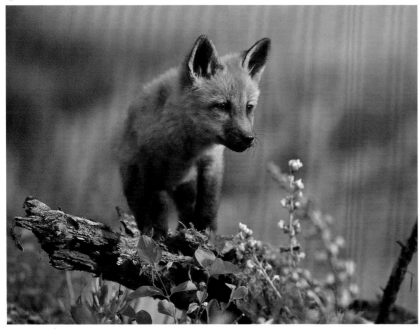

(knees, ankles, elbows, knuckles) and use blurred foreground features to interrupt the exit of long limbs from the frame. If shooting animals in silhouette, look for opportunities to catch the subject when each of its legs is distinct and separated and its head is presented in profile. This agenda does not work in every situation and rarely can be fully implemented, but by having it at your fingertips you will be able to purposefully apply or discard each of the items depending on the circumstances.

## GROUP PORTRAITS

Animals in groups compound the number of factors you must juggle. The behavior, position and pose of each subject needs to be monitored nearly simultaneously so that the most telling components can be recorded in synchrony. The best captures result from keying the composition to one leading subject, bringing in members of the supporting cast on an *ad hoc* basis when their roles are most powerful and complementary. The strength of the composition is most at risk when shooting two animals, a situation which readily fractures and polarizes the center of interest. To achieve a unified effect, select subjects that are matched in physical appearance; engaged in similar behavior, such as howling or sleeping, relating to one another (courting); or focusing their attention in the same direction.

## LIGHTING

Any type of light can produce an exciting portrait.

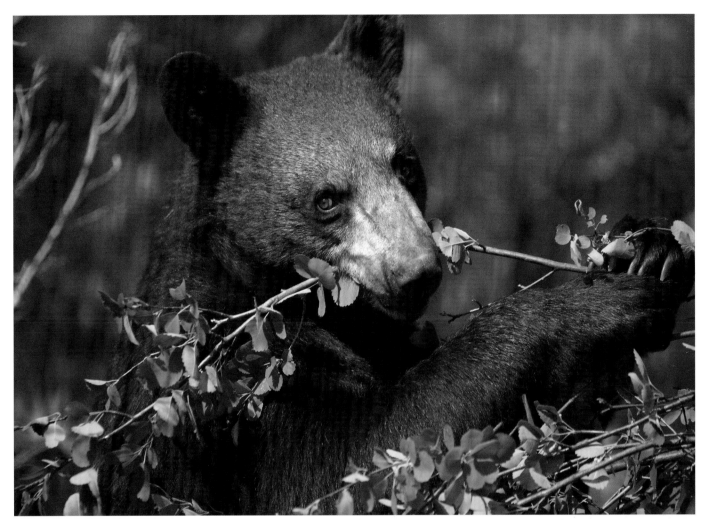

The standard and often most productive treatment utilizes front lighting early in the morning or late in the afternoon. You can't go wrong by flipping this switch but there are other options on the console that produce unexpected results frequently more dramatic. Learn to understand and appreciate how light reveals your subject, especially in connection with the suggestions outlined here.

Once you become comfortable working with these procedures in actual field situations, you're ready to abandon the formula and experiment with novel tactics that may flow more spontaneously from your own sense of design and how you experience and perceive the natural world.

*Black bear chomping foliage (above). Portraits exhibit unity and strong visual flow when the animal is recorded looking back over its own body. This capture exhibits all the key characteristics mentioned in the chart.*

*Part Four*

# Light on the Land

# Finding Photogenic Landscapes

*Ten clues to evaluating the photographic potential of any landscape setting*

I'VE BEEN HERE BEFORE to search for clues — to measure the angles and proportions of the view, to take sightings on the spires of granite, to gauge the texture of river cottonwoods. I've checked the disposition of the stone monuments against my compass and staked a claim where I'll set up my camera to capture the first intoxicating light of dawn as it streaks across the cliffs or breathes its fire onto tumbling pillows of cloud that hang above.

All has been investigated in advance and I'm ready to capture the revelation of light and shadow, form and color, texture and line that will come as the sun clears the horizon.

How can you research a landscape to discover

***Organ Pipe Cactus National Monument, Arizona (above).*** *Photogenic landscapes are typified by strong color and interesting foreground elements. Both are found in abundance during spring bloom in this park.*

***Colorado River at Horseshoe Bend Arizona (left).*** *Some landscape venues are unmistakably grand. Nevertheless you need to search for the features and await the conditions described in this chapter in order to present the subject at its most striking. Mamiya 645 AFD with Phase One P25 digital back, Mamiya Sekor 35mm f/3.5 lens, two-stop split neutral density filter, ISO 100, 8 seconds at f/22.*

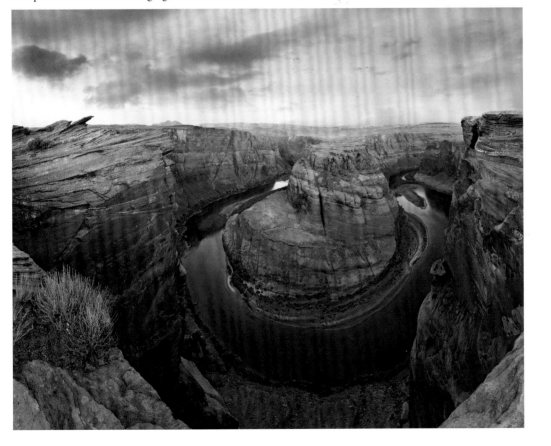

## COLOR FIRST

The presence of strong color is the best indicator of the landscape's potential for surrendering a great photograph. The most attractive color to humans is red. Find this hue, even in small batches, and chances are you've found a good place to set up your tripod. Wildflowers, lichens, leaves, rocks, even flamingos in rosy hues can be incorporated into the wider scene. Give these color nuggets a lot of attention by placing them prominently in sharp detail in the foreground region

*Prickly pear cactus at Mustang Island State Park, Texas (above). Broken clouds add interest and improved contrast to your pictures at any time. Be especially attuned to their potential late and early in the day. When the sun is below or on a clear horizon, clouds are illuminated in a rainbow of fiery hues.*

its potential for compelling imagery? What are the clues that can lead to great scenic photographs? Following are the ones that I look for. They are relevant whether you are anticipating shooting a sand dune, snow-capped peak, surf-battered beach or slick-rock canyon. I've never found all the clues at the same site, but even a few of them are a firm forecast of dramatic image possibilities.

of the composition. Entire vistas may be tinted in fiery pigments — the canyon country of the American southwest, the eastern forests in autumn, the arctic tundra in summer. Such clues are impossible to miss and icons for what is beautiful about the North American continent.

More subtle color harmonies can also lead to great pictures, such as those projected by the cool

hues of a foggy seascape or the peachy tones of sand dunes in twilight.

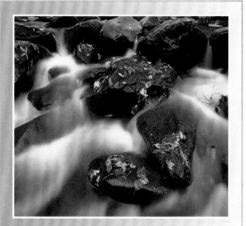

## Water Motion

*There are two approaches to photographing waterfalls. One technique is to use a brief exposure ($1/125$ second or faster) to freeze the movement of the water. The other, usually more appealing method, is to use an extended exposure ($1/15$ second or slower) so that the water is recorded as a silky blur. To accentuate the effect, try to include features in the scene that are stationary. On calm days, colorful foliage provides a dynamic foil to the milky stream. If it is windy, use rocks or tree trunks to set up the scene. Due to the brightness of the flow, waterfall pictures are normally successful only on cloudy days, when contrast is low and the entire scene is evenly lit. Zoom lenses are helpful because camera positions are usually restricted by water spray, dense foliage and the stream or river. Most compositions work best when the falls are photographed from below, allowing the viewer's eye to follow the water flow into the picture to the center of interest. Also look for camera angles that capture the flow moving diagonally through the picture frame.*

## CLOUDS MAKE THE DIFFERENCE

Nothing energizes an impending landscape-shooting session more than clouds. My favorites are the cottonball, cumulous variety, but any kind, anywhere in the sky will tickle my trigger finger. Most preferred are formations that are near the horizon and above the target area. At sundown or sunrise, these clouds can turn many shades of rose, mauve, scarlet and yellow. These powerful picture elements create their own dynamic but complementary center of interest that enlivens the landforms below. At dawn, their rich colors are reflected onto the scene to infuse the composition with a distinctively warm color bias. Even when shooting during midday, clouds are beneficial; their varied formations can be used to relieve

*Northeast Creek, Mount Desert Island, Maine (below). Look for opportunities to bring reddish hues into landscape compositions. Being the color of blood (which simultaneously signals food and danger) it is the most attractive color to humans.*

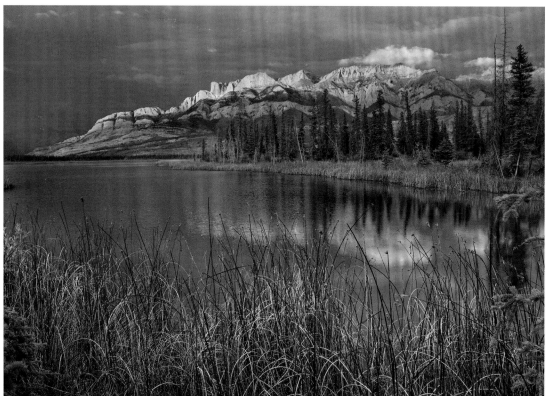

*Miette Range reflected in Talbot Lake, Jasper National Park, Alberta (above). Calm weather greatly improves a scene's potential, allowing you to record foliage detail at slow shutter speeds and small apertures for greater depth of field. Mamiya 645 AFD with Phase One P25 digital back, Mamiya Sekor 55–110mm f/4.5 lens, one-stop split neutral density filter, ISO 100, 1/2 second at f/22.*

be sharply recorded during long exposures. Wildflowers, grasses, shrubs, foliage, pools of water, sand grains (as in sand dunes) and even tree trunks are picture elements affected by wind. Consider the implications of this clue — what is your exposure duration once you have stacked on a few filters, loaded a high resolution/low ISO setting, set the aperture at f/32 to maximize depth of field and waited for that last, fiery gasp of light over distant peaks? Often it can be in the neighborhood of 10 or 15 seconds. In these situations, I hold my breath and pray Mother Nature does the same. The best chance of encountering still conditions occurs about 30 minutes before and after sunrise. Be patient and learn to shoot between the occasional zephyr.

the starkness of a clear midday sky. When passing through clouds, sunlight is diffused and refracted into shadow areas illuminating detail and color and bringing more of such scenes, inherently high in contrast, within the dynamic range of the sensor.

## CALM ATMOSPHERE FOR DETAIL

For landscape photographers, a still atmosphere offers added design possibilities. It means that you can shoot with great depth of field subjects that you might otherwise have to edit from the composition because they move around in the wind and cannot

## LET IT SNOW

Fog, mist, haze and falling snow infuse ordinary landscapes with moody energy. Such meteorological events add novel distinction to scenic photographs. Staying abreast of weather forecasts (local television usually provides the most accurate information) will

help you be on site when atmospheric effects are working their magic.

### NORTH/SOUTH CAMERA ANGLES

Search for a camera position that is north or south of the target landscape. This camera angle will record landforms (at the ideal times of sunset or sunrise) when they are illuminated by sidelight. Sidelight allows the most effective use of polarizing filters, giving extra density to sky regions and added color saturation to vegetated landscapes. It also models the terrain, showing contours, shapes and textures more distinctively than any other lighting angle. In the northern hemisphere, a camera view from the south opens the landscape to both strong sidelight and weak front light, resulting in lower contrast, more subject detail and purer color.

### CHECK FOR OPEN HORIZONS

When you find a landscape feature that appeals to you, check to see if the east and west horizons are clear of light-obstructing landforms — an important consideration no matter what shooting angle you chose. These offensive topographies are most apt to handicap your shooting aspirations when shooting in mountainous regions. If the site you have chosen to photograph lies close to adjacent peaks, there will be no dramatic color in the sky until after the target landscape is shrouded in deep shade and bereft of both natural color (especially warm tints), form and texture. If the eastern horizon is open, plan to shoot at dawn; if the western horizon is clear, be on site for sunset. This schedule offers the best chance of combining rich color, dramatic skies and well-modeled landforms.

*Big Sur Coast, Garrapata State Park, California (below). Try to anchor your landscape compositions on interesting and colorful foreground elements such as ice plants tinted with autumn finery. Keep foreground subjects within the depth-of-field zone and magnified to show interesting detail and texture.*

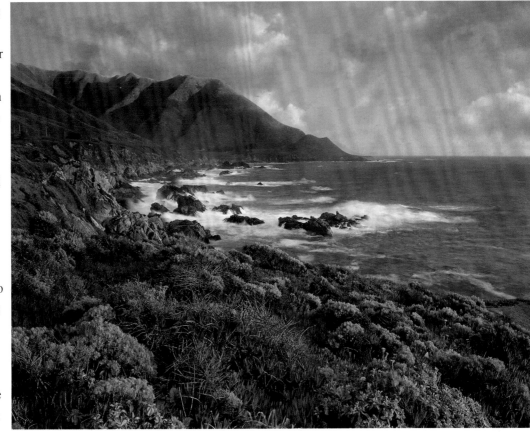

## *Capturing the Moods of the Shoreline*

*The shoreline is a reliable source of dramatic land-scape imagery — a marriage of soaring skies and open ocean, an unending confrontation between tide and terrain. Following are some of the strategies that I use when working the shoreline.*

*My first consideration is to be ready for amphibious work. I carry my equipment in a vest (see page 41) and, depending on the temperature, wear chest-waders or shorts and nonskid river sandals (Chacos). This allows me to move around tide pools, scramble over rocks and shoot even when waves are swirling around me and the tripod. I carry the usual assortment of scenic tools — a couple of zoom lenses covering ultra wide to moderate telephoto focal lengths, a cable release, polarizing and split neutral density filters, and plenty of batteries and CF cards.*

*The best camera positions (especially when there is surf) are often right where* waves break onto the beach, territory hazardous for equipment. I keep handy a cotton cloth to wipe salt spray from camera and lenses and keep an eye on my tripod when it is set up in sand that may be shifted by incoming waves. A single wave can quickly undermine the tripod and topple the camera into salt water. I cover up controls on my camera with flaps of duct tape in case I should receive an unexpected splash.

*Early morning is the preferred shooting time. Footprints have been erased overnight by the tide and the atmosphere is calm enough to record well-defined reflections in tidal pools. This period is*

**Sandy Beach, Oahu, Hawaii (right).** The best place to set up your tripod at most beaches is where the waves break onto the shore. This is a hazardous location for equipment and you need to stay alert for big sneaker waves that may land periodically, splashing or flooding you and your equipment and possibly even placing you in danger. In areas of big surf, spend 30 minutes evaluating wave patterns before descending to the water's edge. Foregrounds and colorful skies form the basis of most compositions. Look for waves breaking over rocks and swirling around in sinuous patterns as they flood the beach.

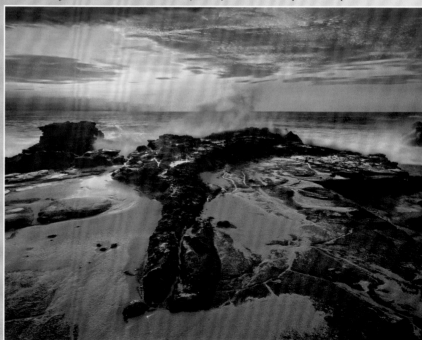

*ideal for the Atlantic coast, which lays open to the rising sun, but on the Pacific edge, mountains and seaside cliffs leave many beaches in shadow during the best light of early morning. Here, I look for shorelines with low elevation backdrops or those on the south-facing beaches of projecting headlands. During periods of low tide, sea stars, mussels, kelp and other sea life are exposed to provide added decoration to compositions.*

*I look for a combination of strong foreground elements and interesting wave action. Once the tripod is set up and the scene is framed, I attach a cable release and observe incoming waves, taking a shot each time I anticipate a dramatic splash or sinuous stream of moving water. On sandy beaches, receding waves leave momentary patterns of glistening sand, rivulets and pools that reflect the color of the sky from a low camera position.*

*It's essential to use neutral density filters for good detail in both highlights and shadows. Hard-edge (rather than soft-edge) filters are especially desirable, as compositions frequently bring together a clean, uninterrupted union of sky and sea. Beach scenes gain identity and perspective when living elements such as gulls, herons, kelp or sea stars are part of the composition. I portray these elements prominently. I may close in on them with a wide-angle lens set for the hyperfocal distance.*

Joy Fitzharris

## FOREGROUND DETAILS

The best landscape photographs are made in locales that harbor interesting foreground details. The southwestern deserts have prickly pear and saguaro cacti, the arctic has its bear grass and autumn berries, the Eastern Sierra its bowling-alley boulders and sagebrush, the Oregon Coast its sand dunes and sea stacks. These micro features can be used to set up the scale of a scene, establishing important perspective cues that infuse a flat plane of pixels with a convincing sense of three dimensions. The photographer's choice of appropriate camera angle can use micro features (such as trees and rock formations) to frame and focus viewer attention on a silky waterfall or soaring sandstone arch.

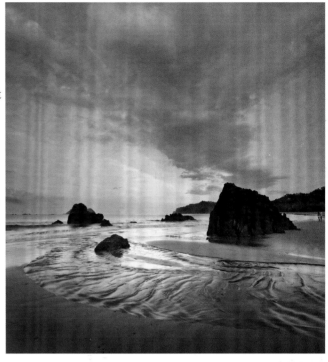

*Playa Espadilla, Manuel Antonio National Park, Costa Rica (above). To accentuate this peaceful twilight scene, I used a polarizing filter to darken the dramatic sky backdrop. I triggered the exposure with a cable to ensure maximum sharpness. Mamiya 645 AFD with Phase One P25+ digital back, Mamiya Sekor 55–110mm f/4.5 lens, one-stop split neutral density filter, ISO 100, ¹/₂ second at f/22.*

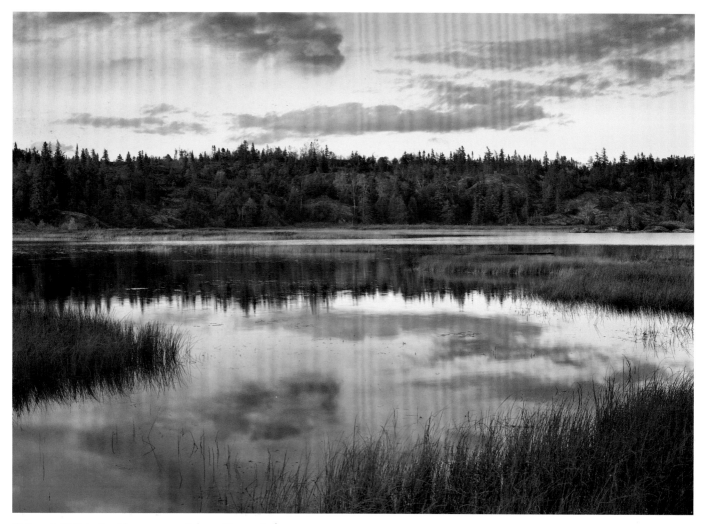

*Halfway Lake, Pukaskwa National Park, Ontario (above). To capture this reflection of the sky's most dramatic color elements required some soggy tramping through soft-bottomed sedge marsh. For reflection photography, be prepared to get your feet wet.*

### LUNAR/SOLAR ACCENTS

Check your calendar for periods when the moon shows itself in the sky. In rare instances it will appear in your viewfinder over the landscape in just the right place. Usually, you will want need to employ multiple captures and computer manipulation to achieve natural lunar luminosity and detail.

Including the sun in the composition also adds drama to the scene but introduces insurmountable contrast problems unless multiple captures are made for later assembly on the computer.

### MAGIC MOMENTS BESIDE STILL POOLS

Few landscape elements get me more excited than

still water. Beaver ponds, vernal pools, lakes, lagoons, river backwaters and tide pools are all indicators of fantastic scenic shooting. Water bodies, large and small, can be found over most of the continent (including the desert regions of the southwest) with a little diligent searching. With appropriate camera positioning and lighting, they can be used to

### Digital Contrast Control

*The revealing detail and natural color in both sky and land/sea portions of this sunrise capture of a breaking wave was made possible with a two-stop split neutral density filter. In digital photography, you needn't strive for a perfect balance and distribution of tones as you would with film. As long as the curve is centered within the histogram space, you should have adequate image data to make further adjustments to brightness and color as well as precise local corrections to areas where straight-edge filtration was unable to match inherent irregularities of the horizon.*

*You can control contrast with even more precision by taking a series of bracketed exposures and combining them in Photoshop with the HDR (high dynamic range) feature, which automatically selects and combines the best tonalities from each of the captures.*

throw mirrorlike reflections of the landscape, in effect redoubling its beauty and presenting a repeated harmony of picture elements. These reflections become most striking in calm weather during periods of sunrise and sunset when the oblique angle of illumination leaves the pool's substrate in shadow, producing the clearest, most perfect reflections. If you intend to incorporate reflections in a landscape shot, it's best to arrive on the scene prepared to get wet. Sporting chest waders or even shorts and sneakers, you can conduct an uncompromising search for the best camera position (for more suggestions on shooting reflections, see page 162).

see page 162

## ANIMATE WITH ANIMALS

Opportunities to capture a beautiful landscape that also includes wildlife are rare. Unlike other landscape clues, this one is not reliable and your shooting will generally be more productive if you give priority to devising the compositions

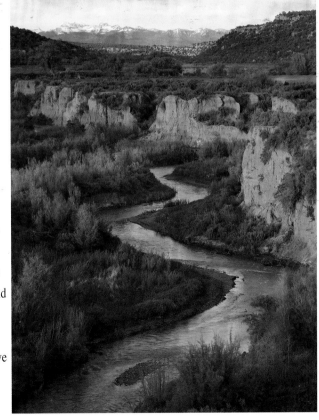

*San Juan Mountains and McElmo Creek near Cortez, Colorado (below). Position your camera to the south or north of the scene to capture landforms dramatically modeled under sidelight during the key shooting periods of sunrise and sunset. Mamiya 645 AFD with Phase One P25+ digital back, Mamiya Sekor 105–210mm f/4.5 lens, Singh-Ray circular polarizing filter, ISO 100, ¹/₈ second at f/22.*

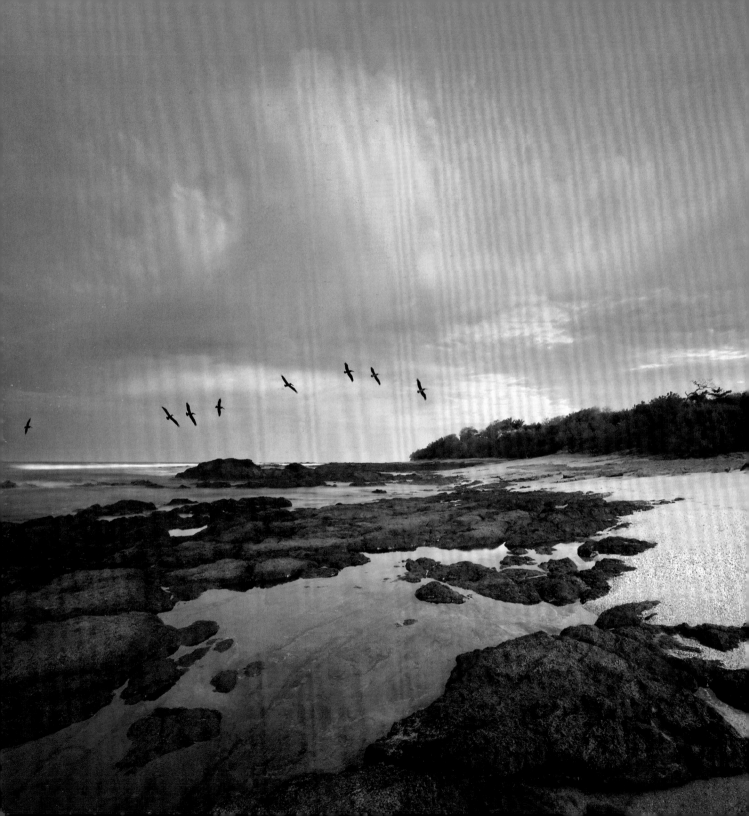

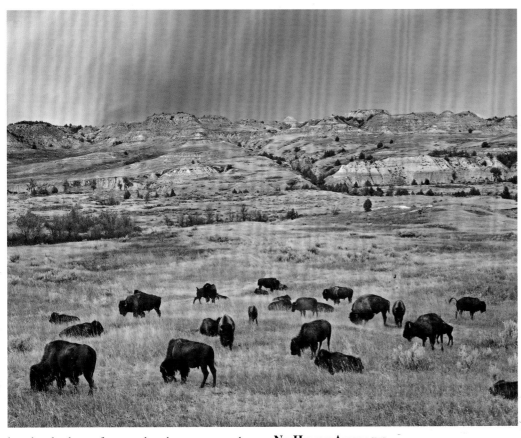

based on landscape features alone but are prepared, nevertheless, to make modifications should luck bring an elk, moose or flock of swans into the frame. Your best chances to engage this landscape motif will normally occur when you are shooting wildlife and you should school yourself to keep one appreciative eye on the larger scene. Should animals, light and landscape features develop the potential for landscape imagery, switch to a wider focal length or retreat to a position that will provide an expanded view of the scene.

## No Human Artifacts

Even in rural areas it is difficult to come upon landscapes that are free of human artifacts — telephone poles, highways, dams and all manner of buildings. For the most peaceful and productive experience, focus your efforts where nature is protected and human artifacts are largely absent — national parks and forests, designated wilderness areas and sparsely settled territories.

# The Power of Perspective

*How to infuse your landscape photos with the impression of three dimensions*

*Klondike River, Tombstone Territorial Park, Yukon (right). The rumpled topography and spruce groves in this view, normally expressive of deep perspective, have been compressed by the use of a telephoto lens.*

*Prairie verbena and desert marigold at Franklin Mountains State Park, Texas (far right). The feeling of deep perspective evoked by this photograph is primarily the result of framing the scene to emphasize the receding size of the wildflowers and cacti. Plants of the same species make great perspective cues due to their generally uniform size. Mamiya 645 AFD with Phase One P25 digital back, Mamiya Sekor 35mm f/3.5 lens, Singh-Ray circular polarizing filter, ISO 100, 1/4 second at f/32.*

**THE PORTRAYAL OF DEPTH** is the primary attraction of a landscape photograph, more important to the picture's technical success than subject matter, color or any other pictorial element. To express the third dimension convincingly, we need to capture and arrange the features of a landscape in a way that best projects their spatial qualities, keeping in mind that we see the world quite differently than a camera does. Not only do our two eyes work in stereoscopic view, but we move around, crane our necks and reappraise the scene from different angles, often in but a fraction of a second, to gain a better appreciation of the depth and scale of the visual confrontation. By contrast, the still camera is afforded but a single, frozen view in its generation of a flat photograph. To bridge this optical gap, we need to emphasize and clarify those cues in the landscape that express depth.

## Size Cues

The relative size of landscape features is one of the most obvious cues in conveying the depth and scale of a scene. Objects that are close to us appear larger than the same objects further away. Utilizing this cue is first a matter of incorporating in your composition familiar features that are similar in size, or at least are perceived to be so by the viewer, and then

positioning the camera so that they are presented on film in differing proportions. Such components most commonly include trees, shrubs and wildflowers of the same species. Animals can also be used as size cues — bison, elephant seals, elk, snow geese, sand-hill cranes, roseate spoonbills and other gregarious species. The perfect placement of the camera shows such size cues arranged at regular intervals largest to smallest on a diagonal plane or some variation of it (an S-curve for example) which leads to the landscape's most important element — rainbow, setting sun, colorful cloud bank or a special terrain feature. You may never come across such an idealized circumstance, but it's important to be aware of the potential and work toward it when shooting.

There are other less common but equally powerful size cues to which you should become sensitive. When cumulus clouds dapple the sky, they appear smaller nearer the horizon. Sand ripples, caked mud flats and ocean waves can all be used to present a uniform pattern of decreasing size cues. From an appropriate camera angle, rivers, streams, sand dune ripples and fallen logs all exhibit the railroad track phenomenon — the convergence of parallel lines toward a vanishing point (actually a variation of the effect of size cues).

## ANGLES OF VIEW

When used in conjunction with size cues, lens focal length generates a powerful perspective effect. By emphasizing the differences in size cues, wide-angle

*South Unit, Theodore Roosevelt National Park, North Dakota (above). A three-dimensional impression is created by a clearly separated series of planes lined up from foreground flowers through to blue sky in the far distance. Mamiya 645 AFD with Phase One P25+ digital back, Mamiya Sekor 45mm f/2.8 lens, polarizing filter, ISO 100, 1/4 second at f/32.*

exceptional effect (i.e., with the closest size cue being near the lens' closest focusing distance). Much of the time, however, you will be working in concert with other design prerogatives at some compromise distance.

## LOWS AND HIGHS

Because the eyes of a standing human are some 5 or 6 feet above the ground, landscape features that are close to us are usually positioned lower in our field of view than those more distant (clouds excepted). For a maximum three-dimensional effect, I normally set up at about a 45-degree angle (above the horizontal) from the first size cue in the composition regardless of its distance from the camera and using a focal length wide enough to include at least the horizon and a bit of sky. If you place the camera too low, you will lose visual exposure of the spaces between size cues; if you set up too high you will lose the horizon and the familiar eye-level configuration of the size cue — either angle will result in a flatten-

lenses increase the perceived distance between elements in the composition and promote a feeling of deep space. Telephoto lenses achieve the opposite effect by compressing the distance between elements in the scene. For the most extreme perspective effect you should position the camera as close as possible to the nearest size cue in the composition. You will normally need to shoot at f/22 or smaller to achieve satisfactory depth of field if you are working for an

ing of the scene. You also need to position carefully the camera on a horizontal plane so that the number of size cues clearly portrayed is maximized (avoid overlapping of cues). Sometimes this step requires that you move the camera forward or backward as well as sideways. In most situations you should set depth of field to include both the closest size cue and features on the horizon (usually infinity). I don't consult depth-of-field scales or bother to calculate hyperfocal distances. I normally focus on the middle point of the closest cue (rather than the leading edge), dial in f/22 or f/32, have a quick peek at the scene with the lens stopped down, and then hope that the wind stays calm while the shutter is open (exposures are usually in the one-second-plus range). In practice, setting camera position is normally a trial-and-error procedure exercised until the most effective design is achieved based on interrelated factors of color, light and subject matter, as well as the desired perspective effect. I try not to rush this stage of the picture-taking process.

## OVERLAPPING

Another useful perspective tool that needs skilful handling is overlapping. Precise lateral and vertical placement of the camera is usually needed for this strategy to work effectively, especially when utilized with smaller landscape features such as trees or rocks. Such elements are often so similar that when they are recorded in an overlapping arrangement, they may frequently blend together in a muddle not readily distinguished by the viewer. To avoid confusion, try to overlap only simple areas of contrasting color, line direction, brightness or shape (horizontal limbs crossing vertical trunks, for example). The most effective use of overlapping can be done with intersecting landscape planes. Such situations are most frequently encountered in hilly or mountainous terrain. Try to frame areas where there is a confluence of interesting contour outlines running in

*Beach at False Klamath Cove, Redwood National Park, California (below).* *These scattered rocks are ideal size cues — familiar, relatively uniform in appearance and growing steadily smaller as they move up the picture frame. I set the camera at about a 45-degree angle above the horizontal on the closest group of rocks. This position maximizes separation and definition of individual rocks while sustaining the size gradient between the nearest and farthest.*

opposing diagonal directions. Topographies lit from the side or back, or photographed in early morning when mist hangs in low-lying areas, will show the most definition between planes and the most obvious overlapping.

## SIDELIGHT FOR VOLUME

Landscapes illuminated from the side exhibit shapes whose surfaces and contours are well distinguished by areas of highlight and shadow. This makes it easy for the viewer to compare and identify important

## Composing to Show Depth

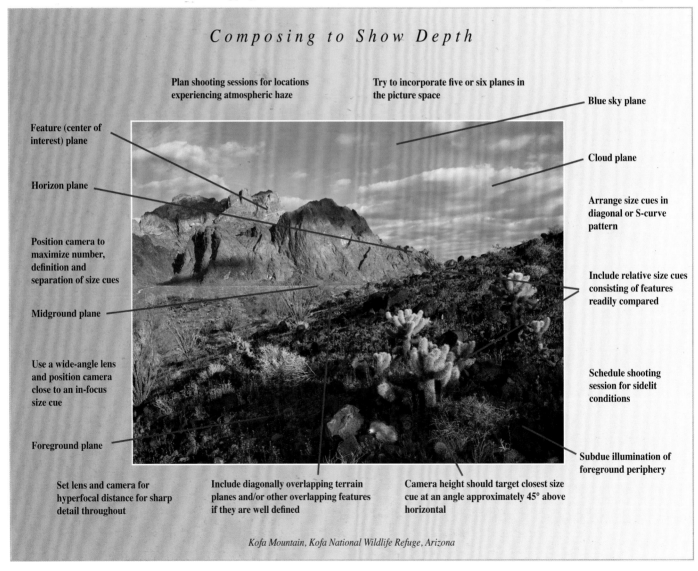

Plan shooting sessions for locations experiencing atmospheric haze

Try to incorporate five or six planes in the picture space

Blue sky plane

Feature (center of interest) plane

Cloud plane

Horizon plane

Arrange size cues in diagonal or S-curve pattern

Position camera to maximize number, definition and separation of size cues

Include relative size cues consisting of features readily compared

Midground plane

Use a wide-angle lens and position camera close to an in-focus size cue

Schedule shooting session for sidelit conditions

Foreground plane

Subdue illumination of foreground periphery

Set lens and camera for hyperfocal distance for sharp detail throughout

Include diagonally overlapping terrain planes and/or other overlapping features if they are well defined

Camera height should target closest size cue at an angle approximately 45° above horizontal

*Kofa Mountain, Kofa National Wildlife Refuge, Arizona*

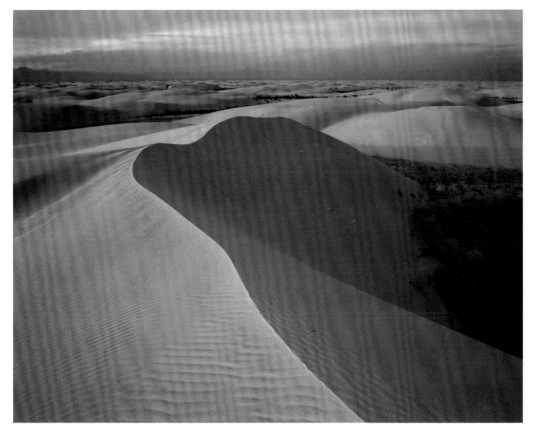

size cues, textures and other spatial relationships. The overlapping of objects or planes is emphasized and made more distinct because the shadow portion of one is set against the highlight portion of another. The earlier in the day you shoot, the greater the effect. To flatten perspective, shoot early or late in the day with the sun directly behind you for full frontal illumination.

## HAZY DAYS (ATMOSPHERICS)

Due to particles suspended in the atmosphere, close objects appear more detailed than those further away. Known in photo jargon as "aerial perspective," this phenomenon can be used to create three dimensions in landscape photos. It is most commonly encountered in the form of fog, mist, rain, snow, dust and, unfortunately, haze. Few settled regions of North America are free of haze created by fossil-fuel generating stations and other types of industrial pollution. Air quality in the Grand Canyon and Great Smoky Mountains National Parks, for example, has declined to the extent that the panorama

*Rock formations, Curt Gowdy State Park, Wyoming (far right).* *The shapes and textures of these massive rock formations are defined by early morning sidelight. These size cues lead the viewer's eye through the scene toward the line-up of distant terrain features.*

*Playa Santa Maria, Costa Rica (below). The diminishing width of the tidal pools in the foreground draws the eye into the picture, utilizing the "railroad track" technique of projecting three-dimensional space. Canon EOS 5D, Canon 24–105mm f/4 IS lens, ISO 100, ½ second at f/22.*

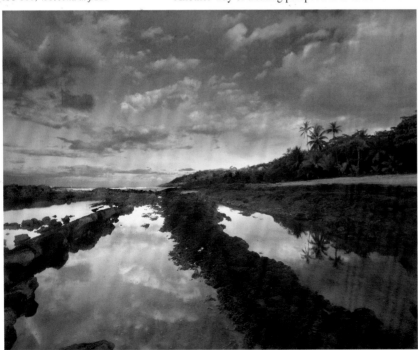

photos of 10 years ago are rarely possible today because of limited visibility. A little haze goes a long way in creating perspective effects. At present we need less of it, not more, if we are to be able even to see the landforms we wish to record. When shooting in the moody atmosphere of fog, you will encounter varied opportunities on the ragged periphery of a fog bank where you can modulate the effect by waiting for the fog to shift or by changing position yourself. If working in mountainous regions, head for high ground near the ceiling of the fog; in coastal areas head inland toward elevated terrain.

### DIMENSIONAL IRONIES

Another way of treating perspective is to combine contradictory spatial cues for ironic effect. You can interpret an assembly of haze-rimmed, overlapping foothills by shooting with a space-compressing telephoto or, conversely, use a wide-angle lens to record a featureless stretch of still water punctuated by a single island. The allure of scenic reflection photos is due in part to their inherent perspective contradiction — the reflection at your feet is the same size but usually less distinct that the terrain features it mirrors in the distance.

### FIVE PLANES

If you've become overtaxed by this litany of techno tips, allow me to put one more spin on these important concepts. When scouting for deep-perspective scenics I look for landforms exhibiting five distinct planes. Ordered from near to far, they are as follows: (1) The foreground plane features interesting landscape details that set the scale for the composition; (2) the midground plane contains well-defined size cues that lead the eye into the picture; (3) the feature plane shows the center of interest, usually a dramatic landform; (4) the cloud plane is ideally a puffy collection of cumulus or nimbus; (5) and the sky plane comprises the final backdrop in pure shades of blue, rose, peach or amber, depending on the time of day. Sometimes a sixth plane (the horizon plane) spreads itself behind the feature plane. Try to record each plane clearly and distinctly to achieve maximum projection of deep space imagery.

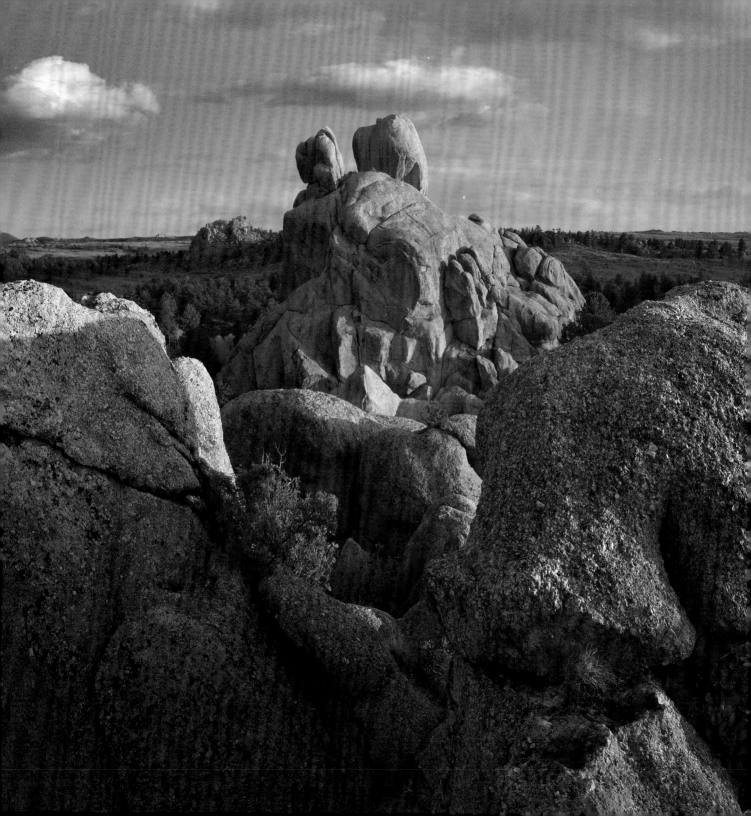

# Nature's Mystical Mirrors

*How to record dramatic reflections of the landscape*

*Maroon Bells, Maroon Lake, Colorado (below). Amphibious gear is often essential to accessing the best camera positions. For this angle, I donned chest waders to cross a creek at the lower end of the lake.*

**A REFLECTION'S GRAPHIC** allure emanates from two mingled sources: the strangely inverted repetition of image color and shape and the unlikely marriage of firm ground and liquid illusion. Whatever the dialectic, reflection photos project the most compelling of landscape motifs.

## OUTFITTING

Your normal assortment of gear should provide the basis for a specialized, stripped-down reflection kit. A tripod that doesn't get jammed by water, sand or mud is essential. Zoom lenses are valuable for precise framing when access to the ideal shooting spot is restricted by deep pools, ooze, cattail barriers or slippery rocks. Optical coverage of 20mm to 100mm is ample (35mm format). Be prepared to enter the soup or sit in the mud if perfect composition is important to you. I wear neoprene chestwaders, which are warm and durable. In summer, shorts and sneakers may suffice if you are young and hardy. This kind of amphibious work calls for a vest big enough to hold (at a minimum) an extra lens, a few filters, your usual battery and storage card complement,

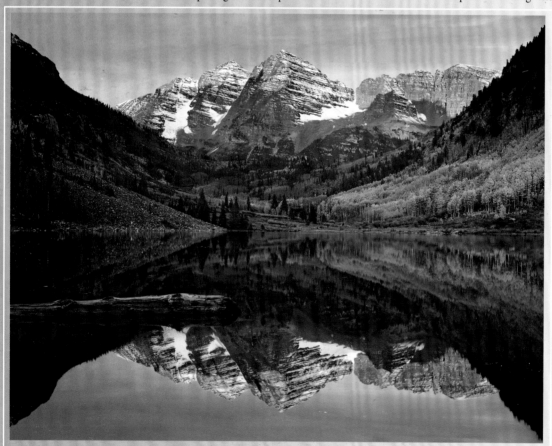

pepper spray if you are shooting in bear country, a cable shutter release and a small rag for wiping water drops and gunk from lenses and filters. The camera should be carried on your tripod, which doubles as walking stick, crutch and depth-finder.

## ORIENTATION

Beaver ponds abound in North America's wilderness areas and they are usually ideal places to capture reflections. But anything that throws off an image has equal potential — oceans, lakes, marshes, puddles or even wet sand. The best

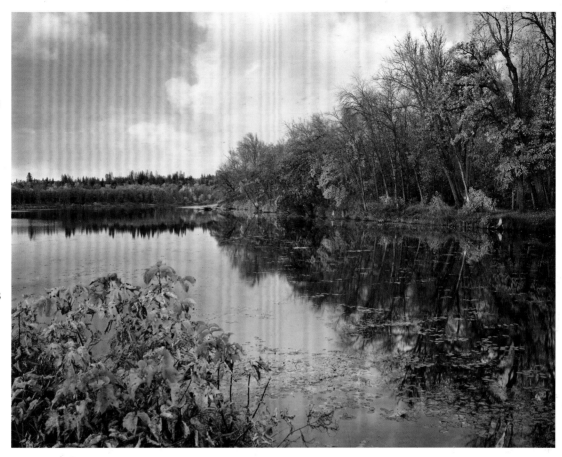

time to shoot a reflection is just before and after sunrise. To avoid stumbling around in the darkness, you need to scout for tripod spots the day before. It may take a while for you to find a pool that's exactly right. When you are sizing up a location at midday, don't be fooled by the lackluster impression. The light and stillness of dawn or dusk will add the necessary magic. First look for a prominent landscape feature that is worth capturing for its own sake — a mountain, rock precipice or beautiful forest — and

then search for water that might catch its reflection. Strive for the best combination of lighting angle (front or sidelighting), subject angle (whatever is most defined and/or distinctive) and foreground elements (simple elements that can be used to interrupt or frame the reflection — logs, rocks or aquatic vegetation). If it's windy during your reconnaissance, the reflection may be indistinct, but you should still be able to evaluate the scene's potential and get major features to line up.

*Marshs Lake, Spruce Woods Provincial Park, Manitoba (above).* *Taken at sunrise when conditions are most likely to be calm, with the camera targeted to capture colorful foreground elements to set the scale of the scene. Mamiya 645 AFD with Phase One P25+ digital back, Mamiya Sekor 45mm f/2.8 lens, one-stop split neutral density filter, ISO 100, 1 second at f/22.*

## North America's Big Four

*These are arguably the most famous reflection-photo locations on the continent. Except for the first site, all are well signed and easy to find.* **Grand Tetons from Schwabacher Landing** *(Grand Teton National Park, Wyoming) is a sunrise shoot. I prefer summertime (autumn is also good) as storms improve the likelihood of clouds above these soaring spires. Ask a ranger to point out Schwabacher Landing on the park map (it's not marked). Once at the parking lot, walk north on the riverside trail 100 yards to just past the beaver dam.*

*    **Mount Rainier from Reflection Lakes** (Mount Rainier National Park, Washington) is also a morning shot. The lakes are right beside the highway. August is best if you want a wildflower foreground.*

*    **Mount Rundle from Vermilion Lakes** (Banff National Park, Alberta) is best at sunset although sunrise is also good. There are half a dozen nice pools right beside the road; pick a sheltered one with your favorite foreground.*

*    A few miles west of Aspen, Colorado, is the location of a classic alpine landscape,* **Maroon Bells from Maroon Lake**. *The best time is mid-September when the aspen-draped lower slopes flash gold. If you go before Labor Day, access up to the lake is only by shuttle bus although private vehicles are permitted until 8:30 a.m., which is plenty of time to grab a few captures.*

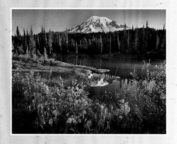

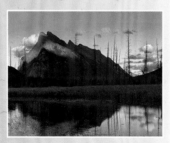

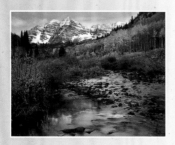

## CRYSTAL VISIONS

It's not difficult to capture a perfect, mirrorlike reflection. No guarantees, of course, but if you are in the right location at the right time using a few special techniques, you should emerge from the underbrush with fine images — even sublime ones on occasion. Your main task is to avoid or neutralize the effect of wind on water. Dusk and especially dawn are likely to be still. If your pool is rumpled before sunrise, don't be downcast; the calmest period frequently arrives a few minutes after dawn. Be patient; allow 30 minutes or so if the light is holding and the atmosphere is calm. Chances are the surface will flatten completely for a few seconds — enough time to collect your prizewinner.

The best pools are small and sheltered by large shrubs, trees and boulders out of the line of fire. Within the pond, look for areas that will be least affected by breezes — patches of water protected by floating logs, emergent vegetation, sandbars or exposed rocks. These buffers can be incorporated as important design elements in the composition. As foreground tidbits, they set up the scale of the scene, create an impression of three-dimensional space, and where they interrupt the mirrored landforms, reaffirm the ironic interplay of solid matter and its fragile rebound. For brilliant reflections in shallow pools, keep the camera position low (I often shoot while kneeling) to prevent the image of the pool's substrate (especially if it's light sand or gravel) from bleeding into the surface reflection.

## FILTERS FOR NATURAL RESULTS

Most filtering is intended to bring the contrast range of the scene within the more restricted contrast range of the sensor so that both shadows and highlights show fine detail and full color gamut. To capture the high drama of a wilderness reflection, you will need a polarizing filter, a one-stop split neutral density filter, and a filter holder (or duct or gaffer tape). Because most landscape reflections are shot with wide-angle lenses, large filter sizes (4 x 5 or 4 x 6 inches) eliminate

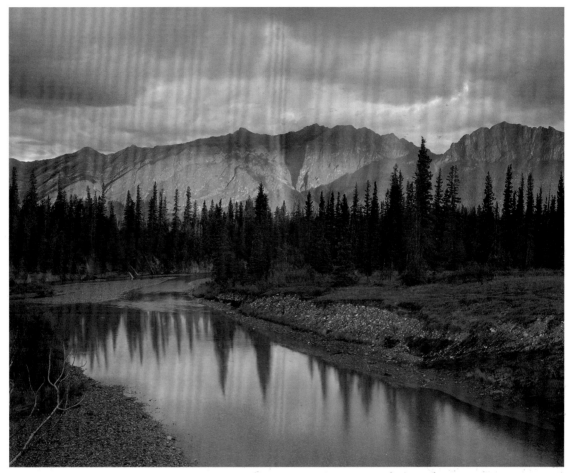

vignetting problems. The transition zone between the clear and neutral density areas of the filter should be abrupt (hard-edge) or gradual (soft edge). Cokin, Hi-tech, Lee and Singh-Ray offer good selections.

Using the filters is easy. First attach the polarizing filter and adjust it so the the sky is darkened to maximum. This automatically results in the pool throwing its most distinct reflection. At this point contrast may be constrained adequately for you to start shooting. Make sure the histogram is showing all of the data well centered in the graph and occupies about 80 percent or less of the total width. If exposure spans or exceeds the width of the histogram, add the split neutral density filter to further reduce the brightness of the sky and increase exposure by $1/2$ stop. While viewing the scene at small aperture (about f/22), carefully position the filter to darken bright areas (skies and sunlit landforms

*Rainbow over Fairholme Range, Exshaw Creek, Alberta (above). Quick action was needed to capture this roadside opportunity. The pool briefly picked up the reflection of rainbow and illuminated peaks. Mamiya 645 AFD with Phase One P25+ digital back, Mamiya Sekor 55–110mm f/4.5 lens, one-stop split neutral density filter, ISO 100, 1 second at f/22.*

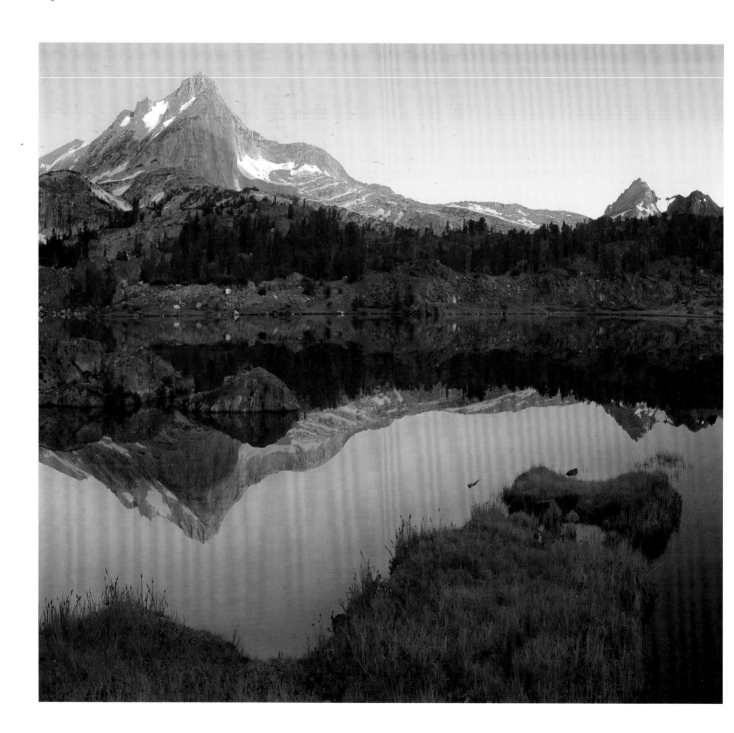

such as mountaintops catching the first rays of the rising sun). This will constrain exposure values and provide good detail throughout the frame. With both filters in place, make another test capture to check the histogram and then begin shooting to record a variety of compositions as well as both vertical and horizontal frame orientations.

## THE FILTER SQUEEZE

The two-stop split neutral density filter is sometimes needed to adequately darken very bright (hazy) skies and projecting landforms that are snow covered. At sunrise or sunset in hilly or mountainous regions, you will often engage a scene that is bright top and bottom (the landform and its reflection) and dark in the middle (areas in shadow). To record detail

Two-stop split neutral density filter

One-stop split neutral density filter

throughout the scene, you need to squeeze the shadows by placing neutral density filtration over both the landform and its reflection. The shadow areas in the middle will then come well into the dynamic range of the sensor. As the border between the sunlit and shadow areas is seldom horizontal, you will need to shift the filters to a diagonal orientation. For instance, a sloping skyline might require you to angle the top filter from upper left to lower right and the bottom one from lower left to upper right, Of course, you can also take a series of varied exposures for subsequent computer assembly as a high dynamic range composite.

*Cascade Mountain at Johnson Lake, Banff National Park, Alberta (above). For this dramatic sunrise setting, I used the filter-squeeze. Tonalities were later refined in Photoshop.*

*North Peak from Greenstone Lake, California (far left). Camera position and careful framing employ foreground shapes to frame this near-perfect sunrise reflection. Mamiya 645 AFD with Phase One P25 digital back, Mamiya Sekor 45mm f/2.8 lens, two-stop split neutral density filter, ISO 100, 1 second at f/22.*

*Part Five*

# The Close-up World

# Working at Close Range
*How to use special accessories and lenses for close-up photography*

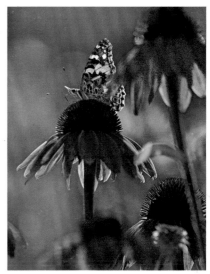

IN CLOSE-UP PHOTOGRAPHY, subject magnification is measured with reference to the size of the digital sensor. If the subject is the same size as its image on the sensor, then it is recorded life-size (or 2X life-size). For 35mm format, a frame-filling photo of a bumblebee would be just about life-size, likewise for a human thumb. A frame-filling portrait of a mosquito would be about 10X life-size and the same type of shot of a chipmunk would be 1:4 life-size. Standard lenses generally focus only closely enough for a frame-filling portrait of a human head (about 1:8 life-size). For greater magnifications, special close-up lenses or add-on devices are required.

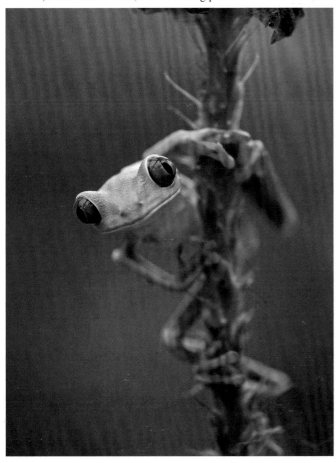

**Painted lady butterfly (above).** *This image represents magnification of about 1:5 life-size.*

**Red-eyed tree frog (left).** *This nonstop specimen was photographed at about 1:4 life-size with a handheld image-stabilized camera at high ISO speed to provide a brief exposure time to arrest subject motion and minimize camera shake. Canon EOS 5D, Canon 70–200mm f/4 L IS lens, extension tube, ISO 800, $^1/_{350}$ second at f/8.*

## MACRO LENSES
These lenses fall into two categories. A true macro lens is designed and specially corrected for high-quality close-up work. It has a focusing range that extends from infinity to a close-up distance that normally yields 1:2 life-size reproduction. Although expensive, this lens can be used without modification for subjects ranging in size from the Grand Canyon to a caterpillar. Macro-zoom lenses allow

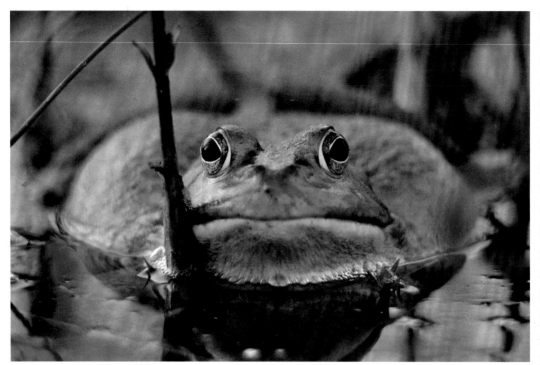

*Bullfrog (above). Frogs can usually be photographed at high magnification provided you make a slow, directly frontal approach and use a telephoto lens in excess of 300mm. The intimacy of this portrait derives from the near water-level camera angle. Canon T90, Canon 300mm f/4 L lens, extension bellows, Fujichrome 50, 1/125 second at f/8.*

in advance. Every animal, even of the same species, exhibits a unique level of tolerance that may vary from hour to hour, day to day and season to season. Butterflies are the most wary of insects, frogs the most wary of amphibians. Turtles are perhaps the most timid of all close-up creatures and bees may be the least. Before approaching a possibly wary subject, try various lenses and accessories on a life-size dummy subject to find a combination that will allow you to work as close as possible without causing flight.

photography in the close-up range but it is often not continuous. Usually you simply adjust the focusing ring to a special setting that pulls in a limited range of magnifications.

Accessory devices that modify prime lenses for close-up work — teleconverters, lens extensions (tubes or bellows) and close-up supplementary lenses — may be combined singly or in combination with one another, offering numerous ways of working at close range. How to choose among these options is resolved by the nature of the subject being photographed. For many creatures you need to photograph from a nonthreatening working distance, something that is often difficult to predict

## EXTENSION TUBES AND BELLOWS

These devices permit varied magnification and produce quality images, even at great reproduction. On the negative side, they reduce the amount of light transmitted by the lens, which limits the range of stop-action photography under ambient light and creates problems when you are working in the wind.

Magnification can be estimated by dividing the amount of extension by the focal length of the prime lens. A 50mm lens with 50mm of extension produces magnification of 50:50 or 1:1; a 100mm lens with 50mm of extension produces magnification of 50:100 or 1:2 life-size. Most extension tubes couple

to all of the camera's automatic functions, except auto-focus (rarely a handicap). All automation is lost when working with bellows except TTL flash. A double cable release can be attached to provide automatic diaphragm operation. Bellows allow the camera to be rotated between vertical and horizontal formats or any angle in between, a convenient feature not possible with extension tubes except for the

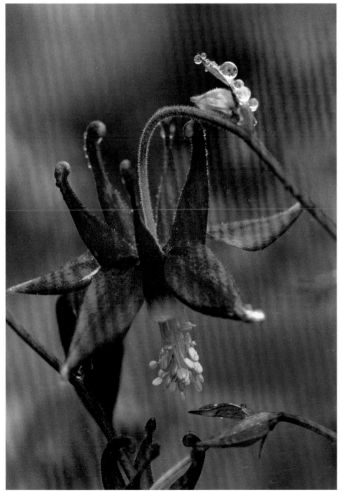

Nikon PN-11 tube, which has a handy rotating tripod collar.

Bellows are designed for high magnification work. Most have a minimum extension of around 50mm. So with a 50mm lens, the minimum magnification is nearly life-size. With a 100mm lens, it is 1:2 life-size.

Bellows are constructed with two sets of rails — one for changing camera position, the other for adjusting the extension. When using bellows, spread the boards for the magnification desired, then adjust the position of the entire assembly on the focusing rail until the scene is sharp. If you are too tight on the subject, decrease the extension; if you are not tight enough, open the bellows further; then readjust camera position.

### CLOSE-UP SUPPLEMENTARY LENSES

These lenses do not reduce the amount of light transmitted through

*Wine cups (above). To isolate these colorful, sculpted subjects, I used a 500mm telephoto lens (with extension tube) set at large aperture to minimize depth of field and soften foreground and background areas of the composition.*

*Wild columbine (left). A bellows and short telephoto lens were used to make this life-size portrait. The fragile bloom was steadied with a plant clamp. Pentax 645, Rodagon 150mm f/5.6 short mount (non-focusing) lens, Horseman View Camera Converter bellows, Fujichrome Velvia, 1/2 second at f/16.*

## *Hummingbirds by Natural Light*

*To photograph this tiny bird, you must take advantage of its near constant need to feed. (The hummingbird sips the human equivalent of 20 gallons of nectar each day.) During early morning and late afternoon, a hummingbird forages 15 to 20 times each hour, visiting flower patches within its territory repeatedly, and takes intermittent rest periods in a nearby tree or bush.*

*To attract the birds, set out hummingbird feeders (widely available). Position them to receive front light in the early morning so that you can shoot at the bird's eye level while you are seated. Once the hummingbirds are accustomed to your feeder, you can move it around for better lighting or camera angles. The birds will quickly reorient themselves to the new location.*

*You can also attract hummingbirds by offering favorite flowers either in pots or in a sunny garden location. Enticing flowers that are also good photographic props have tubular-shaped blooms and include lupines, columbines, penstemons and gilias. Nurseries normally stock a selection of hummingbird wildflowers.*

*Whether you plant flowers or rely on feeders to bring the subject close, you will still need potted flowers if you wish to shoot the birds amid colorful surroundings in good light. Portable flowers can be moved around to create framing foregrounds and backgrounds and coax the hummingbird into photogenic positions and poses. Look for varieties that have red blooms, sturdy stems and stout tubes to steady them in wind. Keep the flowers hidden from the hummers until you are ready to begin shooting.*

*A large table set up near your feeder(s) makes an ideal shooting stage. The shooting angle from your sitting position should also pick up blue sky in the background. Spread the table with a white cloth that will reflect light evenly into the shadow portion of the scene for improved contrast. Arrange the potted flowers so that some occupy the foreground and especially the background as out-of-focus color elements. Set the camera level so that blue sky and a swatch of natural vegetation (backyard trees or shrubs) appears in the distant background. With tubular species, angle the blooms so that the subject approaches and feeds while facing the camera.*

*Shooting will be most productive if you stay back 6 feet or more to permit the birds to feed without nervousness. For this you need a lens in the 500mm range equipped with an extension tube of 25mm to 50mm. Temporarily place an in-flight, hummingbird-sized stand-in at the set to make sure you have the desired magnification (this book, tightly framed, is a good size to start with). With an ISO 400–800 setting, you can shoot at f/5.6 with exposure times between 1/500 and 1/2000 second in early morning light, settings that provide enough depth of field to encompass the bird's body yet render the background soft and smooth, and enough speed to freeze a hovering hummer while re-*

**Crowned woodnymph hummingbirds, female and male (below).** I arranged these native hummingbird flowers near the feeder and used the techniques described at right to make the photograph. Canon EOS 5D, Canon 500mm f/4 IS lens, extension tube, ISO 800, 1/125 second at f/8.

the optical system, giving them an advantage over lens extensions when ambient light is low. They fit prime lenses with matching filter diameters, which means you likely need to acquire more than one set to fit all of your lenses, or use step-up/down rings, which may cause vignetting.

*cording its wings as appropriately expressive blurs. (At exposure times lasting more than $1/250$ second wings become so blurred that they disappear.) Manual focusing is often the best way to ensure that the eyes are sharply rendered and that the composition fully integrates the hummingbird, the flower it is feeding on and supporting elements in the background and foreground.*

*Once everything is ready, entice the hummingbird to your set by temporarily removing the feeder and revealing the flowers. The hummer will be confused at first but quickly spot the natural offerings and swoop in to give the real thing a thorough tasting. It should visit your set periodically allowing you a few motor-driven frames each time it appears. You can replace the feeder after a couple of visits to encourage more regular visits. The hummingbird will usually try a series of blooms before or after sipping at the feeder.*

*Photographing hummingbirds requires advance preparation, patience, persistence and attention to numerous details. Have fun with your hummers!*

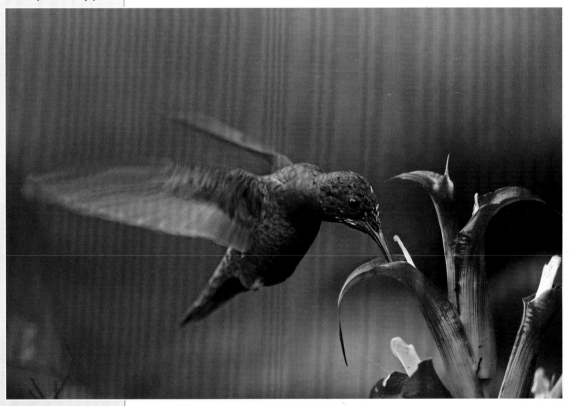

A supplementary lens is classified by its diopter rating, which is the inverse of the close-up lens' focusing distance in meters. A +1 diopter refocuses the prime lens (set at infinity) to a distance of $1/1$ (one) meter, a +2 diopter to $1/2$ meter (500mm), a +3 diopter to $1/3$ meter (333mm) and so on. Not all

*Green-breasted mango hummingbird (above). To lure this feisty male hummingbird to the camera, I hung a feeder on one of its favorite natural food sources. Canon EOS 5D, Canon 500mm f/4 IS lens, extension tube, ISO 800, $1/125$ second at f/6.3.*

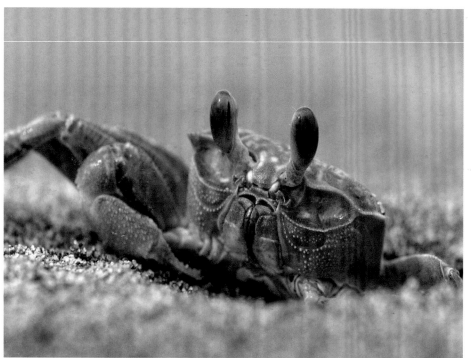

*Sand crab (above). At magnifications approaching life-size, both flora and fauna provide a wealth of graphic elements to fashion into all manner of compositions. For this magnified view, I used a handheld camera with image stabilization while laying on the sand. Canon EOS 5D, Canon 70–200mm f/4 L IS lens, extension tube, ISO 200, $^1/_{500}$ second at f/8.*

*Parrot snake (right). Small reptiles are suitable subjects to record with a telephoto lens (200–300mm) and a +1-diopter close-up lens — an inexpensive, fast-working macro combination.*

manufacturers use this method for naming their lenses. Canon close-up lenses "250" and "500" focus at 250mm (+4 diopters) and 500mm (+2 diopters), respectively. The higher the diopter rating, the smaller the working distance and the greater the magnification. Close-up lenses do not provide a significant magnification increase when used with lens extensions.

Single-element close-up lenses do not produce high-quality results at magnifications above 1:3 life-size. Multi-element professional level supplementary lenses are available from Canon, Nikon and others for use at high magnifications with zoom and telephoto lenses.

## TELECONVERTERS

Teleconverters conveniently increase the focal length of the prime lens by 2X or 1.4X while maintaining the lens' full focusing range. With the lens adjusted to its closest focusing distance, magnifications of about 1:4 life-size are possible with the 2X converter and 1:5 life-size with the 1.4X converter. Teleconverters work well when combined with telephoto lenses to photograph wary subjects such as butterflies, frogs and songbirds. About 10 percent loss of image quality occurs with 1.4X converters and a 20 percent loss with 2X converters. Fortunately, image degradation takes place around the periphery of the frame and is usually not a problem, particularly when this area is not in the depth-of-field zone. If edge-to-edge sharpness is important, stop down one or two stops

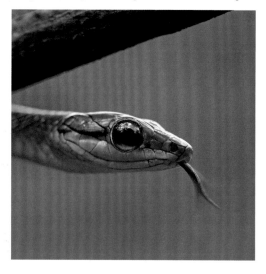

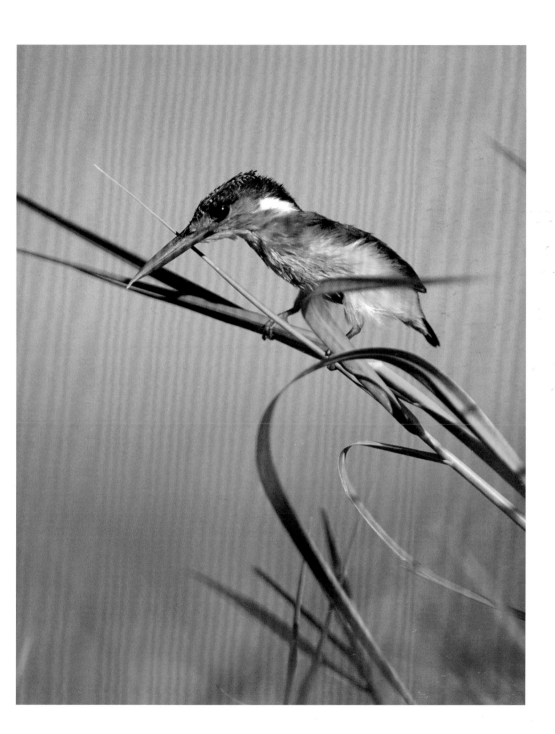

*Malachite kingfisher (left)*. *A 500mm lens with 1.4X teleconverter provided ample close-range power (effective focal length 700mm) to capture this diminutive fisherman intently studying the water below for prey.*

## Insects in a Meadow

As a nature photographer you will find few shooting experiences more enjoyable than recording insects, especially butterflies, in the field under natural light. The key word here is natural — no ghoulish flash laying low the exquisite forms of carapace and abdomen or blistering the minty tints of a spring meadow. All you need is simple equipment, a stretch of prairie and time to savor the circling bee and clattering grasshopper.

I like to use a focal length of about 300mm with extension tube(s) attached for close focusing. The telephoto's narrow angle of view makes it easy to selectively frame blurred background and foreground colors that can be incorporated into the composition. Such a lens also allows you to work a few feet away from your subject (important with timid butterflies). I use a 25mm tube alone or two together to achieve a variety of magnifications up to about 1:3 life-size.

Make sure your lens is well hooded as you will frequently find beautiful compositions by shooting against the light. A rotating tripod collar makes it easy to switch from horizontal to vertical formats and to swap around extension tubes when you wish to modify framing and subject magnification.

Big spaces open to the sky — prairies, meadows and lake shores — are where you can find both plenty of insects and ample light. You won't find shooting to be as productive in forests or dense thickets though they may appear more wild.

Country roadsides and ditches are good almost anywhere. They receive plenty of sun and lots of water runoff from the road, which nourishes plant growth, particularly wildflowers — the key to this approach to insect photography. Not only do wildflowers offer important design elements but the nectar and pollen they produce attract lots of insects and their predators. If you're exploring from the car, look for meadows with butterflies fluttering above as this indicates an active feeding area.

Few picture components breathe as much natural magic into the atmosphere of a nature photograph as do patches of empty space represented by out-of-focus washes of color, especially the vacuous blue of the sky. Using a telephoto lens at or near largest aperture is the starting point for bringing selected areas of strong color-blur into the composition. For the sky you will have to shoot from an angle lower than the flower, across an incline or over a hump toward the open horizon.

**Painted lady on purple coneflower (right).** A lens hood tamed flare and a reflector brightened the shadows of this backlit specimen. Canon EOS A2, Canon 500mm f/4 IS L lens, extension tube, Fujichrome Velvia, $1/250$ second at f/5.6.

**Tiger swallowtail butterfly (below).** Soft ambient light with matt white reflector fill and low camera angle to include a hint of blue sky projects an airy feeling to this portrait. Mamiya 645 AFD with Phase One P25 digital back, Rodagon 150mm f/5.6 lens, Horseman View Camera Converter extension bellow, ISO 100, $1/15$ second at f/11.

*The sky shouldn't sit above the subject in one expanse but should appear in swatches.*

*The key to recording a strong design is not to target the butterflies — they normally fly off at your approach. Rather note the flower(s) that they are feeding on and use this as the framework for your design. Get into position quietly. Adjust focus and framing to capture one robust bloom clearly (a healthy bloom is a source of pollen and nectar). Move the camera position forward and backward and from side to side to reposition colorful out-of-focus blooms and color patches, including the sky, until you arrive at an effective arrangement. Once you are still, butterflies should appear on the stage you have created in your viewfinder (see page 133). With butterflies, strive to bring both the eyes and antennae tips into the depth of field.*

*The best time is mid-morning on a sunny day. Warm temperatures stimulate nectar production and lots of bee and butterfly activity. At these magnifications, when a tripod is used with hands on the camera, a shutter speed of ¹/₁₂₅ second will yield sharp photographs. At slower speeds, switch to a cable release.*

from maximum aperture. If you are using a teleconverter and an extension tube together, place the teleconverter on the camera body first, then attach the extension tube, and lastly, the prime lens.

*Crab spider on camas (above). This diminutive predator waited to ambush small flies that fed on these blooms. Shallow depth of field can be used to surround your subject in soft color.*

## TELEPHOTO LENSES

Telephoto lenses allow you to maintain adequate working distances from wary subjects. They can be used with teleconverters, extension tubes and bellows and close-up supplementary lenses as well as nearly any combination of all four. One of my favorite uses of a telephoto lens in close-up work is for shooting wildflower meadows at maximum aperture. With careful manipulation of camera position

*California poppies (above). Photographed at near point blank range with an ultra wide-angle lens and a 12mm extension tube, this composition was carefully managed by choice of shooting angle and camera-to-subject distance. Minute framing adjustments generated dramatic shifts in subject position and focus. A matt white reflector was placed on the ground below the subject to open up shadow areas.*

and focus distance, you can use the shallow depth of field to create dramatic abstractions organized around out-of-focus background and foreground elements (see page 188).

### WIDE-ANGLE LENSES

Adapting a wide-angle lens for close-up work is best accomplished with a short extension tube (12–15mm). At closer range it creates the same feeling of expanded perspective as at normal magnification. When using close-up supplementary lenses, vignetting may occur with focal lengths less than 24mm. This can be checked by viewing the scene at stopped-down aperture. Most viewfinders only show about 90 percent of the picture area, so vignetting may still appear in the capture even if you can't see it in the viewfinder. I like to push a wide-angle lens into a clump of flowers, with some of the blossoms even touching the front of the lens. Then, working with the camera handheld at ground level, I try various positions — changing the angle even slightly can radically alter composition.

Wide-angle lenses are useful for producing magnifications exceeding life-size with minimum extension and therefore minimum light loss through the optical system. In order to focus at such magnifications, the lens is attached in reversed position on extension tubes or bellows. A reversed 24mm lens with 50mm of extension produces 2X (2:1) life-size; with 150mm of extension, it produces 6X (6:1) life-size.

### TILT-SHIFT LENSES

These lenses make maximum use of depth of field (close-up photography's most limited commodity), making it possible to use larger apertures and faster shutter speeds that freeze motion. Tilt-shift lenses allow the film plane to be aligned with the subject plane with minimal framing compromise. First

establish the framing desired, then tilt the lens to parallel as closely as possible the important elements of the composition, adjust the focus and reposition the camera to capture the scene as originally framed. Finally, using depth-of-field preview, select the aperture and shutter speed combination that best interpret the scene. Keep the shift setting to zero to avoid exposure problems.

Tilt-shift lenses can be used with extensions, teleconverters and close-up supplementary lenses. They are available principally from Canon or Nikon in focal lengths ranging from 24mm to 90mm. The longer focal lengths are generally more useful for natural subjects.

## GREATER THAN LIFE-SIZE

At magnification exceeding life-size, the image

quality of standard lenses begins to deteriorate and working distances are so reduced that the light may be blocked from the subject by the lens itself. Special procedures are necessary to avoid these kind of problems.

## REVERSING THE LENS

Image quality is restored by reversing the lens on the camera body, accomplished by screwing an adapter to the front of the lens. Unfortunately the adapter circumvents automatic coupling devices and makes stop-down metering, manual closing of the diaphragm and manual exposure control necessary.

## ELECTRONIC FLASH

The advantages of working with electronic flash include reliable automatic TTL exposure control, brief exposure times that allow the camera to be hand held and provide

*Orb-weaver spider (above).* To achieve this 2X life-size portrait, I used a 28–105mm zoom lens and a 25mm extension tube, a simple combination that offers a wide range of magnification simply by adjusting the zoom control. When photographing animals at magnifications exceeding life-size, it's necessary to use electronic flash to arrest subject movement and camera shake and have enough light to shoot at small apertures for adequate depth of field. This portrait was made with a hand held camera and dual flash Sailwind unit (see page 180).

*Baby skunk (left).* This captive youngster was recorded with a 500mm lens and 25mm extension tube on a Canon EOS 5D at ISO 200.

*Macro flash brackets with two TTL automatic flash units (above). This apparatus holds two synchronized strobes in place with adjustable arms.*

*Garter snake with extended tongue (right). A simple two-flash system (see photo below) was used to illuminate this subject photographed at near life-size. The brief flash duration arrested both subject and camera movement, resulting in detailed results. White tissue softened the flash for better highlight and shadow reproduction.*

adequate illumination for exposing at low ISO with small apertures to maximize depth of field. Electronic flash is usually the only viable approach for recording small animals at magnifications 1:2 life-size or greater. The artificial feeling of flash can be minimized by placing the flash away from the camera/subject axis and using bounce reflectors or diffusers to soften the light. An efficient diffuser is a single layer of Kleenex, which reduces output by about one stop (compensate for this only if using manual flash).

In close-up work, full flash is used to light both the subject and background; usually no ambient light registers on the film. This type of lighting is thematically suited for images of nocturnal subjects in which portions of the background are black due to flash fall-off. With the notable exception of butterflies, bees and other pollinators, many insects can be included in this category,

as well as many species of reptiles and amphibians. Due to its brief duration, flash is necessary when hand-holding the camera to ensure sharpness.

## FLASH POSITION

In nature, light illuminates a subject from any direction, and so can your flash. The most convenient position for the flash is on the camera's hot shoe,

but you can also place it to one side, above or even behind the subject using a remote synchronization cord and a macro flash bracket or light stand. If you use multiple flashes, be sure that one flash dominates the lighting scheme by reducing the power of the other flashes. Generally, the background light should be reduced by one stop and a fill light should be reduced by about two stops. Consult your flash manual to find out how to do this.

*American alligator (above).*
*This wary reptile was shot with a 500mm lens and extension tube from a distance of 6 feet.*

# Wild Flora

*Conventional and offbeat approaches to one of nature's most expressive subjects*

*Saguaro cactus (below). This detailed study, recorded at 1:5 life-size magnification, was illuminated by a hazy sky and fill light from a matt white reflector.*

**MEXICAN HAT, WILD** adder's tongue, maidenhair fern — romantic names for wildflowers and other flora that comprise the intimate details of a landscape. The natural world is filled with small still-life subjects waiting for a composition. Accessible no matter where you happen to live, they offer photographers endless opportunities for creative self-expression. In this chapter, I'll outline some of the basic principles for making beautiful portraits and then offer some offbeat approaches that should help launch your creative endeavors.

Most of your floral photography will take place close to the ground and you will usually need to use a tripod to insure sharpness. For ankle-high subjects, rest your camera on a couple of beanbags right on the ground. For taller specimens, you can usually work with your tripod legs collapsed and completely spread. The operating principle here is to position your tripod at, or below, bloom level.

## WINDS OF WOE

Once you have the camera stabilized, the next task is to immobilize the subject. Keep in mind that close-ups of flowers under natural overcast light using a polarizing filter and moderate ISO speed (400) require exposures in the 1/15-second range and longer. When the shutter is open this long, even a breath of air will cause the blossom to shake unacceptably. A light breeze makes it nearly impossible to attain detailed, frame-filling photographs. It's advisable to spend such periods working with solid, hard-sided subjects or scouting new areas for possible pictures. Breezy days are also great times for capturing wider views of colorful meadows in blurred motion. This method is suitable for even sunny midday conditions

because shadow and highlight portions of the scene are blended to automatically reduce contrast.

Although the atmosphere seems completely calm, once you study the subject at close-range through the viewfinder, you will discover that there is usually enough energy to jostle fragile specimens. If this is the case, you must be patient and time shutter release carefully to capture the subject between zephyrs. In such circumstances a Plamp (plant clamp — see www.tripodhead.com) comes in handy to keep the blossoms absolutely still during exposure. You clamp the jaws of one end of this articulating gizmo to something solid (avoid using your tripod whenever possible) and the other end to the plant (outside the picture frame, of course). The Plamp is also handy for adjusting the location of the flower in the frame rather than trying to move the camera itself, a cumbersome and finicky undertaking at close range.

## Improving the Light

Although wildflowers are often photographed with artificial light, you will find natural light both more attractive and amenable to controlling the numerous features of the composition. Overcast or hazy skies provide the soft, even illumination ideal for close-up work, especially with wildflowers. Even under these conditions, matt white reflectors improve color rendition and shadow detail, although it may be difficult to notice until the film is developed. If shooting

*Wild daylilies (above). The camera back was angled to remain equidistant from the most important blooms to use the shallow depth of field to best advantage. Mamiya 645 AFD with Phase One P25 digital back, Mamiya Sekor 105–210mm f/4.5 lens, extension tube, ISO 100, 1/4 second at f/11.*

*Gaillardia and bachelor's buttons (right). This dreamy capture was made on a calm day with partially overcast skies that softened the light and made it easy to fit all the data within the histogram. A telephoto lens set a maximum aperture was used to isolate a sharply rendered specimen amid a sea of blur. The camera was kept low to the ground to bring a stretch of blue sky into the background. Mamiya 645 AFD with Phase One P25 digital back, Mamiya Sekor 300mm f/5.6 lens, ISO 100, 1/250 second at f/5.6.*

under sunny conditions early or late in the day, reflectors are essential for close-up portrait work.

### How to Shoot at High Noon

When working under a clear sky at midday, you must take steps to soften the sun's light. A simple procedure, customarily used by professionals, that produces naturally lit, professional-caliber imagery calls for the use of a large umbrella of neutral color (those used by golfers are ideal). Set up the parasol to block all direct sunlight from the subject and the background. Then use a matt white reflector held away from the umbrella to bounce soft light back into the scene. This produces an effect nearly identical to overcast conditions with low contrast and normal color balance. It's great to have an assistant to help out with the umbrella and reflector. If you are working single-handedly with a ground-hugging

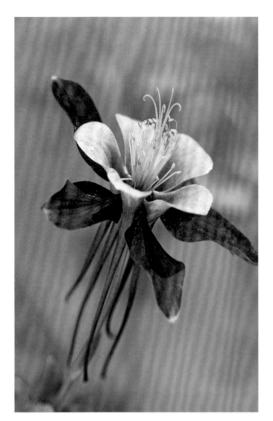

• Sharpest focus should be on the pistils and stamens unless other more distinctive features offer greater visual interest.

• Use out-of-focus patches of color to frame the main blossom.

• Check the picture area (especially around the periphery) to make sure no other elements are sharper, brighter, more colorful, or in any way more attractive than the main subject. Readjust framing as necessary.

• To simplify the composition, shoot at a large aperture for shallow depth of field to soften less important features surrounding the main subject. Once you've made a few portraits and are more familiar with the subject and working at close range, subject, set up the umbrella to lean on the ground, hold the reflector in one hand and trip the shutter with a remote release.

## WILDFLOWER PORTRAITS

Making a simple, detailed portrait of a blossom usually represents a photographer's first attempt at expressing the beauty of the wildflower world. Effective portraiture is not as easy as you might at first think. Here are some suggestions.

• Get close enough. For a portrait, the bloom should occupy most of the picture frame.

*Colorado columbine (left). To generate your own overcast light, use a large, neutral-colored umbrella to shade the subject and bounce light into the scene with a matt white reflector. This photo was taken at midday under a cloudless sky.*

*Lewisia trevosia (below). This portrait was made with a tilt/shift bellows that brought both groups of pistils and stamens into focus despite shallow depth of field. Mamiya 645 AFD with Phase One P25 digital back, Rodagon 150mm f/5.6 lens, Horseman View Camera Converter extension bellows, ISO 100, 1/15 second at f/11.*

*Plamp (right). The handy Plamp (plant clamp – www.tripod head.com) is put to work stabilizing yellow daisies. The Plamp is anchored to a common screwdriver stuck into the ground away from the tripod. Avoid using the tripod to anchor the device as it will transmit vibrations from the camera to the subject.*

*Orange sneezeweeds, asters and scarlet gilias (below). This pseudo-aerial was made with a tripod-mounted zoom lens placed almost directly above the array to allow precise framing of the key floral components.*

you'll want to begin to experiment with alternate imagery less anchored in this formulaic approach.

### Aerial Angles

With small subjects you can take authentic aerial photos without the expense of renting an airplane. You can create those arresting studies in line, form and pattern that are the hallmarks of Cessna-snapping. Your best tool here is usually a zoom lens either with macro capabilities or equipped with an extension tube for close-focusing. Your tripod must be set up so that the camera projects over the flowers far enough to keep the legs out of the viewfinder. This is easy if your tripod has a center column that can be reinserted laterally in its collar (as with some Manfrotto/ Bogen models) to cantilever the camera out away from the legs. Otherwise you need to tip the tripod forward over the subject with the two front legs spread wide to straddle the view and the back leg stretched out and anchored to the ground with your camera bag or some other weight (a bungee cord comes in handy here). The tripod doesn't have to be rock solid, just dead steady for a second or two at a time to prevent the camera from moving during exposure. From directly above, there is no top or bottom to the composition so you can take any angle on the subject you wish. Zoom in and out to test various magnifications. Let the flowers lead the flow of possibilities until you hit upon a graphic that you like. Even with a small patch of blooms, I like to aim so that blossoms around the periphery are cut off to give the impression that the color field extends forever. Framing two blooms is usually a mistake as the center of interest is split, robbing the composition of its unity.

### The Slow Smoothie

This is my favorite wildflower motif. It's a blend of delicious reds, mauves and whites

gently spread into a background of fresh greens. Two conditions are necessary. The first is wind — the ruin of most wildflower photographs but in this case it's essential. Next you need a colorful expanse of blooms about the size of a kitchen table or larger. A normal to wide-angle lens usually works well for mixing up the palette of color. The shutter setting depends on how much the flowers are moving around. Intermittent shakes and shudders may require an exposure of several seconds or longer (unpack your neutral density filters); while in a breeze, a $1/15$ second does nicely. If the exposure is too long the blossoms will lose definition and saturation, too brief and they will look merely fuzzy as if you were not focused properly or were hand-holding the camera. Try various shutter speeds to make sure you get the effect you want and remember to compensate for the change in exposure time by adjusting the

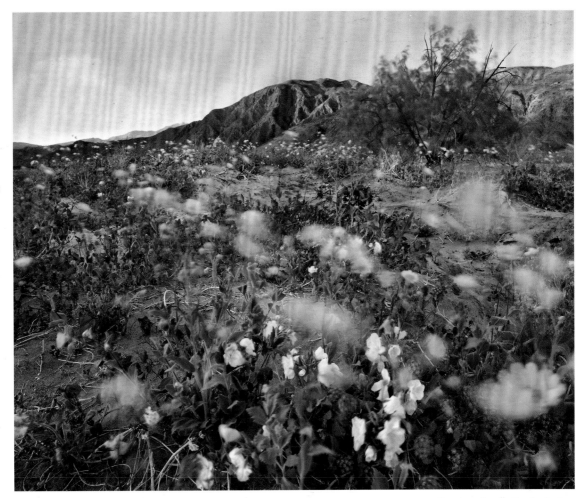

aperture. An average or evaluative meter reading normally yields accurate exposure.

Several refinements offer additional possibilities. If you are set up within a few feet of the flowers, a burst of action-stopping flash can be seared into the mix during exposure. Set both the flash exposure and ambient light exposure for one stop less than full exposure. When added together, these two

*Desert sunflowers blowing in the wind (above). Made possible with a neutral density filter to reduce brightness, a late-day exposure time of 4 seconds blurred the wind-jostled blooms of this vibrant meadow. The camera was tripod mounted and fitted with a short zoom lens.*

values will yield the correct density. It's best to hold the flash off the camera above the flower patch for more even front-to-back illumination. This is easy to synchronize manually for exposures of a second or more (just press the flash's test button when you hear the shutter open). At faster speeds you'll need to attach a sync cord between camera and flash and use standard fill-flash techniques. Another approach uses double captures and produces a similar effect. Make one image at a slow shutter speed for blurring effects and the other at a motion-stopping speed for fine-edged detail. Marry them later on the computer. Variations for generating these blurred composites include defocusing, zooming to a slightly different magnification or zooming during the exposure. The dreamy effects generally spring from a marriage of etched blooms haloed in dreamy color.

### TELEPHOTO PROSPECTING

It's difficult to predict the results of blurred motion techniques. The viewfinder offers few clues of the impending magic. By contrast, this long lens approach allows you to savor the image in nearly full measure before you even trip the shutter. Like many good things, it's a simple undertaking with infinite possibilities. The approach is based on using the telephoto's limited depth of field to place out-of-focus blurs strategically in the composition. You can modify these dabs, blobs and washes of color in size, saturation, definition, transparency and position by judicious selection of camera angle, focal

distance, camera-to-subject distance and camera-to-blur distance. Although this sounds like formula work, it isn't. It's an artistic exercise requiring Mondrianic color sense, Pollockian persistence, du Champsian zeal for experimentation, and Rodinesque appreciation of form before all the lush pieces of the puzzle can be fused in the viewfinder, ready for exposure. A telephoto lens in the 400mm–600mm range fitted with an extension tube for resolving close-up blooms is the ideal brush for creating these painterly effects. You may choose to work in the abstract, devising sensuous combinations of pure colors and shapes. Or select a bloom or bouquet for sharp rendering and clear identification and let this center of interest anchor and shape the complement of blurry chromas.

It's difficult to prejudge such scenes with the naked eye — you need to analyze the picture elements through the lens. To do this, kneel behind the tripod with the camera positioned at bloom level. If the sun is low in the sky, opt for a front-lit view to capture pure saturated colors. If shooting during midday, set up for backlighting so that petals and leaves are transilluminated and glow with inner color. This back-door defense against high noon's laser preempts burned highlights and frozen shadows. Of help in further reducing contrast is the shallow depth of field that the telephoto projects into the scene to soften the edges of out-of-focus shadow and highlight areas.

Once lighting issues are settled, I begin measuring the range, precise angle and trajectory to the target blooms. Camera range is a compromise between how large I want the featured flowers to be

*Narrow-leaved penstemon (far left). In this image, a tripod, plant clamp, calm atmosphere, well placed depth of field and vibration-free shutter speed (1/4 second) resulted in sharp detail.*

*Blue flag iris (below). I found this combination of blurred and sharp color swatches by casting around through clumps of irises with a 300mm lens fitted with an extension tube. Mamiya 645 AFD with Phase One P25 digital back, Mamiya Sekor 300mm f/5.6 lens, extension tube, ISO 100, 1/125 second at f/5.6.*

the aperture at maximum, or nearly so, with whatever shutter speed renders normal exposure at a center-weighted, average or evaluative meter reading. Warm sun and soft breeze, bird twitter and insect buzz, delicate scents of moist earth and minted grasses make it easy to linger dreamily over the beautiful sights in the viewfinder. Just remember to take a photo once in a while!

### DOWN AND DIRTY

Change into play clothes for this one — no need for those pesky tripods

and the size and definition of the complementary color blurs. Camera angle determines just how the color patches are arranged around the main subject, and the trajectory is adjusted for both arrangement of floral elements as well as for the inclusion of blue sky (yes) or clouds (none or a few). Each shift in camera position and lens focus serves up a new composition for you to enjoy and evaluate. The process becomes less trial and error as you get a feeling for how the many factors engage one another. Set

either. For these ground-hugging shots, mother earth provides all of the camera support you'll need. The intent is to take the viewer inside the floral bouquet while setting the blooms up against the most inviting hue in the universe — the blue ceiling of a sunny day. An ultra wide-angle lens is required here, something in the range of 20mm. To get it to focus close enough, you'll need to attach an extension tube of 12–15mm (longer tubes will not bring the subject into focus) between camera and lens. Keep a

polarizing filter handy to provide more color saturation in the sky should the camera angle and timing of your shoot make this practical. Crawl up to a color patch (yellow and orange petals look most dramatic against the blue) and shove your camera right into the center of a tight bouquet. So much the better if leaves and petals brush against the front of the lens. Once you've calmed down from your first revealing peak in the viewfinder, you can begin to arrange the overload of gorgeous colors and shapes into an effective composition. Minute shifts of camera angle and position generate dramatic changes in the scene. Once the artist in you has it just right, stabilize the camera position with anything handy — pebbles, sand, your hat or maybe the useful beanbag support you remembered to bring along. Check depth of field through the lens and then adjust focus, aperture and shutter speed for the best rendering of subject sharpness. Trip the shutter with the self-timer or a cable release, avoiding both camera shake and wind-induced movement of the blooms. Most of the time, color and contrast improve with the use of a reflector placed on the ground right beneath the flowers. A simple sheet of white paper works as effectively as anything.

Of course, warm weather sees wildflowers sprouting everywhere. Before you set out, surf the Internet for the latest information on blooming conditions and up-to-date wildflower hotline numbers. Great shooting and happy travels!

*Fun with sunflowers. A favorite floral subject, sunflowers are treated here with three different approaches. An aging group of specimens was photographed in the wild with special care given to camera angle for presenting a triangular arrangement of sharply focused blooms against a harmonious, out-of-focus background (**far left**). Purple asters were used as accents in this studio arrangement (**left**). Intriguing details and textures were captured in soft light at close-range in this tight, straightforward take. Background blue sky was simulated in Photoshop (**above**).*

*Part Six*
# Digital Processing

# Digital Darkroom Equipment

*Storing images in the field and processing them in the studio*

**NATURE PHOTOGRAPHERS SHOOTING** digital images require equipment additional to the standard camera-and-lens kit. You need a computer with image-editing software so that you can process, edit and prepare images for printmaking, Web publication and other uses. On forays of more than a day, you also need a storage device to clear compact flash (CF) cards for future photo sessions. This section provides information for the beginner on professional equipment and procedures.

## SAVING IMAGES IN THE FIELD

Your camera's first level of storage is the in-camera compact flash card. For landscape shooters, who rarely use the motor-driven bursts common in wildlife photography, the best-sized cards are in the 1–2 gigabyte (GB) range (not larger). One card is enough to handle a half-day of steady shooting, provided you delete mistakes periodically. You can offload images during the normally quiescent midday period. By carrying a larger number of smaller-capacity cards you don't put all your eggs in one basket, and you have better

protection against card malfunction or catastrophic data loss.

Once a CF card is full, you need to clear the captures to a larger storage device. You can offload files directly to a laptop computer with hard-drive capacity or to a stand-alone image tank (a specialized hard drive

*Mule deer in alpine meadow (below).* Although this photograph was recorded on film, once scanned it can be corrected and modified using standard digital imaging techniques.

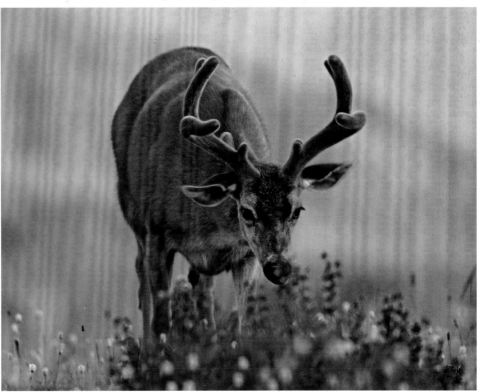

with a photo-storage chip). Ideally, you want both so that your images are recorded in two places should data be accidentally lost from one of the devices. As most scenic shooters have end-of-day access to an AC power source (lodging or vehicle equipped with a DC/AC power inverter), a laptop with peripheral hard-drive backup is standard. If you are on an extended shoot with no access to AC power, it's best to pack enough CF cards for the trip. One gigabyte per day should be sufficient if you delete unsatisfactory images in-camera as you go along. More economical but weightier and riskier are one or two CF cards and a portable, battery-powered image tank for downloading. This approach leaves your entire shoot

*Bobcat (below). A 2 GB compact flash card can record about the same number of high resolution images as two 32-exposure rolls of 645 film. In practice, flash card capacity is greater because exposure bracketing is not necessary and you can delete inferior imagery from the card as you go along.*

*Digital Tailgate Studio*

Laptop computer (Apple iBook)

Extra hard drive (Firelite 60 GB)

CF card reader with Firewire cable

*This standard system provides on-the-road Photoshop, plenty of storage and backup security. To use the portable hard drive (which draws power and data from the computer via a Firewire cable), the computer must be plugged into the vehicle's cigarette lighter using an inexpensive DC/AC power inverter.*

at jeopardy should the portable drive be lost or damaged, not to mention the battery challenges.

## PORTABLE STORAGE DRIVES

If you are working without a laptop, you need an image storage tank that will allow downloading directly from the CF card. These devices have built-in card readers and simple LCD menus for initiating and monitoring transfers as well as indicating remaining capacity and battery level. Most are equipped with AC and DC hookups and use lithium ion rechargeable batteries. Capacity ranges from 20 GB upward — plenty for a week of backcountry shooting, provided you have enough battery power (about 10 GB of download per charge).

If you only need backup storage for

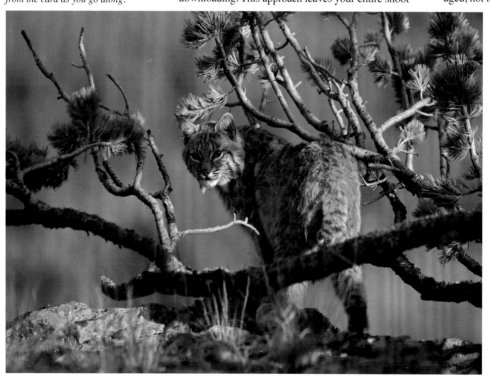

your laptop computer, any external hard drive will do. For traveling, smaller is always better, and drives that draw both their power and data from the computer via a Firewire or USB cable are the most convenient. A variety of lightweight units are available.

## COMPUTER AND SOFTWARE

Post-shooting work begins once the image data is placed on a computer's hard drive. This is where the image is processed (transformed from the camera's proprietary file formats [RAW] to standard TIFF, PSD or JPEG formats that can be adjusted with image processing software and read by other computers. You can tune color balance and saturation, brightness and contrast, dodge and burn, remove imperfections, straighten horizons and make hundreds (if not thousands) of other manipulations with speed and accuracy (see subsequent sections). The standard and best image editing software is Adobe Photoshop (in full or limited versions). There is not much difference in computer brands or platforms, Apple, Dell and Hewlett-Packard being prominent. Due to the large amount of data in a color image, get the fastest processor you can afford, at least 1 GB of RAM and two high-capacity hard drives, one for immediate storage and the other as backup (300 GB minimum/drive). For additional security, you should archive your collection on DVDs or a third hard drive stored in a different location.

> ### Calibrating Your Monitor
> *A calibrated monitor is essential for accurate color processing and publication. Monitor performance changes with time, requiring calibration touch-ups about once a month.*
> *• For Windows use Adobe Gamma Utility, found in the Control Panel.*
> *• Mac users go to System Preferences > Displays > Color. More accurate calibration, available through third-party software, is recommended.*

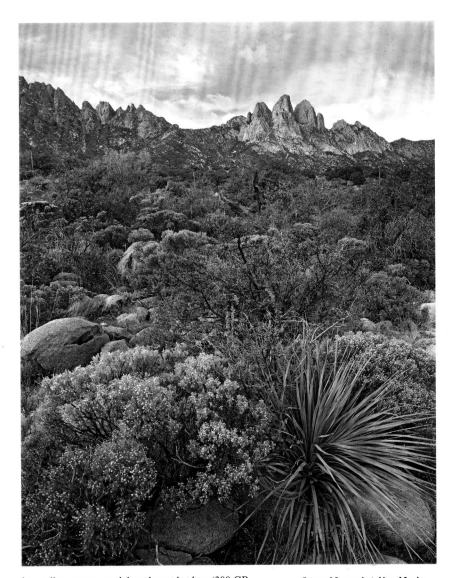

*Organ Mountains, New Mexico (above). Adjusting digital color balance, saturation and contrast is based on the original RAW file, how you remember the scene and what seems natural.*

# Preparing Images for Presentation

*Professional art print, website or print media display*

*Northeast Creek, Mount Desert Island, Maine (below). This image was converted from RAW format to Adobe RGB 1998, a large color space standard for professional and fine art inkjet printing. Mamiya 645 AFD with Phase One P25+ digital back, Mamiya-Sekor 45mm f/2.8 lens, Singh-Ray polarizing filter, one-stop split neutral density filter, ISO 100, $^1/_{30}$ second at f/22.*

THIS SECTION DEALS with the computer work necessary to prepare digitally captured images for presentation. The information is just as useful for photographers working from film images that have been scanned for digital manipulation or printing.

All references to actual software steps refer to Photoshop CS. This is not a comprehensive treatment but rather a brief introduction to a few of the many Photoshop features used in preparing digital images for presentation, both commercial and private.

## RAW MODE

Professional digital photographers capture images in RAW mode. This saves all the data in its original state — there is no in-camera processing of the image, no sharpening, no tweaking of color or contrast. To work with RAW image files (saved as formats specific to each camera model), you must convert them to a standard lossless (no image data lost in compression) format — either TIFF or PSD (Photoshop format). This is accomplished on a computer with appropriate software.

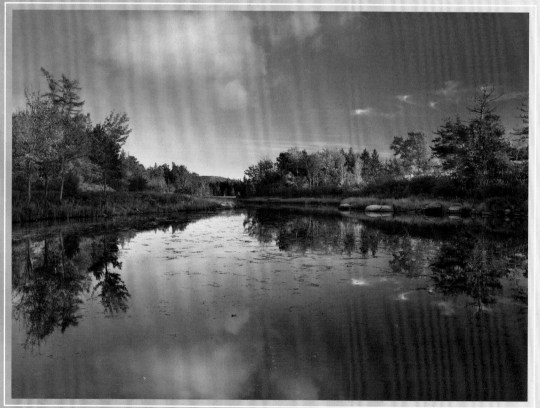

Photoshop CS usually does the best job and offers conversion for most types of digital cameras.

### FROM CAMERA TO COMPUTER

You should convert your RAW files to TIFF or PSD format (not JPEG, which loses data in compression). Before you open the files in Photoshop, you must set the working color space (Edit > Color Settings > Settings). The larger the color space, the more data is retained from the original RAW file and the more options you have for subsequent use.

### THREE COLOR SPACES

Following are the color spaces most useful to landscape photographers:

1) For immediate conversion you should choose ProPhoto RGB. This provides the largest color space, or gamut (range of color/tone variation), and is well suited for fine-art printing. This space retains all the data you need to reconvert for other uses.

2) Next in line is Adobe RGB (1998), a space designed for conversion to CMYK color mode, which is used for high-quality commercial printing (like this book). This is the color space you need for submitting RGB images for editorial consideration in magazines, calendars, and so on.

3) The third and smallest of the essential color spaces (there are many others) is Adobe sRGB IEC61966-2.1. This space has a color gamut designed for Web-posting and is the standard to which most computer monitors are designed and factory set.

Keep in mind that once you convert and save the image to a smaller color space, you cannot recapture the lost data. Consequently, it's wise to archive your RAW files for future uses not yet anticipated.

*Scarlet macaws (above). When converting an image from one color space to another, be sure to safeguard a copy in the largest color space in a lossless file format such as TIFF or PSD (not JPEG) for future use. Canon EOS 5D, Canon 500mm f/4 L IS lens, ISO 200, 1/30 second at f/8.*

### FINE-TUNING THE CAPTURE

When a RAW capture first opens in its new color space, it will look dull and not very sharp. Not to worry — Photoshop's numerous controls can quickly bring the scene back to its original state. The adjustments of the image's basic characteristics of color and brightness are interrelated and normally require back-and-forth tweaking before the desired result is achieved. Make your changes using adjustment layers (Layer > New Adjustment Layer).

### ADJUSTING BRIGHTNESS LEVELS

The first correction is usually made to image brightness (Image > Adjustments > Levels). In practice

this is a fine-tuning of your in-camera exposure and makes judging subsequent changes to other aspects of the image more accurate. If you verified your exposure against the camera's histogram at the time of shooting, a minor adjustment is normally all that is needed. Use an expanse of blue sky, patch of grass, green leaf or other common feature as reference. If the scene is low in contrast (e.g., landscapes shot under overcast conditions with skies cropped out), you may wish to increase contrast for more brilliant color. This is done by adjusting the input sliders to more closely bracket the histogram (see sidebar, page 200).

### Adjusting the Levels Curve

You can make changes to specific ranges of the tonal scale using Curves (Image > Adjustments > Curves). Holding down the Control key (Windows) or the Command key (Macintosh) click the region of the image you would like to adjust. A control point appears on the curve. Using the arrow keys, you can move the point upward to lighten or down-

ward to darken the area clicked in the image. You can use the same dialog box to adjust individual RGB tonal values.

### Adjusting Color Saturation

Usually, the next step is adding more color saturation (Image > Adjustments > Hue/Saturation). Again, choose a generic color-pegged feature to serve as reference (blue skies, green foliage) and make a master correction to all colors simultaneously. Avoid pumping colors excessively. Save adjustments to hue and color saturation to specific areas for the final stages of editing.

*Autumn leaves in frothy stream (far left). Your RAW files will often look unnaturally colorless. An increase in saturation via Photoshop brought out the inherent brilliance of this still-life capture. Mamiya 645 AFD with Phase One P25+ digital back, Mamiya Sekor 55–110mm f/4.5 lens, Singh-Ray polarizing filter, ISO 100, 1/15 second at f/11.*

*Halfway Log Dump Beach, Bruce Peninsula National Park, Ontario (below). Crooked horizons can be fixed in a jiffy — at the loss, however, of peripheral image features.*

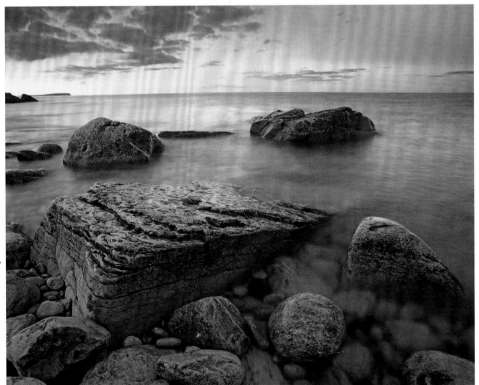

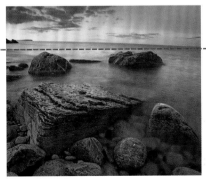

### Adjusting Low-contrast Files

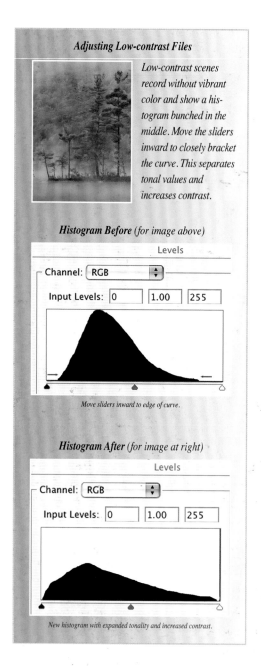

*Low-contrast scenes record without vibrant color and show a histogram bunched in the middle. Move the sliders inward to closely bracket the curve. This separates tonal values and increases contrast.*

### Histogram Before *(for image above)*

| Levels | | |
|---|---|---|
| Channel: RGB ⬍ | | |
| Input Levels: 0 | 1.00 | 255 |

*Move sliders inward to edge of curve.*

### Histogram After *(for image at right)*

| Levels | | |
|---|---|---|
| Channel: RGB ⬍ | | |
| Input Levels: 0 | 1.00 | 255 |

*New histogram with expanded tonality and increased contrast.*

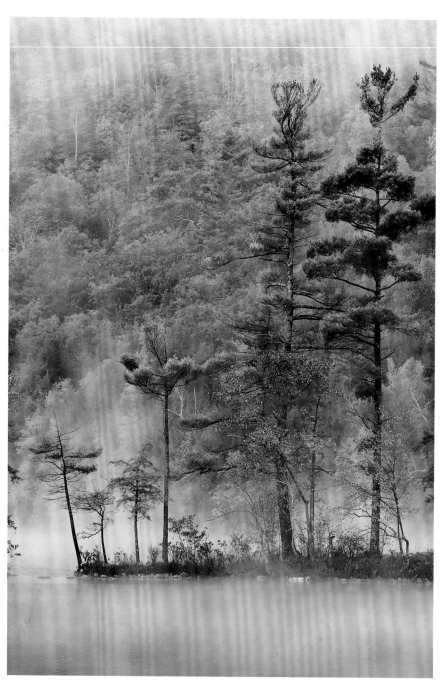

## Modifying Color Balance

Now you are ready to take a closer look at overall color balance. As I shoot outdoors almost exclusively, the camera's white balance is by default set for "daylight" (rather than "auto white balance"). Except for scenes recorded at twilight, color balance usually requires only minor adjustment. Again, use universal features as reference.

## Adjusting Contrast

One of the most important qualities of an image, contrast is the degree of difference between adjacent colors. The term is used to describe both the scene being photographed and the resulting

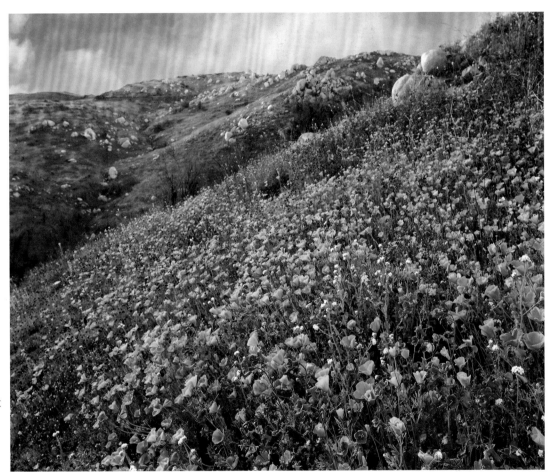

### Gaps in the Histogram
*Gaps in the histogram, often due to high contrast, indicate loss of color data. Sometimes you want "contrasty images" (Web use); at other times subtle variation in color tone may be preferred (art prints).*

image. High-contrast scenes and imagery exhibit great differences between the brightest and darkest color tones whereas low contrast versions show little difference. Normally, landscape photographers prefer to retain an accurate record of the setting being photographed, and contrast adjustments are made in order to present as much color information as possible while retaining a faithful rendering of the original scene. Split neutral density filters are crude

*California poppy meadow, Canyon Hills, California (above).*

*When making color adjustments to a landscape image, I normally start by adjusting the blue of the sky, which displays a universally consistent hue (dependent on time of day). Next I attend to the greens, striving for a hue that appears fresh but not oversaturated. Other colors are keyed to these two.*

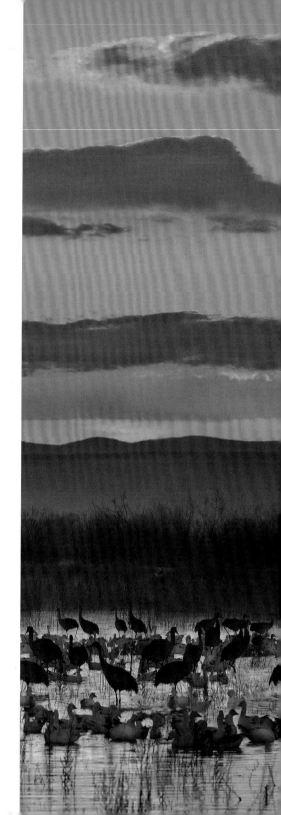

*You can apply Photoshop filtration to any area of the image by isolating it with one or more of the selection tools — magic wand, lasso and marquee. This is especially handy for adding density to skies — much as you would with an on-camera split ND filter. You can also use this method for patching in density that the filter missed due to an uneven horizon. Once you make the selection, it must be feathered (Select > Feather) to achieve a seamless transition. Selections can be used for making specific changes to any image feature. Convert the selection to a mask for even more editing options.*

***Bosque del Apache National Wildlife Refuge, New Mexico / digital composite (right).*** *When shooting digitally, you needn't correct all contrast issues in-camera using neutral density filtration. Provided the image data fits comfortably within the histogram, you can adjust specific areas for more accurate color and detail in Photoshop. Here, density and color were modified selectively in the sky and marsh once the image was on the computer. The small flock on the wing, photographed at a faster shutter speed, was added from another capture in the same series. Mamiya 645 AFD with Phase One P25 digital back, Mamiya-Sekor 300mm f/5.6 lens, ISO 400, 1/4 second at f/16.*

methods of modifying scene contrast (usually by adding more density to skies) when the image is captured. Photoshop provides numerous ways to continue this process in a much more precise and selective manner.

• **Standard overall adjustment** (Image > Adjustments > Brightness/Contrast). Use this adjustment for minor tweaking. Compare your before and after histograms to see how much data you may have lost (evidenced by gaps in the histogram). Data loss should be avoided.

• **Shadows/highlights** (Image > Adjustments > Shadow/Highlight). Use the sliders to darken highlights and brighten shadows. It's easy to overdo it, so examine affected areas at 100 percent magnification for unwanted noise and fogging (shadows) and unnatural color shifts (highlights).

• **Midtone contrast** (Image > Adjustment >

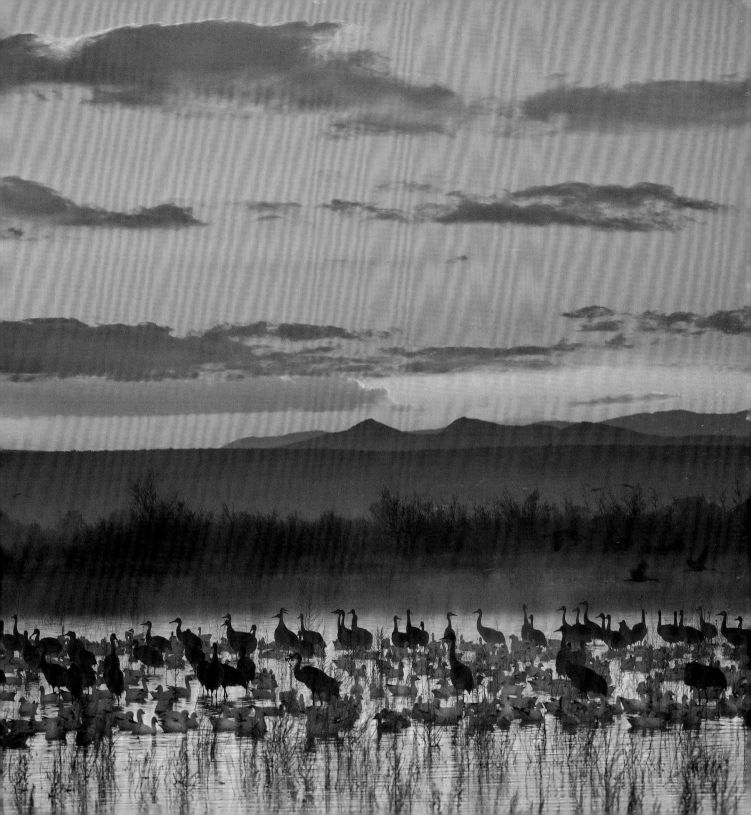

*Snow leopard / digital composite (below). When adjusting snowy images, I first tune overall color, working to give a natural hue to skies. Then I selectively move the whites toward a more neutral tone as they are often overly blue. This is easy (Image > Adjustment > Selective Color > Whites). This image of captive cubs was made from two 35mm transparencies scanned on the desktop with a Nikon Super Coolscan 9000.*

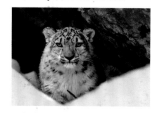

Shadow/Highlight > Show More Options > Midtone Contrast). This adjustment is sometimes handy for punching up midtone color in images where highlight and shadow areas are already near their limits.

• **Dodge and burn tools.** These are mouse controlled and work just like in your old darkroom, only with far more precision and easy redo.

• **Selective contrast adjustment.** Sometimes the image needs only adjustment in a certain area. Photoshop provides tools to isolate these regions so that the rest of the image will not be affected. Use any of the methods described above to modify the selected area (see sidebar, page 200).

### RETOUCHING

Once you are satisfied with the image's brightness, contrast and color, you need to repair small imperfections, usually a result of dirt on the camera's imaging sensor. Examine and retouch at 100 percent magnification. You may also wish to remove unwanted image features such as trash, footprints and telephone wires. The tools and techniques are similar in both cases.

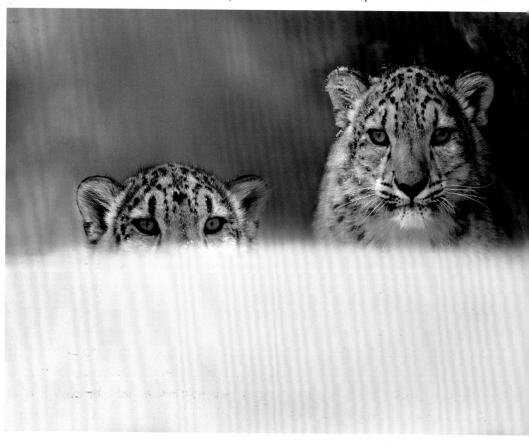

• **Healing brush.** This tool allows you to paint pixel samples from one part of the image to another. It matches the texture and lighting of the sampled area to the spot being repaired, resulting in seamless blending. This tool is especially useful for working with scanned transparencies, where it is important to match grain structure.

• **Clone stamp tool.** This tool also copies pixels from one area to another, but, unlike the healing brush, it does not modify the sample to blend into the new position. It is used for bigger jobs such as repairing skies that have been darkened excessively by filtration or lens vignetting or for removing a road sign or streak of flare.

## FILE FORMATS AND RESOLUTION

At this point you are ready to size and save the image to a file format for specific use. Here are the basic guidelines for standard types of presentation. When downsizing, be sure to keep a copy of the high resolution file.

• **Website/computer monitor.** Size the image at 90 pixels per inch (resolution for high-quality moni-

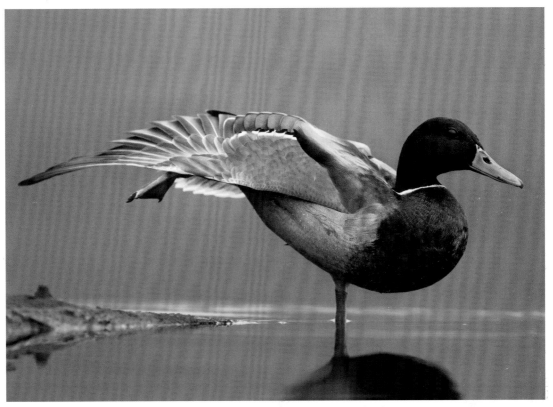

tors) at the dimensions you wish displayed.

• **Art print from inkjet printer.** Size the image at 225 pixels per inch at the print dimensions.

• **Books, calendars, magazines.** Size the image at 300 pixels per inch at the size of page reproduction. This is the standard requirement for editorial use.

## ADJUSTING SHARPNESS

The final stage of image preparation before output is sharpening. Sharpening does not add more detail or resolution. It increases contrast between adjacent pixels so existing detail is more succinct. How much

*Stretching mallard duck (above). This image was sized to 300 dpi at the magnification it appears here. Then I sharpened it with the Unsharp Mask filter while judging the results on screen at 50% magnification — a good approximation of the detail that will be apparent once the image is printed for illustrated book use.*

*Bison (below).* *The Smart Sharpen filter is a good choice when sharpening photos with dense shadows, areas that tend to become "noisy" when sharpened. This filter allows you to selectively reduce sharpening effects in these darker parts of the image.*

### Sharpening Artifacts

*Sharpening is primarily a matter of finding the line between sharp and oversharp. Here's what to avoid.*

**Halo.** Reduce pixel radius.

**Noise.** Adjust shadow fade amount (Smart Sharpen) or raise threshold (Unsharp Mask).

**Pixel clumping.** Reduce amount and increase threshold (Unsharp Mask).

you sharpen an image depends on its ultimate use and reproduction size. Sharpening causes a loss of image data and cannot be reversed once the file is saved. For best results, each image should be custom sharpened based on its inherent characteristics

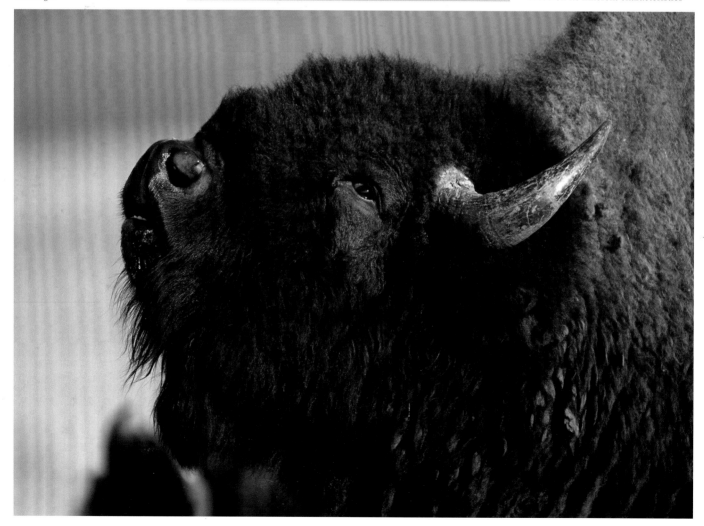

and intended use. The biggest pitfall is oversharpening, evidenced mainly as halos appearing around object peripheries, noise in dark areas and clumping of pixels (see the box opposite).

Photoshop's best sharpening tools are Smart Sharpen (Filter > Sharpen > Smart Sharpen) and Unsharp Mask (Filter > Sharpen > Unsharp Mask). Smart Sharpen's distinctive feature is providing control of sharpening in highlight and shadow areas. Here are some tips on using these two filters.

• Analyze the effects at 100 percent magnification.

• In Smart Sharpen, set the "Remove" option to "Lens Blur" (allows more sharpening with less halo than the "Gaussian Blur" option). The "Motion Blur" option is used for imagery made with a handheld camera, a practice generally eschewed by landscape shooters.

• As a starting point for both filters, set "Amount" to 150 percent and "Radius" to 1.0 pixels. Generally, the larger the final image presentation size, the larger the radius setting (up to 2.0 pixels for an 11 x 14 inch art print or calendar image). For Web presentation, 4 x 6 inch prints or quarter-page reproduction, set the

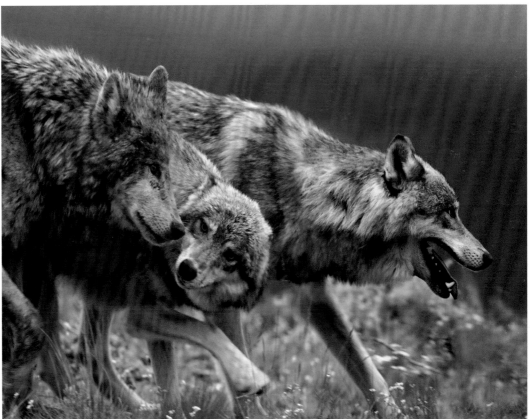

radius at about 0.3 pixels as a starting point.

• Examine shadows and highlights for noise/halos. In Unsharp Mask, raise threshold if sharpening artifacts appear. Similarly, in Smart Sharpen, fade sharpening for relevant area (shadows or highlights). Click the Advanced button to access these controls.

There's a world of photography to explore in Photoshop, but that's the subject of another book (some good ones are cited on the next page). Meanwhile, good luck with your shooting!

*Captive gray wolves (above). To increase sharpness in this image, I honed subject details with the Unsharp Mask filter. I then selectively adjusted contrast (Image > Adjustments > Curves) of the foreground vegetation to give it more brightness. For this I Power/Clicked (Macintosh) on the area and then toggled upward with the arrow key.*

# *Resource List*

**NEWSLETTERS**

*North American Nature Photography Association* (www.nanpa.org). Provides education and inspiration, gathers and disseminates information and develops standards for all persons interested in the field of nature and wilderness landscape photography.
*Photograph America Newsletter* (www.photographamerica.com). Produced by Robert Hitchman, these periodic guides provide in-depth information for landscape and nature photographers about travel logistics and specific scenic shooting sites. Contact the publisher for a full list of back issues.

**BOOKS**

*The Art of Bird Photography: The Complete Guide to Professional Field Techniques,* Arthur Morris, Amphoto Books, 1998.
*Photoshop for Nature Photographers: A Workshop in a Book,* Ellen Anon and Tim Grey, Sybex, 2005.
*Digital Nature Photography: The Art and the Science*, John and Barbara Gerlach, Focal Press, 2007.
*Photo Impressionism,* Freeman Patterson and André Gallant, Key Porter Books, 2001.
*Photography and the Art of Seeing,* Freeman Patterson, Key Porter Books, 1979.
*Close-up Photography in Nature, Third Edition*, Tim Fitzharris, Firefly Books, 2008.

**WEBSITES**

There are thousands of amateur and professional websites dedicated to nature photography. Here you can find everything you ever wanted to know on the topic. These three sites are especially useful and good starting points for further exploration.
*Outdoor Photographer* (www.outdoorphotographer.com). Basically an online collection of *Outdoor Photographer* magazine current and past issues. You can spend days exploring the plethora of information provided on this well-made, attractive site.
*The Luminous Landscape* (www.luminous-landscape.com). This site provides authoritive reviews of equipment and film as well as informed tutorials on advanced techniques and current issues of interest to nature photographers.
*Popular Photography & Imaging* (www.popphoto.com). Lots of photo tips including my column on nature photography. Best source for archived lens tests and equipment reviews.

**EQUIPMENT**

*Kirk Enterprises* (www.kirkphoto.com). Source for Kirk ball heads and other equipment.
*Really Right Stuff* (www.reallyrightstuff.com). Source for Really Right Stuff ball heads and other equipment.
*Singh-Ray Filters* (www.singh-ray.com). Top quality **3 1901 04583 9778** iety of landscape applications.
*Wimberley* (www.tripodhead.com). Source for Plamps, gimbal heads and flash brackets.